Sue & Whitney:
There is a real pleasure
in seeing someone so excited
by the prospect of A "READ"!
It is VERY GRATIFYING!
MANY ThANKS!
ENJOY!

(+ JOE, Too!)

ZIMBABWE
SHONA SCULPTURE

SPIRITS IN STONE

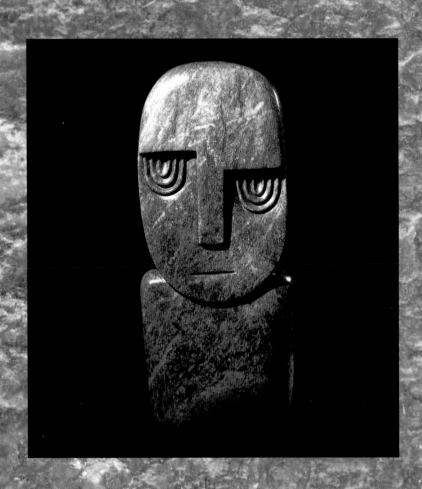

ZIMBABWE
SHONA SCULPTURE

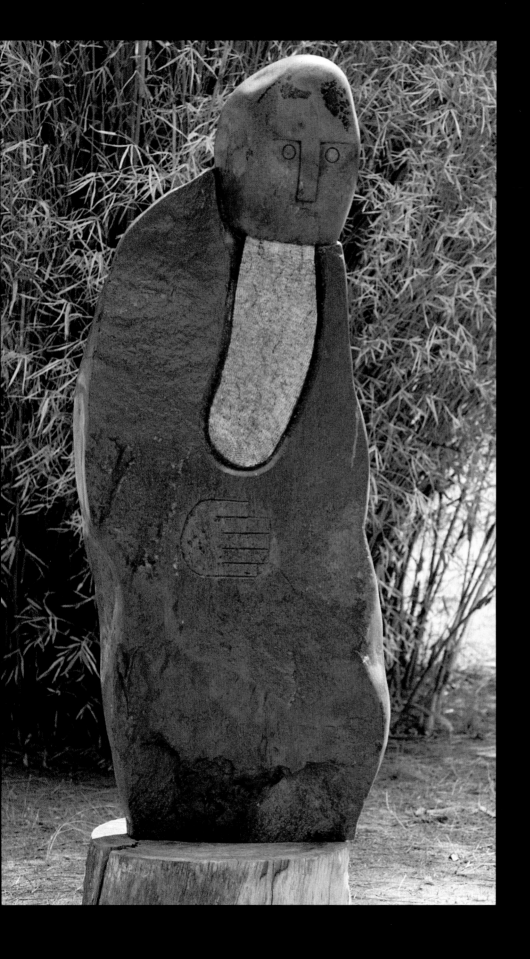

SPIRITS IN STONE™

The New Face of African Art

by
Anthony & Laura Ponter

Principal Photography
Robert Holmes

Additional Photography
Anthony Ponter & Ashley Ponter

Additional Studio Photography
Mike Spinelli

Book Design
Rod Wallace / Q Design

Editorial Assistance
Hope Belli Tinney

■

Publisher
Ukama Press
California

PUBLISHER

UKAMA Press
P.O. Box 1839
Glen Ellen, California 95442
800-255-5540 x 25 for orders.
Website: www.spiritsinstone.com

Publisher's Cataloguing in Publication Data

Ponter, Anthony & Laura
Spirits In Stone, Zimbabwe Shona Sculpture
 Bibliography
 Includes index
Library of Congress Catalogue Number 92-81448
ISBN: 1-881407-07-1 Hard Cover
 1-881407-50-0 Soft Cover
Printed in Singapore by Tien Wah Press
First Edition, 1992
Second Edition, 1997

All sculpture heights referenced throughout this book in the
captions are approximate.

Any inquiries regarding SPIRITS IN STONE—the book, or the
sculpture, text, and photographs therein—should be directed
to UKAMA Press at the above address.

Cover Photo: *Chaminuka*, Gift Muza
Title Pages: *Wise Grandfather,* Henry Munyaradzi

DEDICATION

HUBERT PONTER
1916 to 1991

Munhu Chaiye—The Good Man

In Shona the term *munhu chaiye* describes a most
highly respected member of the community. Every
man aspires to live as the Good Man, and to be called
so by his descendants. After his death, the Shona who
knew and respected father honored him with this title.

His wisdom, warmth, humor and generous nature
guided so many in his extended family throughout the
world. We dedicate this book to him.

ACKNOWLEDGEMENTS

The people whose commitment deserve special acknowledgement:

Our supportive and ever steady family: Bernard Ponter, Elsie McGrady, Mark & Ashley Ponter, & Marva Whelan.

Sculptor Edronce Rukodzi, whose wisdom, memory of oral history and steady patience nurtured our understanding of the complex Shona culture.

Sculptor Richard Mteki, for his profound sculptural expressions and genuine friendship.

Sculptors Richard & Leah Katinhamure (Laura's *sahwira*).

Young sculptor Felix Tirivanhu, for touching our souls.

The sculptors of the Guruve Region.

Our encounters and experiences with all the sculptors, their families and their works have deeply enriched our lives. We thank each of them for their talent, commitment and generosity.

Arnold & Joan Travis—St. Joan, yes indeed. Vision, perseverance and spiritual strength, thy name is truly Joan.

The authors and photographers wish to thank Eastman Kodak Professional Imaging Division for the materials grant for the photography and production of this book. Their interest and faith in the project provided great impetus to us.

AT&T, Polaroid, British Airways, Coca Cola Enterprises, Color 2000—San Francisco, and Guttman & Associates.

National Gallery of Zimbabwe; Natural History Museum, Bulawayo.

Zimbabwean President, Robert Mugabe; Embassy of the Republic of Zimbabwe, Washington D.C.; His Excellency Ambassador Amos Midzi, and former Ambassador Stanislaus Chigwedere and Mrs. Lillian Chigwedere; Thomas Bvuma, Information Counsellor.

Chapungu Kraal and Mr. Roy Guthrie.

Our heartfelt thanks to:

ROBERT HOLMES and MIKE SPINELLI for capturing the essence of Shona on film;
HELEN HENNINGER for giving our Shona project its first chance;
ROD WALLACE for surviving incredible design deadlines;
BETH and JIM DUNBAR for the first uncrating and museum exhibit;
UKAMA PRESS for believing in Shona sculpture and shouldering this project;

Our appreciation to the many institutions that recognized and encouraged people's understanding of Shona culture and stone sculpture:

California Academy of Science, Institute of Human Origins, San Diego Museum of Natural History, Atlanta International School, The Breakthrough Foundation, The Hunger Project, Commonwealth Institute, Urban League, United Negro College Fund, the NAACP, Pacific Asian Art Museum, Sensai Hodokai Foundation, Marriott Corporation, Los Angeles Chamber Orchestra, Natural History Museum of Los Angeles County, World Affairs Council.

Our deep appreciation to the many sensitive, dedicated and adventurous art collectors and supporters who found inspiration in the sculpture and who are too numerous to list.

Grateful thanks also to all the following for their generous encouragement and support:

Kenneth & Joyce Adamson
Ricardo Akstein
Peter Alvarez
Michael Archer
Charles, Thea & Kristan Archuletta
Koji Asada
Dame Margaret Ashford
Sir Richard Attenborough
Lori Austin
Susan Baldi
Larry & Joann Bangs
Steve & Lisa Barkalow
Jon, Danielle & Dylan Beamer
Julie & Matt Belluomini
Frank and Lori Biehl
Joanne Black
Don & Susan Bowie
Robert Boyd
Joe Bravo
Pierce Brosnan
Stuart & Pamela Bruder
Daryl Buffenstein
Susie and Warren Buffett
Mathew Burnett
Bobbie Burns
Bob Burrows
Gary Cardaronella
Brian & Michelle Carter
Jim & Marilyn Carter
Diane Chauffe
Cael & Mary Chappell
Robert & Denise Chesne
Robert & Annetta Chester
Amos & Priska Chirunda
Scott & Ora Clayton
Jacques Clerk
Roy & Helene Cohen
Diana Coleman
Dick Colton
Robert & Diana Crew
Gavyn Davies
Linda & Perry Davis
Anneke DeLaat
John Denver
Don & Christine Dil
Tim & Jinny Ditzler
Joan & Bob Donner
Beth & Jim Dunbar
Jim & Carolyn Eastman
Roy Eisenhardt
Bryan & Phylliss Ellickson
Dale Ellison
Edward Ellman
Terry & Lin English
Sarah Epstein
Malcom Evans

Morgan Fairchild
Cassandra Flipper
Steve & Kathy Florence
Solie & Mary-Ready Fott
Ann Franklin
Gary & Elinore Freeman
Gary Friedman
David Gale
Dania & Foster Gamble
Peaches Gamble
Gordon Getty
Austin Gibbons
Michelle Gleed
Danny Glover
Whoopi Goldberg
Andy Goldstein
Louis Gossett, Jr.
David Green
Sandy Greenberg
Joan Guerin
Robert Guillaume
Gene Hackman
Albert Handlemann
Mick Hager
Melita Easter Hayes
Sir Edward Heath
Tom & Rami Henrich
Jules Heumann
Gary & Joan Heymann
Frank Hirsch
Mary Hodge
Simon & Wendy Hodgson
Ruben Hurin
Sally & Robert Huxley
Don & Lenora Johansen
Lonnie & Maria Elena Josie
Raul & Merel Julia
Gina Kaiser
Norman Katz
Steven & Judy Kazan
Bill & Keith Keischnick
Marla Keiss
Keenan Kelsey
Jim, Linda & Sam Kennedy
Joseph Kennedy
Don & Jan-Marie King
George Kramer
Ben Lane
Marty & Louise Leaf
John Lee
Sir Samuel LeFrak
Elaine Leventhal
LeNeil Lewis
Kwang Liew
Bruce & Caroline Ludwig
Beverly Magid
Mahari Family
Gordon McCormick
Rod McManigal
James & Myrna Manly
Sandra Marsh
Dulcie Maxworthy
Daniel Miller
Rose & Marvin Miller
Reid & Robert Mizell
Kimbell Moss
Sam Neely
Kathryn & Leo Nelligan
Denise Nicholas
Robert & Eleanor Nordskog

Mary Novie
Kurt & Kim Oesterreicher
Phillip Osborne
Robert Padgett
Charles Parrish
Elizabeth Pastor
Sam & Alice Pettway
Mason & Liz Phelps
Roy & Olga Plaut
Eckhard & Susan Polzer
Tina & John Poochigian
Richard Prior
John & Helen Raiser
John & Rosemary Raitt
Robert Ratony
Mr. & Mrs. Lou Rawls
Ada & Barrie Regan
Laura Regan
Cathy Ridenour
John & Patsy Robinson
James & Georgia Roderique
Nicolas & Pamela Roditi
Tiny Roland
John & Dodie Rosekrans
Bruce & Carol Ross
Ora Ross
John & Wendy Sadler
Fran Salkin
Eric & Janet Savage
Paulette and Rino Schena
Norman Schmall
Susan Brawley Schmidt
Andre Schnabl
Ted Schnur
Ken Scofield
Enid Schwartz
Tina & Jim Selman
Anne Shaw
Gene & Betty Shurtleff
Brenda Simmers
Paula Simon
Tom Skerritt
Irwin Smiley
Christine Barber Smith
Hon. Fern Smith
John & Layne Stabler
Thomas Stallard
Jimmy & Gloria Stewart
Elizabeth Swanson
Charlotte Maillard Swig
The Takvam Family
Dorothy Tinney
James Tinney
Craig & Lynn Trojahn
Sandra Tuck
David Turnbull
The Twist Family
Marianne Tyler
Cicely Tyson
Loet Vanderveen
Paul Wade
Lady Olivia Waldron
Victor Waldron
Alice Walker
Christie & John Walton
Phyliss Wattis
David Welch
Sir Roy & Lady Valerie Wellensky
Steve & Aileen Williams
John & Audrey Wilson

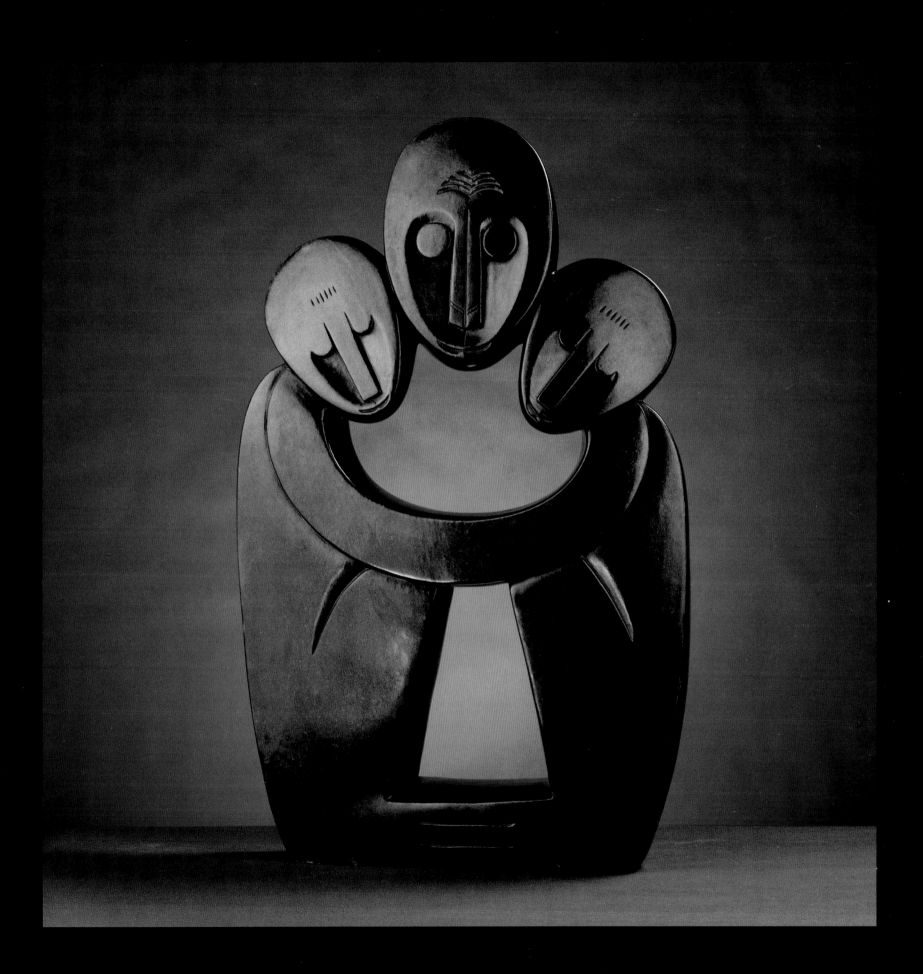

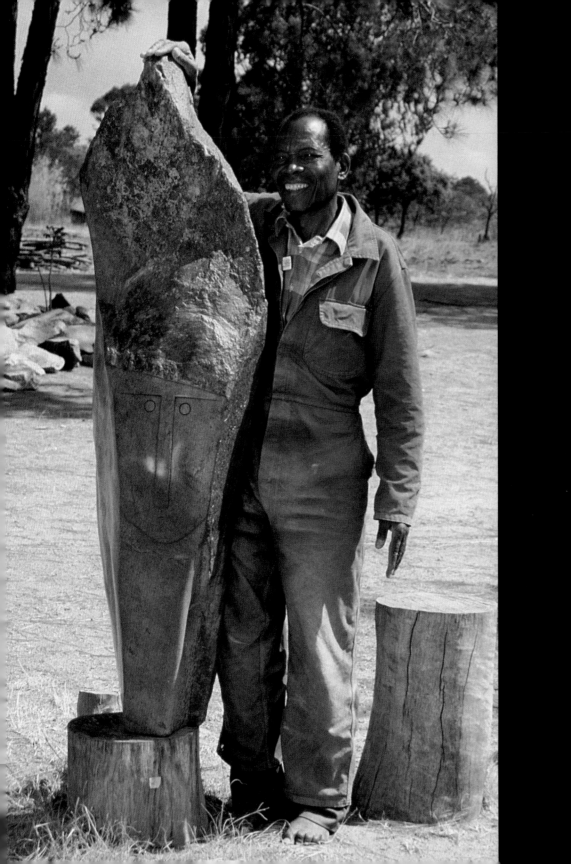

T HE EVOCATIVE NATURE OF these sculptures, which reflect the spirit of the Shona people and their ancestors, is bound to impress, stimulate and inspire. No one looking at them can feel indifferent… It may be difficult for some people to wake up to the fact that, quite suddenly, a small country in the heart of Africa is making a major contribution to contemporary art."

—*LORD CHELWOOD*

Guiding Ancestral Spirit
Henry Munyaradzi
(world-renowned sculptor)
65"

(Previous page)
Ukama
Phineas Kamangira
36"

CONTENTS

■

The Zimbabwe Bird, symbol of the new nation, found within the ancient stone city called Great Zimbabwe.

■

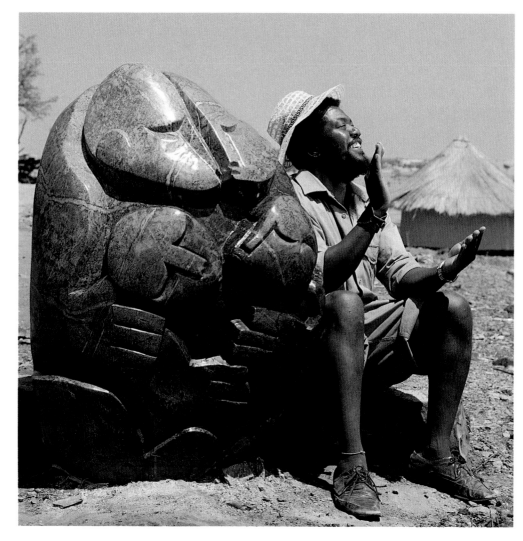

My Good Family
Edronce Rukodzi
40"

"Here in Zimbabwe we are creating
a work of art in stone, a sculpture,
which represents our spirit, our tribe."

Edronce Rukodzi, descendant of King Munhumatapa

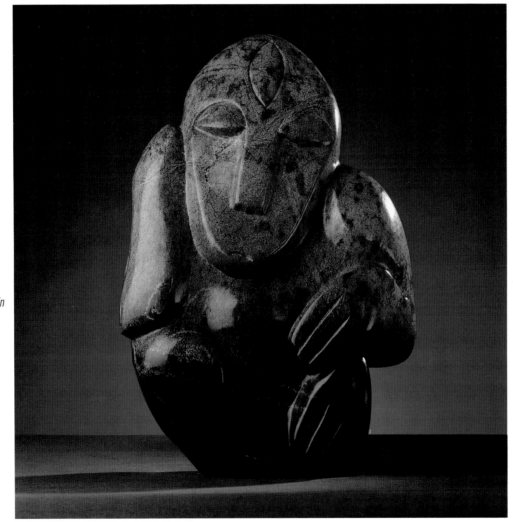

Respected Elder Chieftain
Edronce Rukodzi
18 "

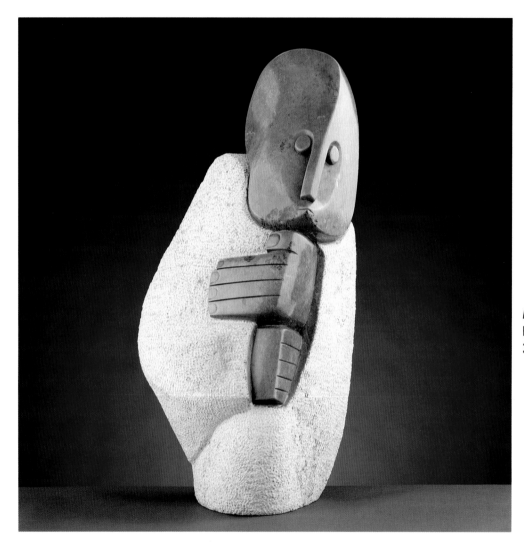

Elder Wrapped in Blanket
Phineas Kamangira
36"

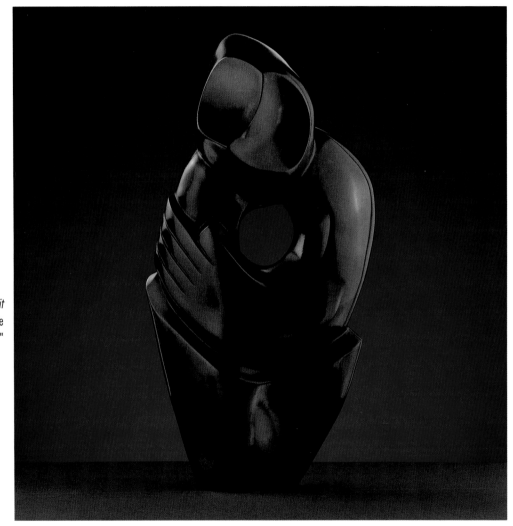

Hearing Spirit
Chirambadare
26"

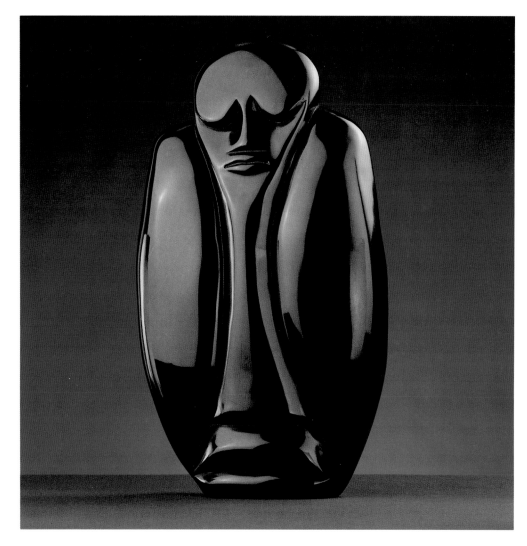

Spirit Rising From Within
Peter Mandala
12"

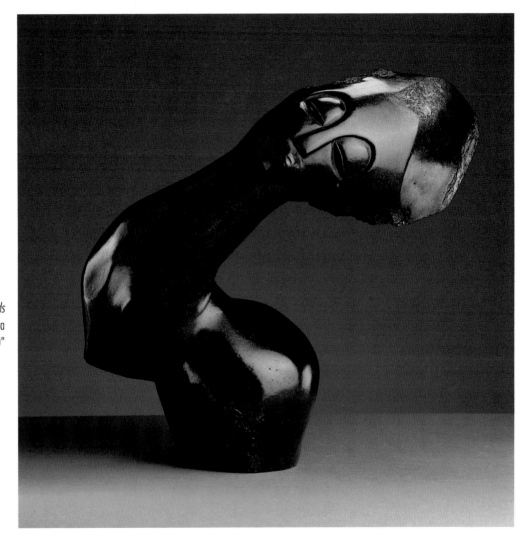

Swept by the Changing Winds
Lazarus Takawira
20"

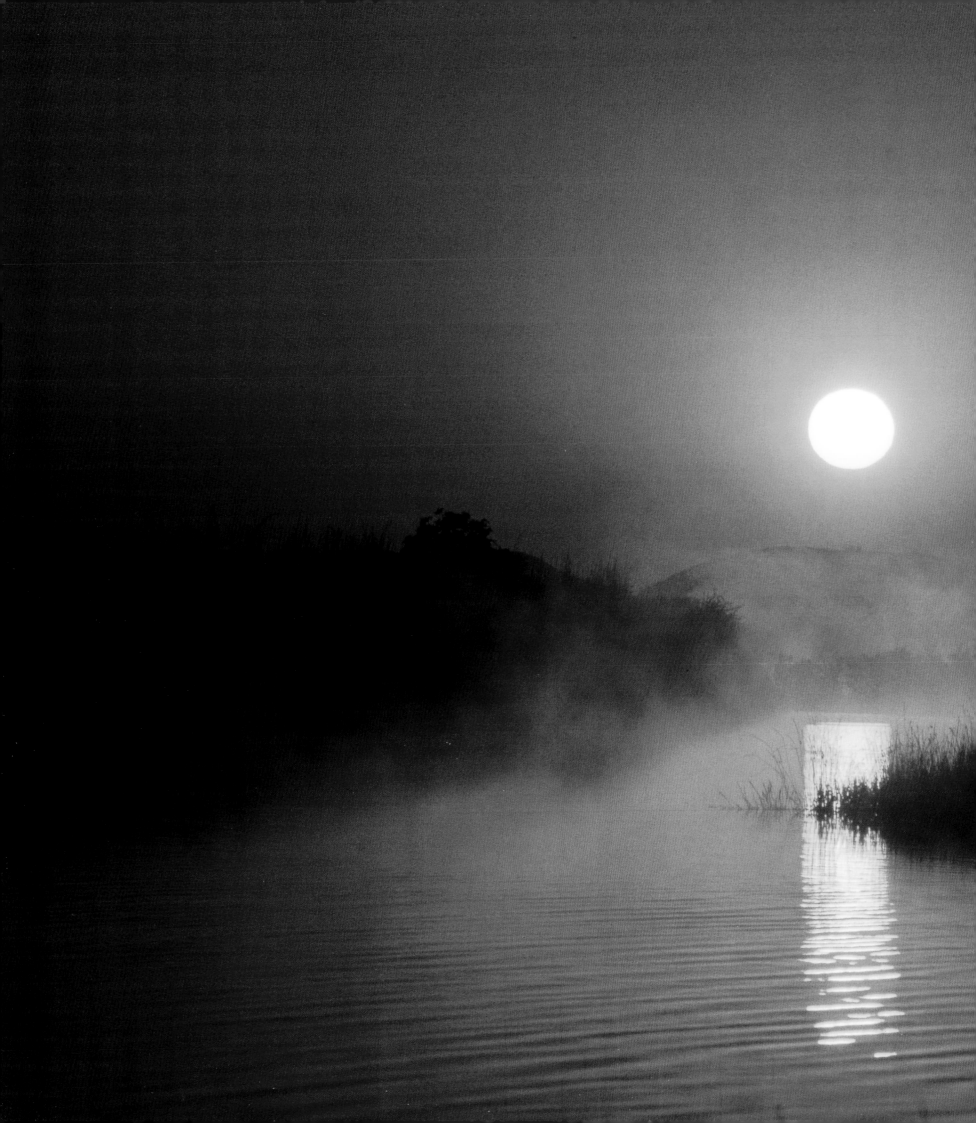

Mvurwe Sunrise

P R O L O G U E

The Ponter family has been collecting Shona stone sculpture and encouraging the artists of Zimbabwe for more than 50 years.

The torch was passed to Laura and me by my late father, Hubert Ponter. Just as the new third generation sculptors are acknowledged for the quality of their carving, we too are continuing into the next generation as collectors. We shall uphold and remain steadfast to father's promise— to nurture and encourage the art and artists of Zimbabwe.

There are as many different viewpoints and opinions about this sculptural movement as there are styles of Shona sculpture. This book reflects our personal experiences and understandings gleaned from friendships that have spanned generations.

This book was never meant to be the definitive work on Shona sculpture or on the remarkable people who create it. We are humbled by the thought of such an endeavor. Instead, this book is meant to introduce others to the excitement we experience every day as collectors and curators of this incredible art form. As an introduction to Shona sculpture, we focused on the sculpture of the Shona people of Zimbabwe and their cultural history. They comprise well over 70% of the population of Zimbabwe. We do not seek to ignore the many significant contributions made by other ethnic groups of Zimbabwe, particularly the Ndebele, who comprise about 15 percent of the population. The traditions, history and contributions of all the peoples of Zimbabwe have created an enduring and rich cultural tapestry.

In this revised edition, we have added a special chapter on the newest of Shona sculptors—the young, burgeoning third generation of men and women artists.

We hope this overview will give the reader a beginning context for understanding the Shona and their sculptural phenomenon. Many volumes have already been written on the cultural heritage and history of Zimbabwe. Should a reader desire further understanding, we recommend the materials listed in our bibliography.

Anthony Ponter

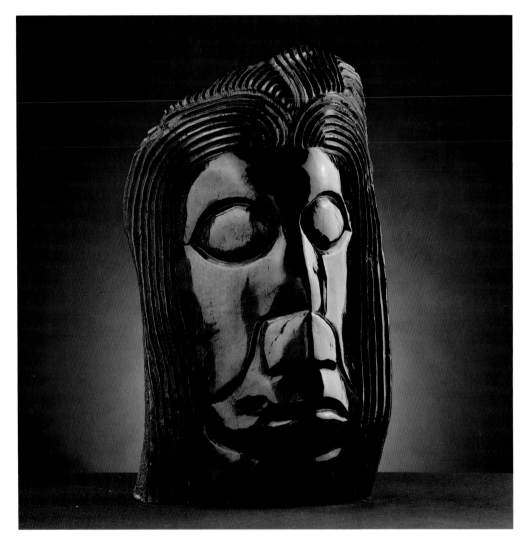

Man Transforming Into Lion Spirit
Felix Tirivanhu
28"

Felix Tirivanhu, who was 14 when we first met him, continues to sculpt powerful pieces. A common theme of his work is that of the boy approaching manhood. He often carves strong, bold faces with a leonine mane, which represents the young man taking on the responsibilities of manhood and the qualities of the lion—courage, dignity and strength.

"Who carved these?" I asked.
"I carved them," Felix said.

I TAUGHT MYSELF

T HE SLIM BOY APPEARED AS AN
apparition in the shimmering heat of the
Zimbabwe summer morning. Laura and I,
bumping along the rutted goat track in our
beat-up Land Rover, hadn't seen a person, village or
hut for miles. Still, there he was, calmly waving his
arm for us to stop.

Dust was burning my eyes and throat, my khakis
were sticky with sweat and my face felt hot and clammy. I
smiled weakly, waved at the boy and told Anthony,
"Please don't stop."

It was 105 degrees at 9:30 in the morning, we were
nearly out of water and we still had an eight-hour drive
ahead of us. I had forgotten what October in
Zimbabwe was like. The locals call it Suicide Month—
suffocating heat and humidity pregnant with

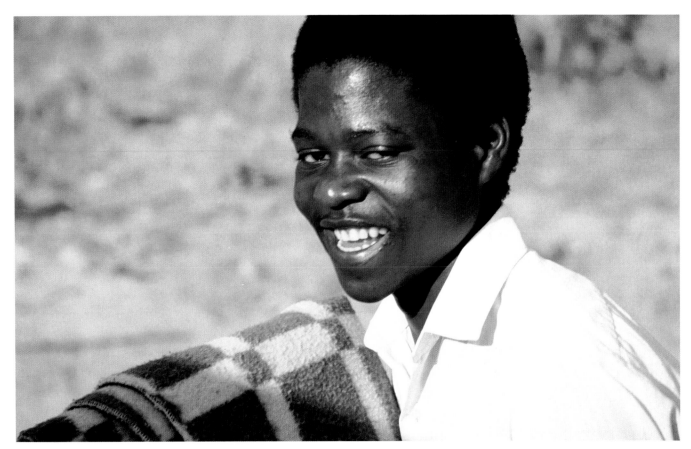

Sculpting prodigy
Felix Tirivanhu, Guruve Region.

precipitation. The cooling rain would eventually come, but the wait was unbearable.

Despite Laura's protest, my curiosity overcame my discomfort and I stopped.

The boy approached our Land Rover greeting us with respect in the traditional way, "Mangwanane, Mr. Ponter, you are here."

"How did you know my name?" I asked.

"I knew you were coming," he said, smiling shyly. "Now you can buy my sculpture."

Laura and I stared at each other. Not only did he know our names, he knew our purpose. For the past five weeks we had been making overland treks to visit sculptors in various remote areas of Zimbabwe, from the high plateaus of the Guruve region to the foothills near Mutare, the gateway to the eastern highlands and the mist-shrouded Nyanga Mountains.

"We've come this far," I said to Laura. "It'll only take a moment. Let's take a look."

We learned his name was Felix and we agreed to follow him, first in the Land Rover and later on foot. Scrambling to keep up with the nimble boy, we thrashed through chest-high elephant grass, slapping at flies and cursing the brambles and thorns that tore at our ankles.

When we finally reached the clearing near his family's thatched *imba*, my heart was racing and I was angry at myself for going along on this wild goose chase.

But then my heart stopped and the anger vanished. There, sitting in the dirt under the canopy of a *musasa* tree, were his sculptures, powerful and polished. All five of them were faces, nearly bas-relief, with angular, exaggerated features framed by a great mane of leonine hair. There was no hesitancy in the style, no tentative chisel strokes.

I was stunned.

How could a boy have carved such masterful, sophisticated sculptures? They looked Etruscan in some way, reminiscent of that pre-Roman civilization that

24

thrived more than 2,000 years ago.

"Who carved these?" I asked.

"I carved them," Felix said.

When Anthony asked who taught him, he replied, "I taught myself."

Though that seemed unbelievable, it also seemed unlikely that he had a mentor in this remote African family enclave or kraal.

Through his broken English and Anthony's limited Shona, we came to understand that the boy had heard through the bush telegraph that we were buying sculpture and we were headed his way. He had been waiting by the dirt track for the past three days hoping to flag us down.

While his mother and younger brothers and sisters stood back and watched, Felix explained that his father was sick and he wanted to sell his sculpture to pay for medical expenses and for food for his family.

We bought all five pieces.

By the time we met Felix we had already encountered dozens of Shona sculptors, many of whom already had international reputations. Their work truly was, and is, world class.

Still, our meeting with Felix, which we say was a chance meeting and he says was guided by the *vadzimu*, or ancestral spirits, was a turning point in our understanding of Shona sculpture.

How was it possible that these people, these untrained sculptors—using primitive tools with no knowledge of past masters or 'proper' techniques—could carve sculptures of such tremendous depth and beauty, sculptures which spoke of the human condition as eloquently to the executive on Wall Street as to the shepherd in Guruve.

Meeting Felix Tirivanhu on the deserted dirt track that day was a moment of truth for us. It made stark the dawning realization that we had no simple way to explain the phenomenon that we were seeing.

Though Shona sculpture is sometimes compared to the work of Picasso, Brancusi, Modigliani or other

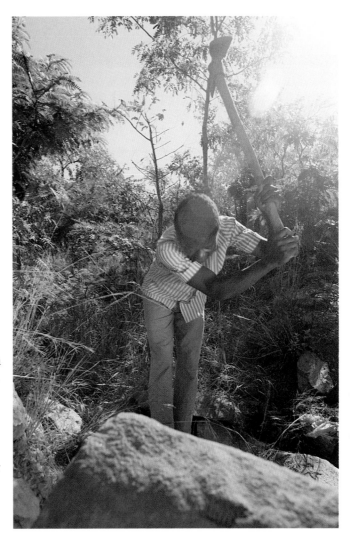

With the sun streaming across his back, Felix swings the pickaxe into the hard ground to remove the spirit stone.

Western masters, we knew the Shona of the mountain highlands had never seen their work. Isolated from the West by geography and politics, the Shona looked within for inspiration—within their own land and within their own spiritual legacy.

We had set out to find sculpture, but we now felt compelled to discover more about these remarkable people and the source of their inspiration which finds such powerful expression through their sculpture.

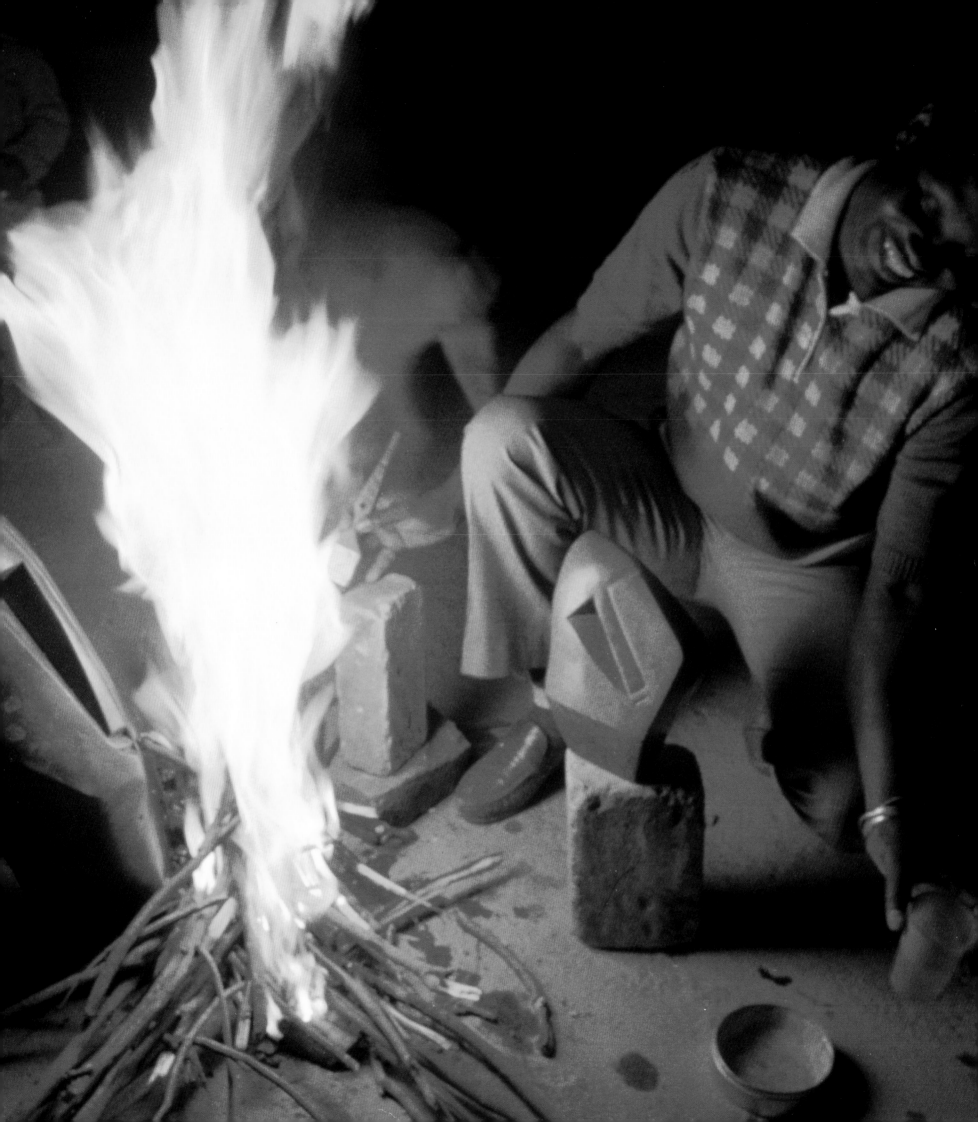

"The Shona sculptors appeared to pick up their tools where their ancestors of several hundred years before had laid them down."

—Pierre Descargues
Art Critic *French Culture*

THE FLAME BURNS BRIGHT

Sculptor Richard Mteki firing his sculpture entitled *Chaminuka.*

WAS IT SPONTANEOUS COMBUSTION or the flaring of a long-smouldering flame? The sudden rise to artistic prominence of Zimbabwean Shona stone sculpture during the past three decades has sent art historians scurrying for easy explanations. And the most obvious are not difficult to find. The most notable, and oft-cited, is the arrival of Frank McEwen, a former art critic and curator from the Musée Rodin, Paris. In 1956, he became the first director of the new National Gallery in what was then Salisbury, Rhodesia.

Colonial Rhodesians, quite eager to emulate the European art scene, invited McEwen to head the National Gallery with the expectation that he would bring with him the sophistication of the Continent. Patrons expected that the National Gallery would bring

'superior' European art to the heart of Africa for their own enjoyment and edification.

McEwen arrived in Rhodesia and, to the colonials' surprise, soon began to pursue different goals. He was eager to encourage an indigenous art movement free of the artifice and empty convention that he had experienced as an art critic in France. He discovered and then encouraged the exceptional artistic ability of the Zimbabwean people. McEwen claimed that he did not attempt to instruct these artists, but merely encouraged them to regard their rich traditional culture as a source of inspiration.

The National Gallery Workshop School, a casual group of artists interested in carving, was one of several artistic colonies that sprung up. Though preceded by several mission schools which offered opportunities for wood sculpting, these later workshop schools quickly became a gathering place for stone sculptors. Though called 'schools', very little, if any formal teaching was done. In this crucible, it was the artists themselves who experimented with the stone, learning from each other and drawing from their cultural and spiritual traditions. McEwen called this process a "drawing out", rather than a formal art school education.

McEwen's desire to encourage the indigenous art movement was buttressed by the simple fact that Rhodesia was geographically and politically isolated from the West during the 1960s and 70s. Because of this geo-political isolation,

Ancestral Spirit
Boira Mteki
20"

the Shona developed their own styles without reference to Western sculpture or art movements. The results were impressive. With no acknowledged historical antecedents, Rhodesia, and then Zimbabwe, soon was known as the homeland of some of the world's most praised stone sculptors.

Michael Shepherd, art critic for the London Sunday Telegraph wrote: "It is extraordinary to think that of the 10 leading sculptor-carvers in the world, perhaps five come from one single African tribe (Shona)."

That all may sound like a case for the spontaneous combustion theory. But McEwen and other students of African history would be quick to douse that idea. According to McEwen, when he started the workshop school in 1956, there was already a deep, invisible foundation of art, even though there was little art being created. But a little was obviously enough to excite McEwen's attention.

In reviewing an exhibition of 100 Shona sculptures at the Musée Rodin in 1971, Pierre Descargues of *French Culture* wrote: "The Shona sculptors appeared to pick up their tools where their ancestors of several hundred years before had laid them down."

The ancient stone sculptors to whom Descargues was referring lived and carved in the flourishing civilization called Great Zimbabwe that was in its ascendancy from the 11th to the 15th centuries.

Despite colonial disinformation to the contrary, Great Zimbabwe, the

largest stone structure in sub-Saharan Africa, was built by Shona ancestors at a time when Europe was just emerging from the brutal Dark Ages. Visitors today can still marvel at the architecture and craftsmanship that created this magnificent stone structure. Appreciating the sophisticated civilization that produced it is far more difficult. Treasures or cultural artifacts which might have revealed the secrets of this complex society were plundered by treasure seekers in the late 19th century. Archeologists have only recently begun systematic studies to discover more.

artistic movement that sprang from nowhere could, with a little nudge from Western culture and collectors, become so prominent in so short a time.

The critic Descargues calls it "persistence of culture." He points out that the few stone sculptures found at Great Zimbabwe had been removed from Rhodesia long before 1956, so they could not have been viewed by the Shona artists carving at the newly formed workshop schools. The historical antecedents, then, had to be sensed, rather than seen.

Though Western art historians tend to marvel at

(Right)
Ancestral Spirit (circa 1940)
artist unknown
8" (collection of Hubert Ponter)

(Far right)
Tatenda (1991)
Maikosi Mstrozo
8"

These two works sculpted at least fifty years apart share similar proportion, theme and feeling. Beginning sculptor Maikosi Mstrozo never saw this older work.

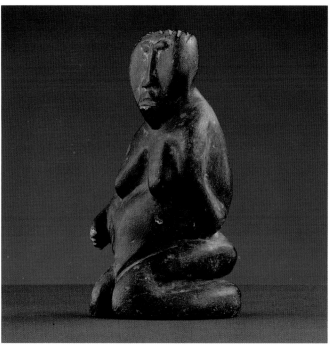
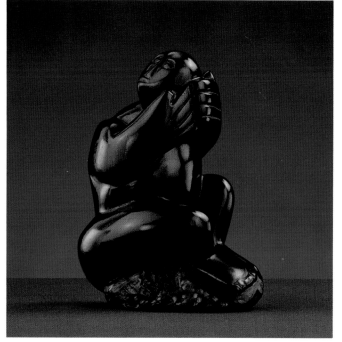

Among the few treasures from Great Zimbabwe which have been recovered are eight large hand-carved soapstone birds which once surrounded the Queen's enclosure. The birds are considered the only surviving examples of large-scale early Shona sculpture. Further evidence of the roots of Shona stone work found on the site were monoliths covered with complicated geometric designs.

The persistence of such a cultural heritage through hundreds of years may seem difficult to explain, but no more difficult than the notion that an

the spontaneous combustion theory of the development of Shona sculpture, Shona oral historians tell a different story. While no one denies that Shona sculpture has benefited greatly from colonial and foreign interest in the second half of the 20th century, critics of the spontaneous combustion theory bristle at the idea that the Shona sculpture movement resulted solely from such support and encouragement.

There is mounting evidence that the presence of Shona sculpture in the 20th century began not in the 1950s as is popularly believed, but as early as the turn

of the century. The Shona were carving, oral historians insist, but the colonials did not appreciate their work, so they simply did not see it. Since there was no market for stone sculpture, and since it served no religious purpose, artists had to be farmers first and sculptors in their spare time, of which there was little. Still, men did carve.

Joram Mariga, who learned wood sculpting from his father and brothers in the 1930s, recalls being intrigued by a piece of bright green soapstone he found in the fields of Nyanga in the late 1940s. He scratched away at the soap-like piece, then went off to find its source. After finding a bigger piece he "started to carve stone for the very first time." He said his sculptures were "little things to please myself."

Five years later he was introduced to McEwen. McEwen remembers the meeting.

"He brought me a little milk jug carved in soapstone," McEwen said. "I realized this was an English milk jug for an Englishman who loved his tea! I asked if he could make a head. The head came, made also for an Englishman...

"'If you made a figure for your own family or your ancestors?' I asked.

"'Oh, that would be different.' The figure came, this time of pure African concept — the enlarged head, seat of the spirit, a frontal static pose, a visage staring into eternity with formally posed arms and clenched fists. It was pre-Columbian in nature, as if a spirit image applied to stone could create similar results in spite of a difference of race, place and time."

Evidence such as this gives credence to the smoldering flame theory of Shona sculpture. McEwen did not arrive on the scene to initiate a new art form; he arrived to encourage a creative phenomenon that was already in process.

Sculpting must have been an indigenous, if fledgling art form. Why else would the sculpting workshops have flourished among the Shona? Stone sculpture schools were not set up in other developing countries by ex-patriot artists or by missionaries. Why in Zimbabwe? Part of the answer must be that McEwen recognized the sculpting

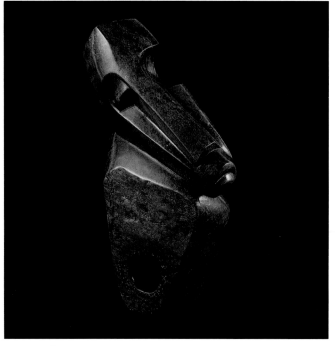

ability of these untrained Zimbabwean artists. Like so much in Shona culture, the artistry seems to be shared and expanded, not hoarded. Before Joram Mariga ever met Frank McEwen, he was teaching his younger relatives the techniques of stone sculpture. Among them was his nephew John Takawira, who with his brothers, Bernard and Lazarus, have earned worldwide acclaim. Boira Mteki, one of the first sculptors to achieve international acclaim was also sculpting before he arrived at McEwen's sculpture workshop.

The first generation sculptors, such as Mariga, the Takawiras, Thomas Mukorabgwa, Moses Masaya, Bernard Matemera, Albert Mamvura, Norbert Shamuwarira, Joseph Ndandarika, Henry Munyaradzi, Nicholas Mukomberanwa and Boira Mteki, stunned the art world when their work was exhibited abroad. Critics and countrymen alike were profoundly affected by this modern sculpture with such ancient ties. The contribution of these first generation sculptors cannot be overstated. Their willingness to share their artistry has enabled hundreds of second and third generation Shona sculptors, both men and women, to masterfully release the spirit in the stone. Now their artistry in turn is gaining international recognition.

This book cannot attempt to name all the artists, or even suggest that the ones who are named are the most important. In every generation there are artists who are bringing new vitality and power to their sculptural interpretations. The sculpture is changing, just as the world is changing. Zimbabwe of the 1940s is a far different place from Zimbabwe of the 1990s. However, the beauty, grace, power and spiritual connections remain in the stone.

Shona sculpture transcends time and place. A contemporary art form, it is deeply rooted in the spiritual beliefs and ancient traditions of the culture from which it continues to emerge.

"If you do not understand the culture of the Shona, you will not really understand what we sculptors are saying in our work," says Bernard Takawira, one of the earliest and best-known of the carvers.

Central to an understanding of Shona culture is the belief that all things are destined and controlled by the powerful spirits of Shona ancestors. The *midzimu*, or ancestral spirits, watch over their progeny, guide them and protect them from evil. During Zimbabwe's war of liberation, the ancient ancestral spirits, working through *masvikiro*, or spirit mediums, guided the modern guerrilla forces to victory.

"They will always influence our lives," Takawira says.

Spirits are everywhere and they can take any form. Animals, rocks, plants and trees—all things in nature have spirits, too.

"You see, with all those spirits around, magic is bound to creep into our sculpture," he says.

Shona sculpture is truly magical. It speaks eloquently of the human condition, whether it be experienced in urban America or in a rural village high in the Nyanga Mountains of Zimbabwe.

Along with the magic are the mysteries. Why did this art form, so dependent on ancient beliefs and legends, suddenly re-emerge in the 20th century after hundreds of years of apparent dormancy?

The mystery may continue to puzzle and confound art critics and historians, but those around the world who love Shona sculpture simply accept the mystery and the magic.

John Povey, a professor of African studies at the University of California, Los Angeles, writes, "No art could be so far divorced from the world of its likely audience, yet equally no art can so certainly speak to a global community."

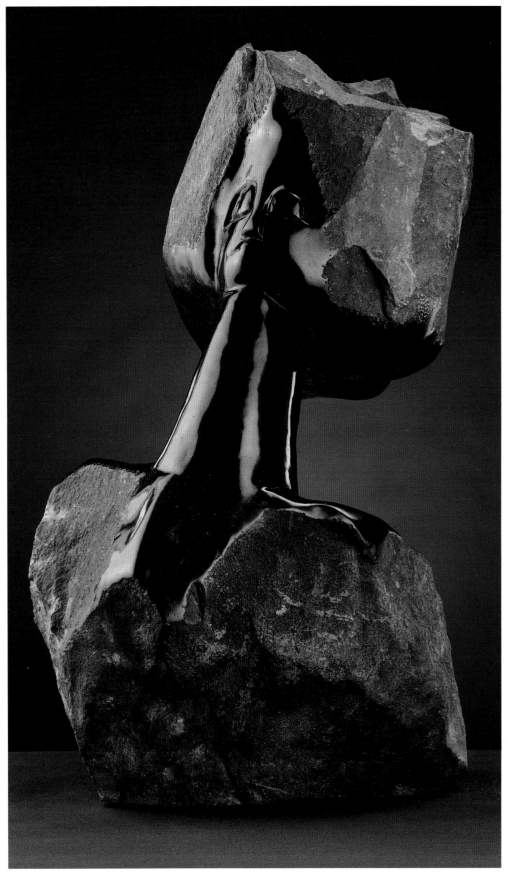

(Opposite)
Sentinel Guardian
Moses Masaya
28"

The Healer
Lazarus Takawira
39"

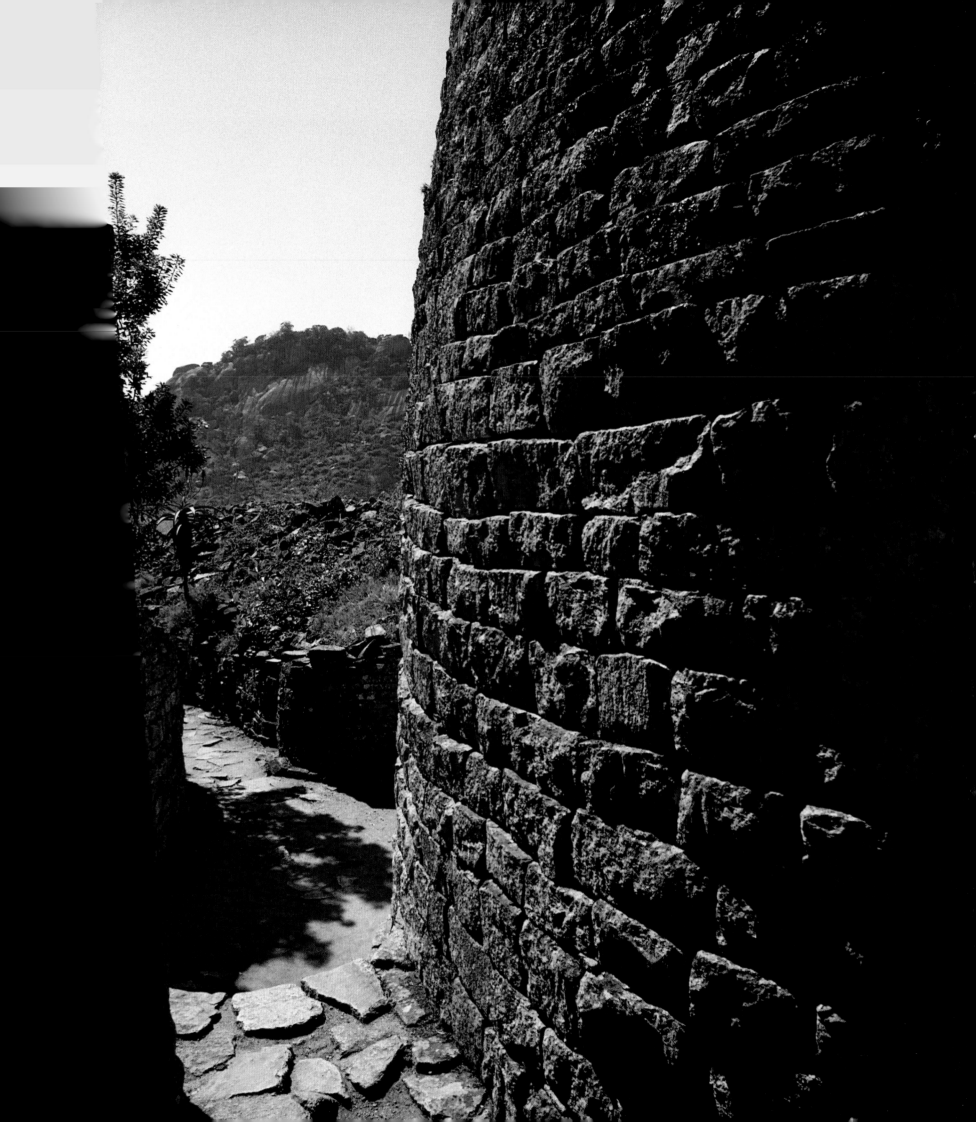

"They have created cultures and civilizations, evolved systems of government and systems of thought, and pursued the inner life of the spirit with a consuming passion that has produced some of the finest art known to man."

—Basil Davidson
African Kingdoms

LAND OF ANCESTORS

These impressive walls within the ancient city of Great Zimbabwe stand as silent witness to a sophisticated civilization that archeologists say began during Europe's Dark Ages and flourished for over 400 years.

THE UPRISING BY THE INDIGENOUS people of the current state of Zimbabwe during the 1960s and 1970s was more than just a battle for land or self-rule. It was also, in a very real sense, a battle for a people's history.

Passed down through an oral rather than written history, the story of the Shona people of Zimbabwe had proved particularly susceptible to distortion for political purposes. The most impressive monument of that culture, Great Zimbabwe, was plundered, as was the true story of that settlement's origins.

The indigenous people have now reclaimed their nation. By doing so, they have recovered, and built upon, their land's glorious past.

The culture we now know as Shona was born on

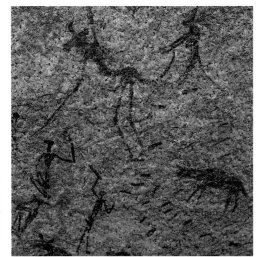

Prehistoric cave paintings by the Khoisan or Bushmen of central Zimbabwe.

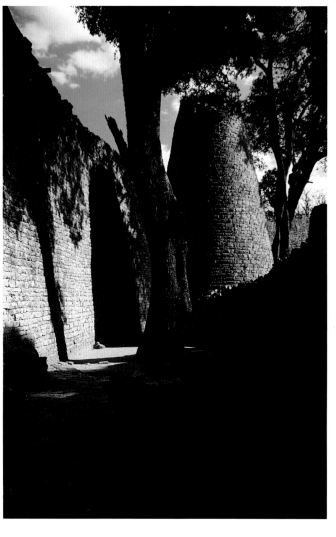

Inside the Great Enclosure stands the 32-foot-tall solid stone conical tower. Archeologists do not know the significance of the tower, but speculate it might have been a fertility symbol.

the fertile plateau between the Limpopo and Zambezi rivers.

The first people known to inhabit that area were Khoisan, who lived in small camps and lived off the land as hunters. Eventually, this band of wanderers moved south and was displaced by Bantus, who had arrived from the north by the end of the second century. Little is known of that migration, but the Bantu settled along the rivers on the high plateau, made their living from raising livestock and farming, and added to their diets by gathering and hunting. There is evidence that the Bantu discovered, and began to use, some of the vast mineral wealth of the region. Iron was smelted and made into farm implements. Gold was traded with Muslim traders on the coast.

In the centuries following the year 1000, a new group of people appeared on the plateau. They absorbed the descendants of the early Bantu into a culture that has come to be known, in modern times, as Shona. The emerging culture brought changes to life on the plateau. Cattle became the primary type of livestock. Mining techniques were improved. Increased trade of gold and ivory brought more riches to the culture. Some men became wealthy; settlements grew.

The full flowering of those cultural and economic advances was achieved in one of the most impressive—and in the end, most mysterious—settlements of its era, Great Zimbabwe.

As Europe was emerging from the barbaric Dark Ages, a flourishing economy was being established on the plains of what is now Zimbabwe. Its focal point was an intricate stone complex, Great Zimbabwe. It was composed entirely of granite blocks exactly cut to a specific size and fitted together ingeniously and precisely without the aid of mortar. Close to a million of these hand-cut blocks were used. The massive walls of this great city took centuries to build and, legend has it, that the kings responsible for the early structures at Great Zimbabwe decreed that each visitor to their court should bring at least three granite stones as tribute.

And there were many visitors. What the Victorians dismissed as a "primitive" society had established an active cattle and grain crop industry and was involved in international commodity trading in gems and minerals. Traders from Arabia sought out this great city, travelling by boat to the Mozambique

coast, then trekking inland. Their ancient paths are seen today dotted with date palms that the traders ate along their way as they sought the great treasures of this legendary city on the Zambezi plateau. The surrounding region contains abundant deposits of copper, gold, mica, nickel, tin and precious stones, including the world-famous deep green emeralds of the

thriving trading center, is now in ruins, her gold, silver and art treasures plundered centuries ago. But impressive sections of the stone structures still stand, bearing testimony to the sophisticated engineering and craftsmanship of the people who built it between six and nine centuries ago.

The Africans of the Zambezi Plateau won their

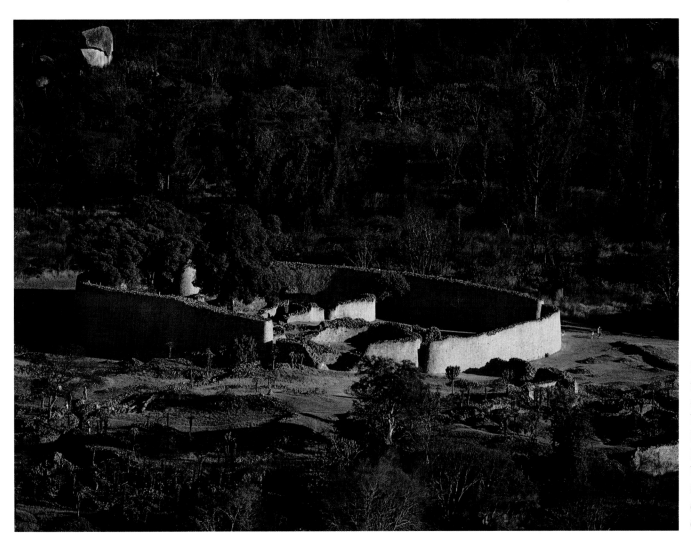

From atop the highest hill in the area, the king of Great Zimbabwe had a commanding view of his dominion. The Great Enclosure, which measured 820 feet in circumference, was the largest structure in sub-Saharan Africa. The queen's enclosure was inside the Great Enclosure. Only the king was elevated enough to look down upon the queen and her entourage.

nearby Sandawana mine.

Radiating outward from Great Zimbabwe, more than 200 stone ruins have been identified, bearing testimony to a widespread flourishing trade and organized culture. All ancient paths, like spokes on a wheel, led to this affluent and influential city.

Great Zimbabwe, once a citadel, holy place and

liberation from the white minority government of Rhodesia in 1980. To honor the heritage represented by the intricate and impressive walls of this ancient citadel, they named their new country Zimbabwe, meaning house of stone and gravesite of great chiefs.

The history of Great Zimbabwe remains

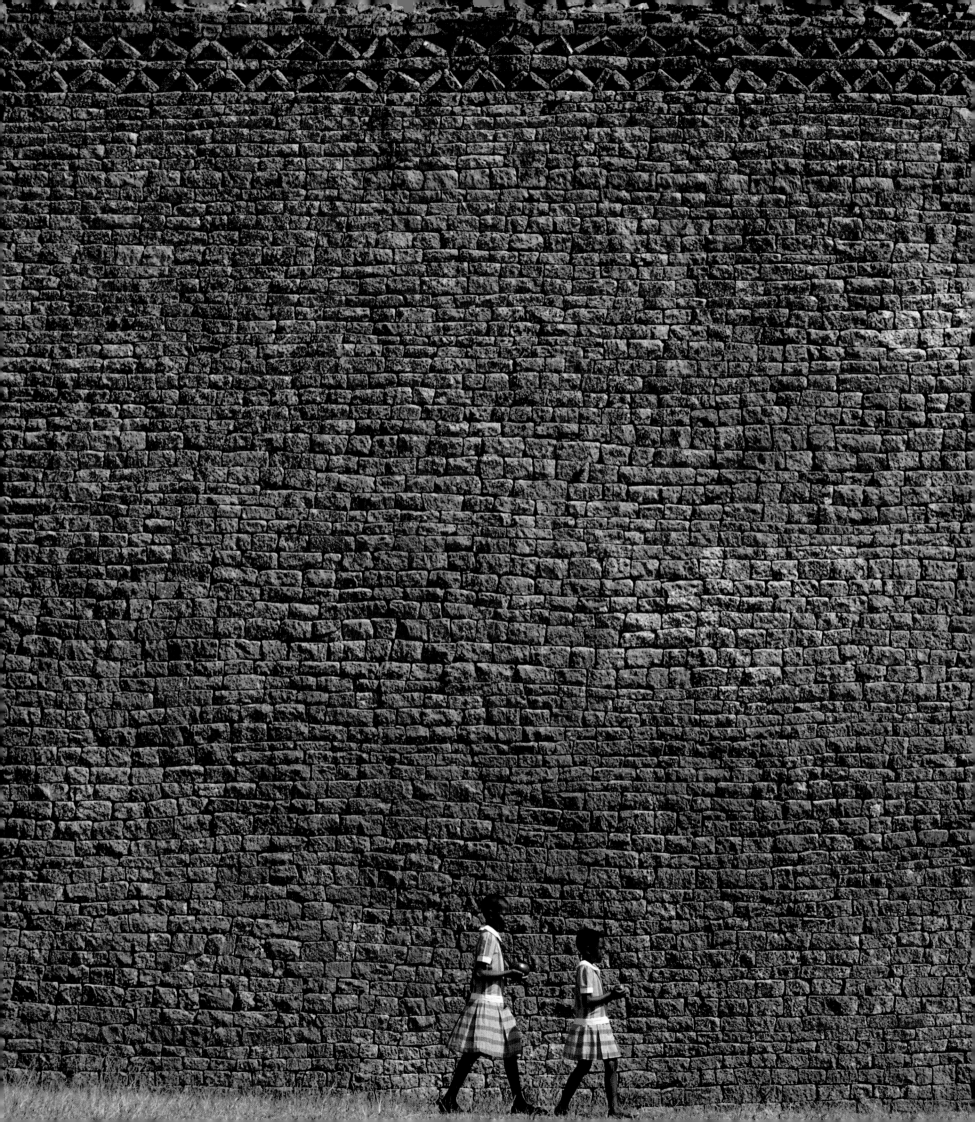

Two young Zimbabwean school girls stroll next to the ancient stone wall built nearly 800 years ago. European explorers, awestruck by the discovery of this deserted stone city in 1868, plundered its riches, including massive stone carvings of birds. Attributing the city's sophisticated stone construction to the ingenious but long-vanished Phoenicians, they refused to believe that the city was built by Africans—the Shona.

The self-buttressing wall is a marvel of early architecture. More than 820 feet around, the Great Wall stands up to 50 feet high and 14 feet thick. Using no mortar or cement, each hand-shaped stone was perfectly formed to fit into the next. The stones fit so closely in many places that the blade of a penknife cannot slip between these ancient building blocks. This construction was all the more remarkable when one considers that there was no written system of recording mathematic equations or architectural specifications.

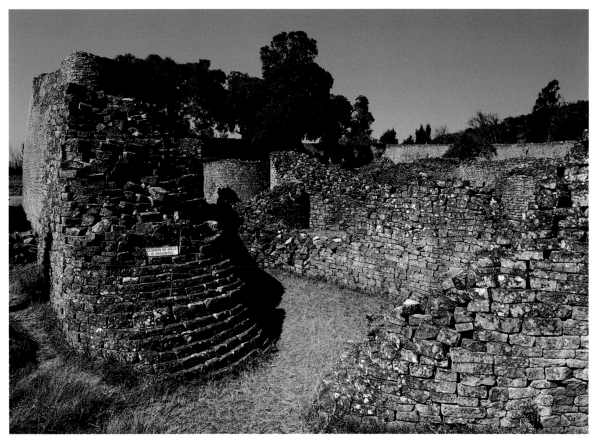

The ancient city suffered greatly in the past 100 years, both from treasure seekers who ravaged the enclosures and later by the Victorian-era revisionist explorer, J.S. Wallace. He attempted to buttress his theory of non-African construction by reconstructing several walls to mimic the ancient Phoenician style. Wallace's theory obviously lacked foundation—his improvements crumbled in less than 60 years. Walls built by the ancient Zimbabweans have withstood erosion and decay remarkably well. Without using mortar, the Shona carefully stacked the stone blocks against one another so that as the earth adjusted and sank, the flexible walls settled uniformly.

shrouded in mystery. Archeologists have not yet found the ancient gravesites of Great Zimbabwe. Remarkably, only three graves have been found in the area, even though the city at its peak was once populated by up to 25,000 people. Carbon dating and other evidence supports the theory that people began living at the site of Great Zimbabwe early in the 1100s and remained throughout the 1600s. The site was not discovered by Europeans until the mid-1800s, long after it was believed to have been abandoned.

Though the Shona have always recognized their ancestral links to the builders of Great Zimbabwe, Westerners have not. For more than a century, a debate among colonials has raged: Who were the builders of Great Zimbabwe?

The first explorers speculated that the builders were pre-Christian people of Mediterranean origin, possibly adventurous Phoenicians. Early white colonials spread the belief that Great Zimbabwe was built by some mysterious "advanced" people who migrated to the area and then disappeared. This version quickly became official colonial doctrine and all evidence to the contrary was suppressed or destroyed.

British-born journalist, Richard Hall, appointed first curator of Great Zimbabwe in 1902, believed Great Zimbabwe was the Kingdom of Ophir described in the Old Testament and home of King Solomon's mines. Sixteenth century Portuguese explorers who heard wonderful tales of the immense wealth and power of Great

Zimbabwe, but never saw it, were the first to speculate that this civilization on the Zambezi Plateau had Biblical links. Hall cleared large areas of archeological deposits looking for evidence of the legendary Ophir, but never found any. Despite a lack of any corroborating evidence, he continued to promulgate his theories and was considered an expert on Great Zimbabwe.

Another English explorer and amateur archeologist, J.S. Wallace, contrived to legitimize the claim about an "advanced" white race by committing an unforgivable sin. He reconstructed several walls and entry corridors to mimic what he believed was the "Phoenician ideal" of design and construction, and then proudly presented his counterfeit work as the

original. (Ironically, his modification of the walls crumbled in less than a century, while the original ancient walls remain standing.) Still, developed at a time when archeology was more romance than research, Wallace's theories struck fertile ground.

The "Phoenician ideal" theory was later challenged by another archeologist in 1906. Scottish archeologist David Randall MacIver wrote that he believed Great Zimbabwe was built by indigenous people. He wrote: "In the architecture, whether military or domestic, there is not a trace of oriental or European style of any period whatever."

Considering the tenor of the times, it is not surprising that MacIver was ignored and Wallace's theory of the "advanced" race of builders was perpetuated by the white colonial government throughout the first eighty years of this century.

Edronce Rukodzi, sculptor and oral historian whose ancestral lineage stretches directly back to the rulers of Great Zimbabwe, says the colonials didn't want to know the truth about Great Zimbabwe, only what was politically expedient.

"There was no black man who was called to witness what they were doing and whatever they were writing. No black man was invited to come and observe what they were writing," he said. "They were doing a system, interrogating by force. They altered and they wrote what they thought was fit for them. Yes, they were doing it by force. They wrote what they wanted. And whenever it was written it was praised as good writing. It would be as ludicrous as if I would come to America and write a history without talking with the indigenous people," Rukodzi stated.

"We (Shona) really know where we come from and our tribe comes from, but if you read their history you find that the history is wrong."

Though the Shona knew better about Great Zimbabwe, he said, no one wanted to hear the truth.

One reason the theory of a mysterious "advanced" race persisted was that, thanks to Cecil Rhodes and his men, the land had been stripped of nearly all cultural and historical artifacts which proved the existence of an advanced Bantu civilization. When Rhodes first began colonizing southern Africa, he and his men coldly and methodically stole or destroyed everything they could find. The first investigations of the ruins were carried out by the Rhodesia Ancient Ruins Company which was given a franchise to explore old gold mines and other places for treasure. The results were disastrous. At Great Zimbabwe and other stone sites they found only small amounts of gold remaining; however, the priceless archeological relics were destroyed by those who thought they were worthless. This destruction was partly out of greed and partly in an attempt to destroy African feelings of nationalism and self-determination.

What began as Victorian ethno-centricity, fueled by the heady business of Empire building, evolved into a systematic and demoralizing campaign of psychological warfare that continued throughout much of the 20th century.

Rukodzi again: "They were telling the outside world that blacks were incapable of ruling themselves. That's why. By talking that way, they themselves have become superior so they can rule the other people."

Finally, in the 1960s and 1970s

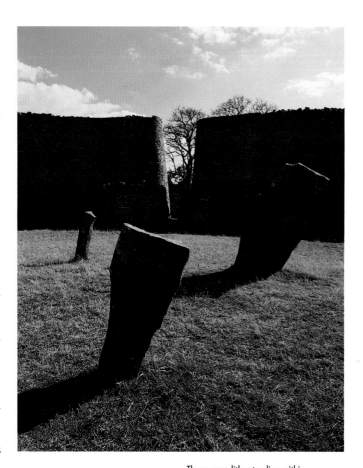

These monoliths standing within the Great Enclosure all point eastward. They are not gravestones. However, they may have had some spiritual or religious significance.

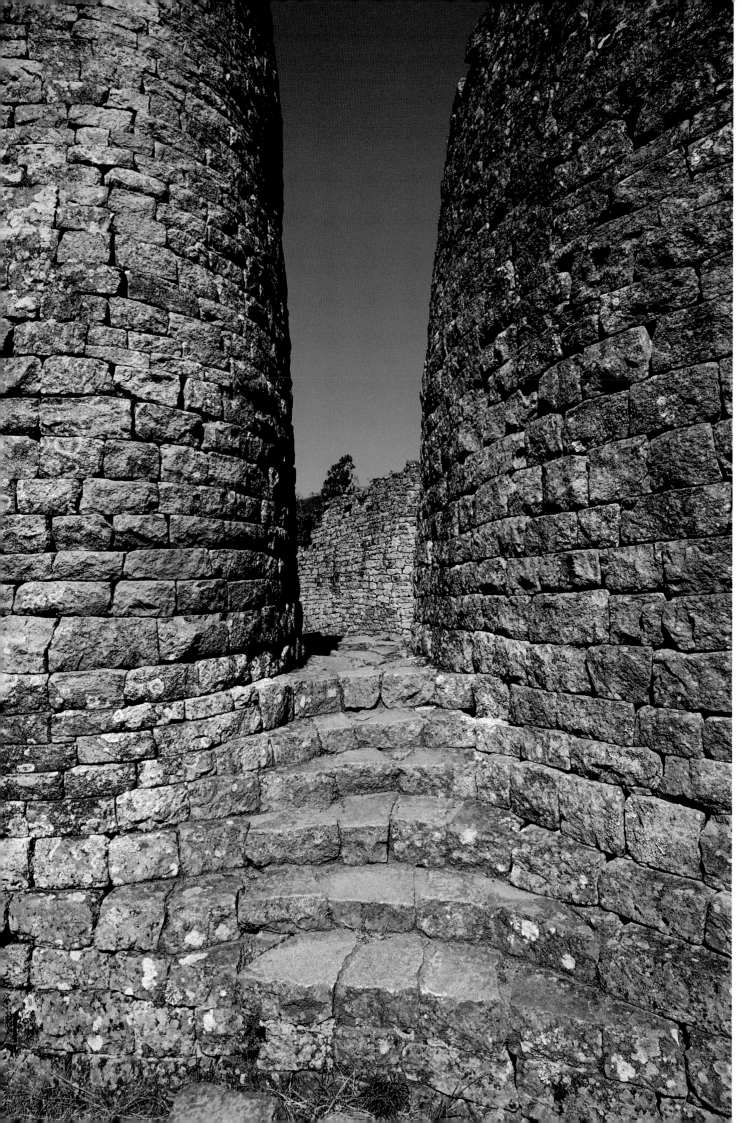

This rounded passageway echoes the changing curved surfaces of the stone steps. These architectural features were unique to the Shona craftsmen and are evidence of a sophisticated and advanced understanding of engineering. Nowhere else in the ancient world were steps designed in this fashion.

several archeologists again began arguing that Great Zimbabwe was built by the Bantu, not by a mysterious white race. However, extensive scholarly research on the site was not begun until after the white government was toppled in 1980.

Modern archeologists, picking up where MacIver left off, say the ancient architecture and construction of Great Zimbabwe has startling similarities with Shona architecture and construction techniques of today.

First, the floorplans of the common peoples' huts at the base of the ancient citadel appear to be exactly the same shape, configuration and east-west orientation as the modern *imbas*, or thatched round houses, still built by rural Shona. Most significantly, the wall joins of the *imbas* today are identical in construction to the excavated huts at Great Zimbabwe.

The construction methods used on the hut walls are practically identical as well.

A second link between the old and the new is the placement of *mushonga* or medicine herbs inside the huts. Archeologists have found evidence that the ancient east-facing walls were also protected by folk medicines or magic herbs, in exactly the same manner in which traditional Shona use magic herbs today. Traditional Shona still believe that the practice of placing herbs on the east-facing walls protects the home from evil.

Recent archeological findings show evidence of a great trading economy, including fragments of Arab glass, Greek and Roman coins, Persian faience and jewelry, Oriental celadon pottery and Ming Dynasty ceramic shards from 14th century China. Several

The Zimbabwean countryside spreads east from the King's Enclosure. One remaining monolith stands as lone testimony to the ancient rituals performed here.

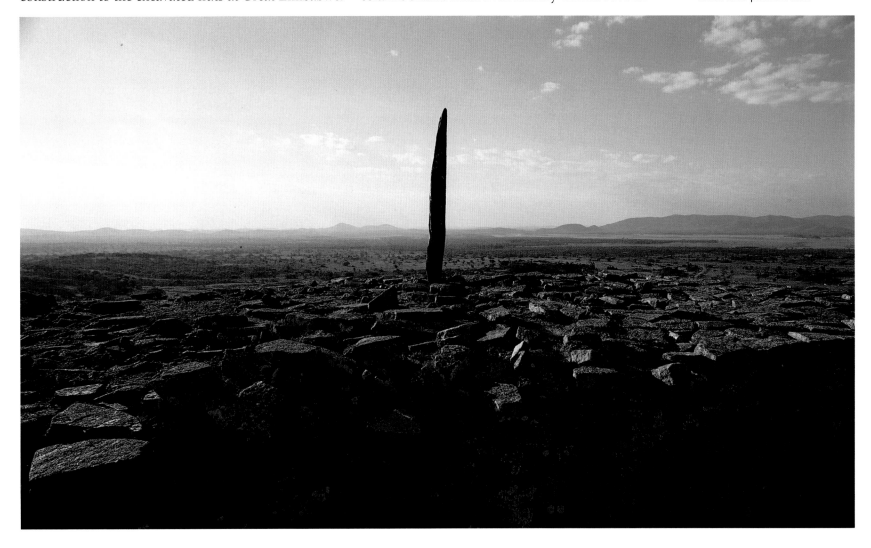

monoliths, some with geometric designs carved into them were also found at Great Zimbabwe. Other works said to come from Great Zimbabwe are the small anthropomorphic figures presently in the British Museum and in the Tishman Museum in New York.

Perhaps the most mystifying question confronting the archeologists is what became of all the human remains from this thriving and great civilization? After all, in over four hundred years of habitation, wouldn't there have been numerous gravesites?

The valley floor is covered with literally millions of

life of 20,000 to 30,000 people. During the 400 years of habitation there would have been hundreds of thousands of bodies. There should have been more than three graves. What happened to them?

Cremation has been suggested, but the Shona have never believed in cremation. By tradition, all bodies are buried in the homelands of their ancestors. The liberation of the spirit after death is the cornerstone of the entire culture and is only possible with proper burial. Traditional burials are accompanied by elaborate rituals that honor the ancestor and so allow

The Zimbabwe birds, which once stood above the eastern enclosure on the hill, are the earliest known examples of Shona stone sculpture. Removed from Great Zimbabwe by white treasure hunters in the late 1890's, these eight eagle-capped monoliths are believed to have been the ancestral link to the heavens. Sometimes called *Shiri ya Mwari*, or Bird of God, their original totemic significance is unclear. The Zimbabwe birds became the country's national emblem after liberation was won in 1980. These national treasures, now returned from England and South Africa, are on display at the Great Zimbabwe Museum.

clay pottery shards and a like number of cow bones. Amazingly, human bones are rare. So rare, that until recent years, none had ever been found. However, with Zimbabwe's recent severe drought, nearby Lake Kyle has receded to 3 percent of its capacity and three ancient graves have been found. But the Great Enclosure and surrounding valley once pulsed with the

his or her spirit to leave the body and become a protective ancestral spirit. Without an ancestral spirit, a family is lost. Calamity will fall on the descendants and the lineage will end.

Unlike Great Zimbabwe, the Khami ruins, located 10 miles west of Bulawayo and developed later, have specific gravesites and hundreds of bones. The Khami

enclosure housed approximately 4,000 to 5,000 people. Evidence shows that when people fled from Great Zimbabwe, some of them went to build the Khami towers and others built hundreds of lesser stone cities throughout south-central Zimbabwe. But the question still remains: why did they leave Great Zimbabwe?

Archeologists have suggested that people left Great Zimbabwe because of deforestation; they simply ran out of trees. Although that wouldn't necessarily explain an immediate, inclusive migration, there is evidence that wood, used for cooking fuel and to heat huts for

Nganga's or shaman's clay mixing bowl. Here the King's future was prophesied, spirits assuaged and healing medicines prepared.

thermodynamics. The ancient stones fit together so well that in some sections of the wall one still cannot insert the thin blade of a pen knife. Remarkably, the height of the wall is consistent around the enclosure and in some places the walls are 14-feet thick.

Rukodzi agrees that deforestation was a problem, but he believes there was a more urgent impetus for the exodus—a tsetse fly infestation that wiped out massive numbers of cattle. Invasion by tsetse fly has plagued the Shona periodically throughout their long history, but Rukodzi theorizes that this infestation was

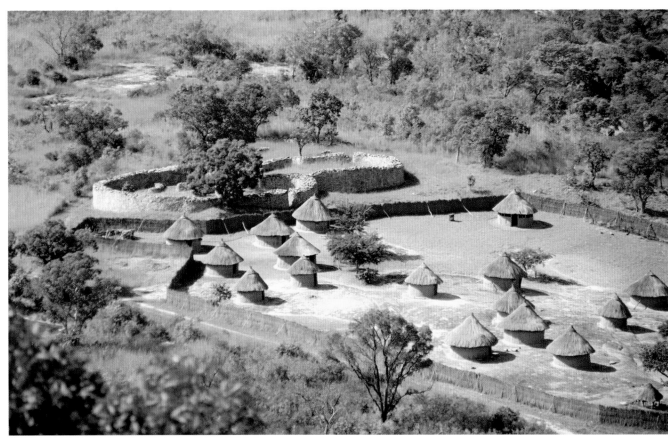

In the mid-1300s the valley floor was dotted with as many as 10,000 *imbas*, apparently constructed identically to the thatched *imbas* of the 20th century. Today these reconstructed *imbas* house the park staff.

20,000 to 30,000 people, became scarce.

Also, great quantities of wood were used to heat the granite outcroppings and accelerate the natural exfoliation of the stone, which normally was a result of the sun heating the cold granite. The ancient Shona technique of exfoliation was a tribute to their excellent masonry and their understanding of the laws of

exacerbated by several added problems—a crippling drought, lack of salt and the arrival of white explorers. The inhabitants of Great Zimbabwe might have been able to overcome each of these obstacles individually, but perhaps the combination of hostile forces was simply too much to struggle against.

Ironically, the modern Shona have few legends or

oral folklore which attempt to explain the exodus from Great Zimbabwe. Archeological evidence confirms that the exodus was abrupt and complete. Since modern Shona are most reluctant to discuss anything bad, especially regarding spirits, anthropologists believe that perhaps after everyone left Great Zimbabwe, for whatever reason, the subject became taboo to discuss for fear that the evil would return.

However, Edronce does not believe that Great Zimbabwe was ever completely abandoned. For evidence he points to the fact that the Zimbabwe birds and other stone monoliths were left in place until foreign plunderers took them away.

"When people abandoned that place it was not

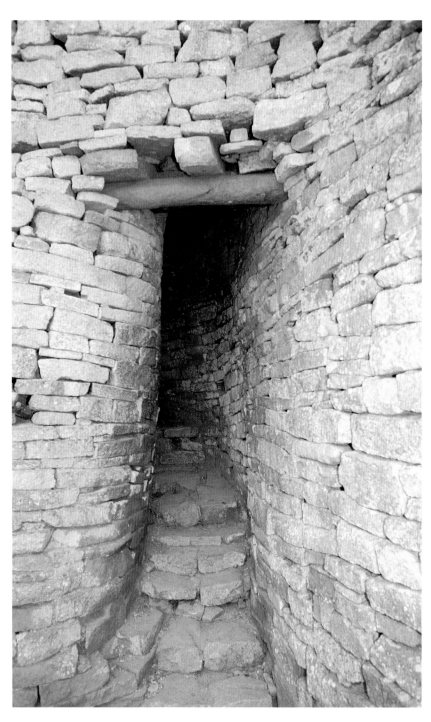
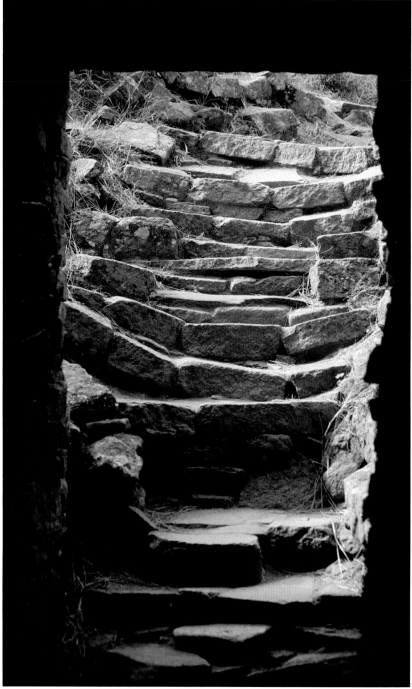

really abandoned," he said. Rukodzi stated that the Shona continued to use Great Zimbabwe during ceremonies celebrating the new moon or the beginning of the year. It was customary for the whole country to put out their village fires. Then, a great fire was lit at Great Zimbabwe. Runners, lighting their branches, would carry the new year's flame to villages throughout the country. Also, every year, between September and January, the Shona still practice the ancient rainmaking rites in the stone shrines of these stone sites throughout the country. Songs, dances, honey and *hwahwa* or beer are offered in ceremonial tribute to petition the ancestral spirits to bring rain.

"That's why those things (spiritual symbols and healers' tools) had been kept there," he explained.

Still, at some point the flames did die and foreign colonialists soon sought to fill the breach left by the withering of Great Zimbabwe. The Portuguese began arriving on the scene in force in the early 16th century. Their attempts to exert both commercial and religious control over the indigenous people were strongly resisted. The people of the Mutapa region inflicted a military defeat on the Portuguese in 1575. The Portuguese persisted, and managed to exert some influence in the area during the next century, before the Shona states of Mutapa and Changamire formed an alliance to drive them out in 1693. However, the practical Portuguese did maintain commercial ties.

It was more than 150 years later that the next foreign threat appeared. This one proved far more difficult to repulse.

Cecil Rhodes, who had amassed one of the world's great fortunes in South Africa and founded the British South Africa Company, saw the land to the north as a critical part of his plans to expand the British empire in Africa. In the European colonial agreements to divide up Africa, the regions called Mashonaland and Matabeleland had been placed in the British sphere of influence. These regions lay between the Limpopo and Zambezi rivers, and were ruled at that time by the

Ndebele's and their king, Lobengula—descendants from Zulu invaders.

At first, Rhodes used diplomacy—although of the most dubious sort—to achieve his goal. He sent a delegation to negotiate an agreement with Lobengula. Betrayed by the Europeans whom he believed to be his friends, Lobengula put his seal on the Rudd Concession without knowledge of its real contents.

Only later did the trusting Ndebele king discover the truth about the agreement he had signed. He had abdicated his powers and annexed his lands to the British Empire.

Rhodes used the Rudd Concession to persuade the British to grant him a charter which cleared the way for the settlement and economic exploitation of Zimbabwe, which was to become part of the British Empire.

Lobengula repudiated the agreement once he found what it really contained, but it was to no avail. A body of 700 armed men came from South Africa and established Fort Salisbury on September 12, 1890.

Conflict was inevitable. The British South Africa Company fortified its settlements. In July 1893, BSAC troops attacked an Ndebele attachment, killing between 30 and 50 warriors. The Ndebele responded. The Anglo-Ndebele War that followed ended with the BSAC in control of Matabeleland, completing the foreign domination of the country. A humiliated Lobengula fled northwest and died in 1894 of smallpox.

Spurred by Rhodes' grand dreams for the region, more foreigners arrived. There were more conflicts as well in the late 1890s, but the colonialists remained in charge. Cecil Rhodes died March 26, 1902, at the early age of 48.

The colonials continued to strengthen their grip on power in the decades following Rhodes' death. In 1922, the settlers of Rhodesia (later Zimbabwe) voted for increased self-rule, as opposed to joining the Union of South Africa. The country became a self-governing

(Far Left)
This narrow portal was one of the last through which a visitor passed before entering the king's courtyard.

(Left)
These worn ancient steps carried countless royal messengers, servants, high council members and foreign visitors as they passed through the royal portal to pay homage to the king.

British colony in 1923. The new constitution continued to tie the right to vote to property ownership, effectively preventing the black majority from gaining any political clout.

In the next decades, political changes in Rhodesia were, for all practical purposes, aimed at two goals: increased autonomy from Britain and making sure that the colonists retained political power over the black majority. African uprisings continued throughout the 1930s, but they were quickly suppressed.

In 1953, Northern Rhodesia, Southern Rhodesia and Nyasaland joined in the Federation of Rhodesia and Nyasaland. But the racially divided voting system of the Federation further hampered black attempts to gain real political influence. The Federation dissolved in December 1963, with the two northern territories, Northern Rhodesia (Zambia) and Nyasaland (Malawi) set on a path toward one-man one-vote rule and independence.

Southern Rhodesia's colonial leaders sought the same status from the British, but were refused by the British government, which demanded majority rule before granting complete self-determination. The party in power—the Dominion Party, which was later known as the Rhodesian Front—refused to make those concessions. Vowing that there would never be African majority rule, the Rhodesian front moved to make sure that Southern Rhodesia would not follow the same path as Nyasaland and Northern Rhodesia. Prime Minister Ian Smith and his government defiantly signed the Unilateral Declaration of Independence on November 11, 1965 which launched the country into a 15 year civil war.

This reckless act set the stage for years of international pressure and internal rebellion. British Prime Minister Harold Wilson refused to send in troops to uphold the existing constitution, instead relying on trade sanctions. The United Nations followed suit.

But in Southern Rhodesia, the two sides in the coming civil war were taking far more direct action. The Smith government detained many black leaders without trial and held them in remote areas. Thousands of Africans fled the country to carry on the fight for freedom. The white government's attempts to strengthen its hold—through brutal police tactics and the establishment of "protected villages" where Africans were herded together to cut off any contacts with the rebels—only increased the number of freedom fighters. By September 1975, an estimated 1,000 volunteers each week were crossing into neighboring Mozambique for training.

In 1976, in a crucial move for the majority resistance, the rival parties, Robert Mugabe's Zimbabwe African National Union (ZANU) and Joshua Nkomo's Zimbabwe African People's Union (ZAPU) moved toward more effective cooperation by consolidating their efforts and forming the Patriotic Front. That action greatly increased the strength of the African nationalist movement, both on the battlefield and at the negotiating table.

On December 21, 1979, the leaders of the Patriotic Front, Joshua Nkomo and Robert Mugabe, signed the Lancaster House Agreement along with representatives of the British and Zimbabwean Rhodesian governments. The agreement called for a cease-fire, which would end a war in which an estimated 27,000 people on both sides had died. It also set the stage for new elections, which were held in February 1980, with Robert Mugabe being elected as the new nation's first prime minister.

The official day of independence was April 18, 1980. Cecil Rhodes' statue was removed from the city he had named Salisbury. It was renamed Harare—in honor of the former great Shona chiefdom of Neharawa who ruled there. In a generous spirit of reconciliation and cooperation, the new nation strode forward to create a homeland of equality for all its peoples. Zimbabwe was reborn.

After the war of liberation was won in 1980, the majority renamed their country Zimbabwe, in recognition of their long, rich history. The name Zimbabwe means house of stone and gravesite of the great chiefs. The citadel stands as the most tangible evidence of the sophisticated artistry and engineering of Great Zimbabwe. The monument is now a favorite site for school children to learn about their cultural heritage.

"The contrast is extraordinary—from rich farmland to desert scrub and from modern city sprawl to rustic village cameos, little changed in more than a century."
—David Jones
The Nature of Zimbabwe

LANDSCAPES OF INSPIRATION

THE GIANT Brachiosaurus no longer thunders across the Zimbabwe plains, but his footprints remain, preserved in the ancient rock. Bordered by the Zambezi and Limpopo Rivers,

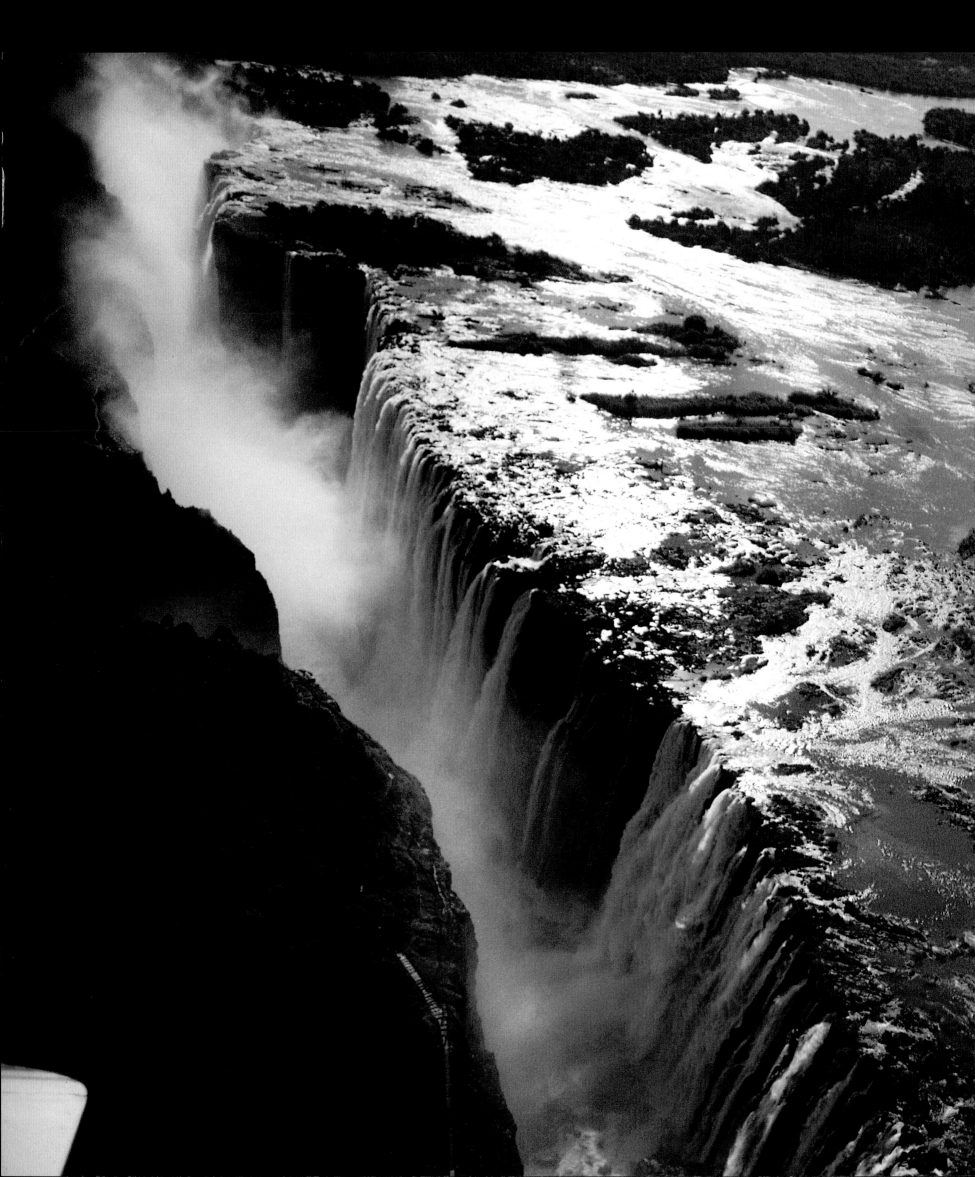

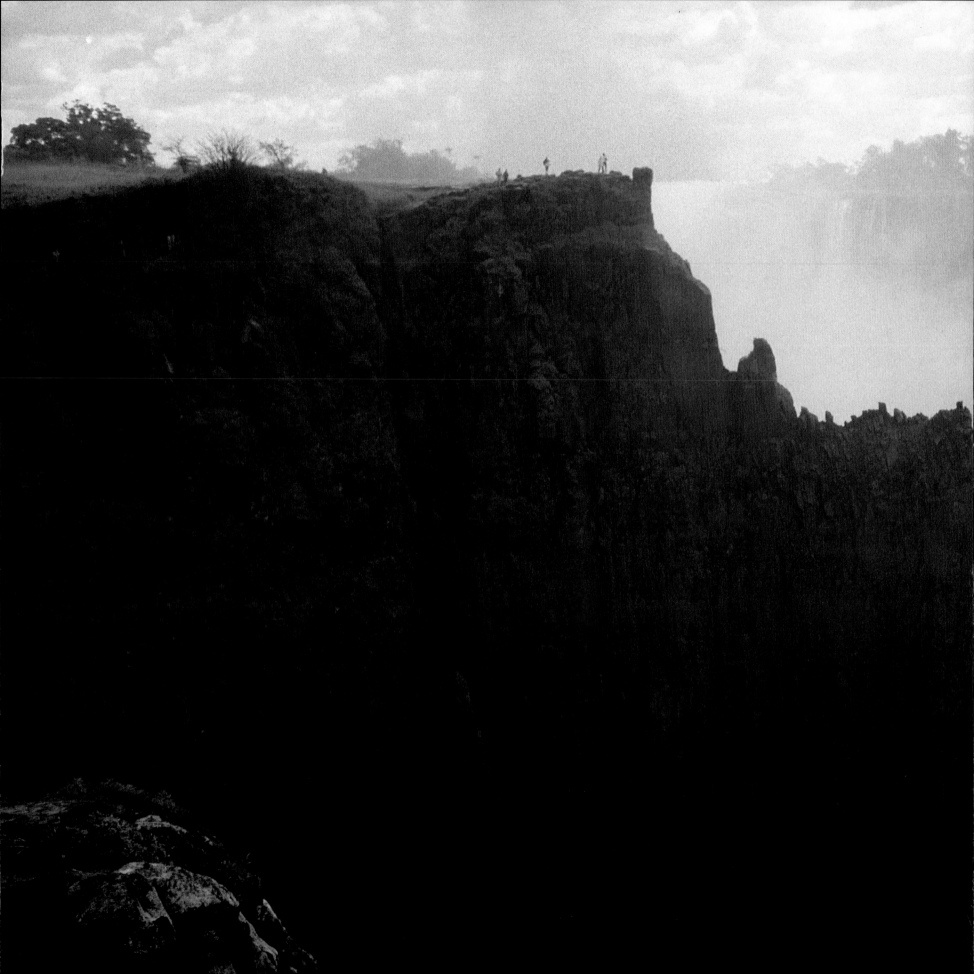

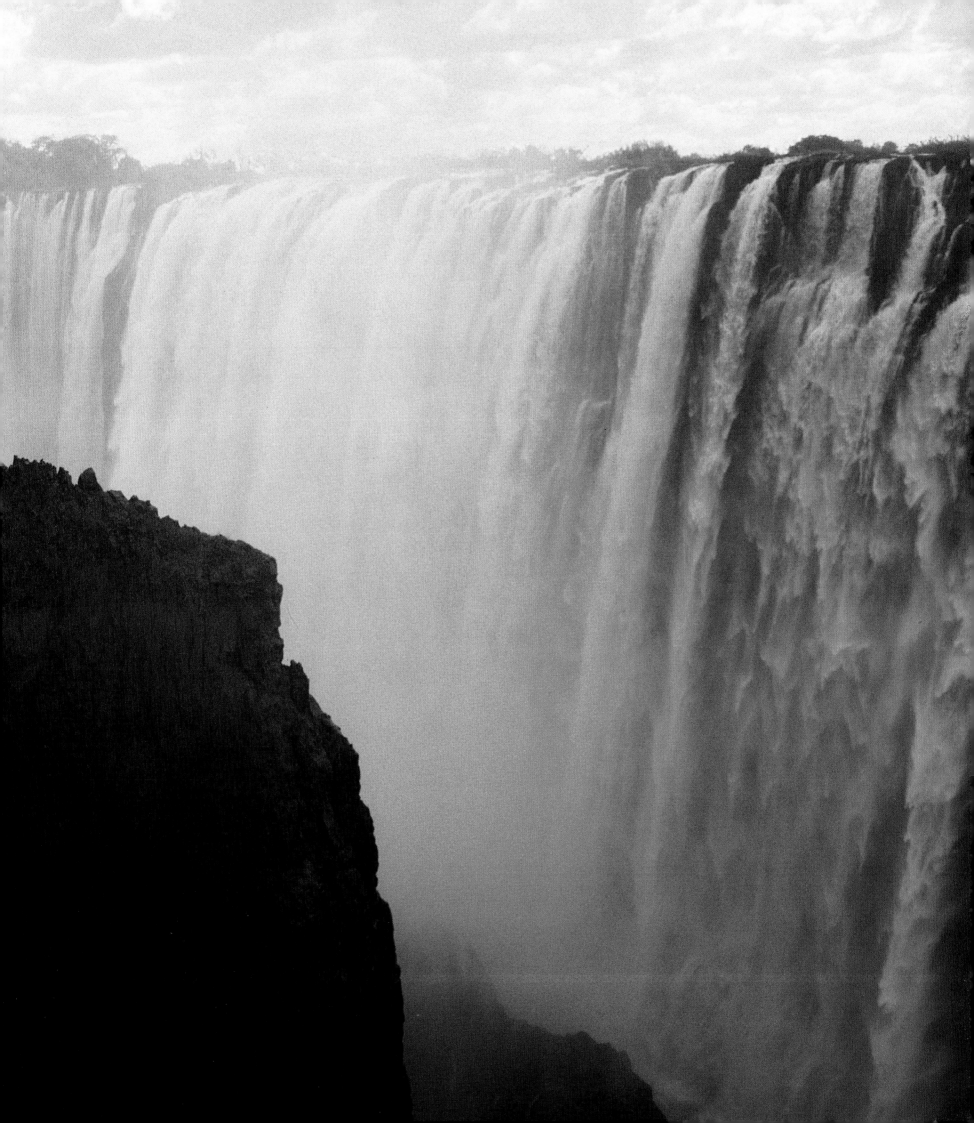

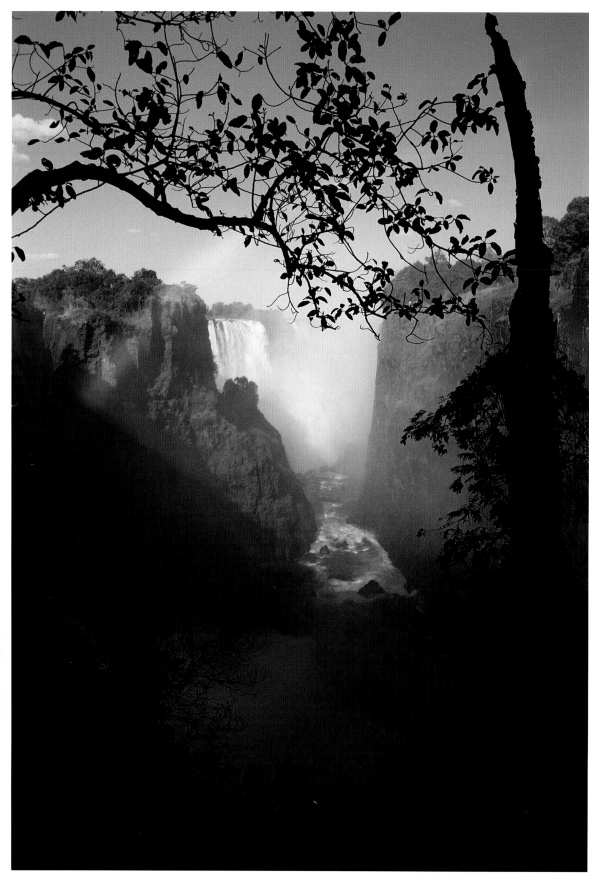

(This and previous pages)
Views of Victoria Falls, called
Mosi oa tunya or "the smoke that
thunders." British explorer, David
Livingstone, after seeing the falls, said,
"Scenes so lovely must have been gazed
upon by angels in their flight."

(Opposite page)
Sunrise in Guruve.

the land reverberates with
primeval associations that
stretch back to creation.
When the earth cooled more
than three billion years ago,
the land that was to become

Zimbabwe was blessed
with an incredible bounty
of geologic wealth and
natural splendor.

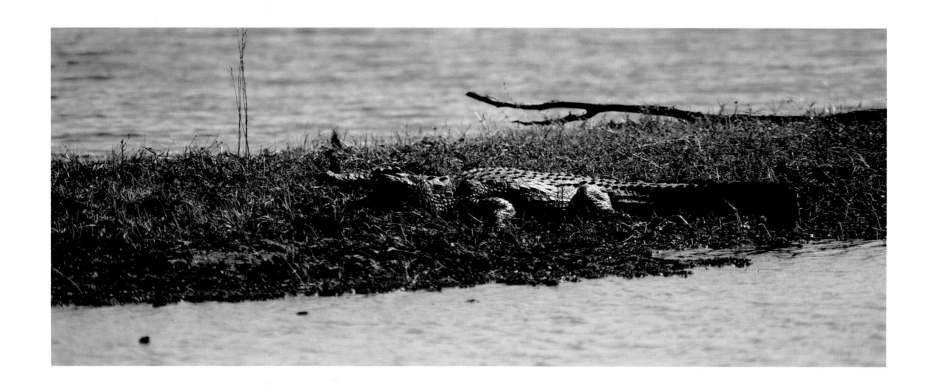

Prehistoric crocodiles still slumber on the banks of the Zambezi River.

Black rhinos, whose ancestors walked in the shadows of the dinosaurs, still browse the river valley.

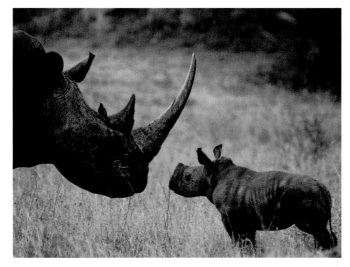

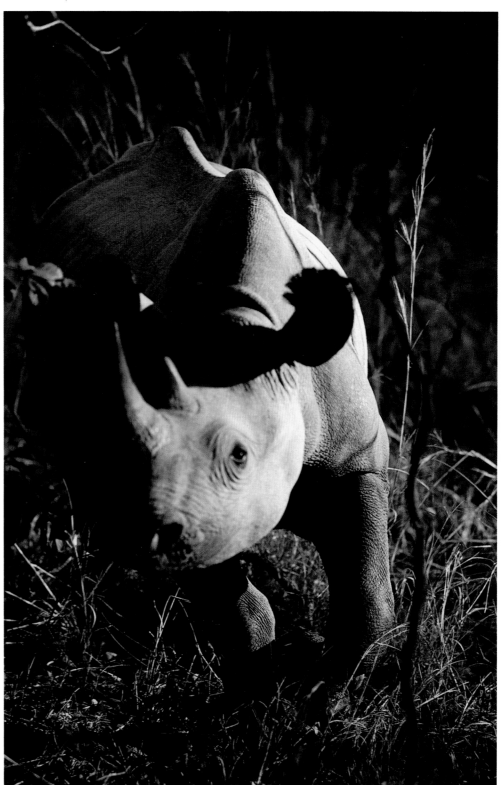

Zimbabwe, with its pro-active conservation policies, is home to myriad wildlife, including great lumbering elephants, giraffe, cheetahs, lions and kudus.

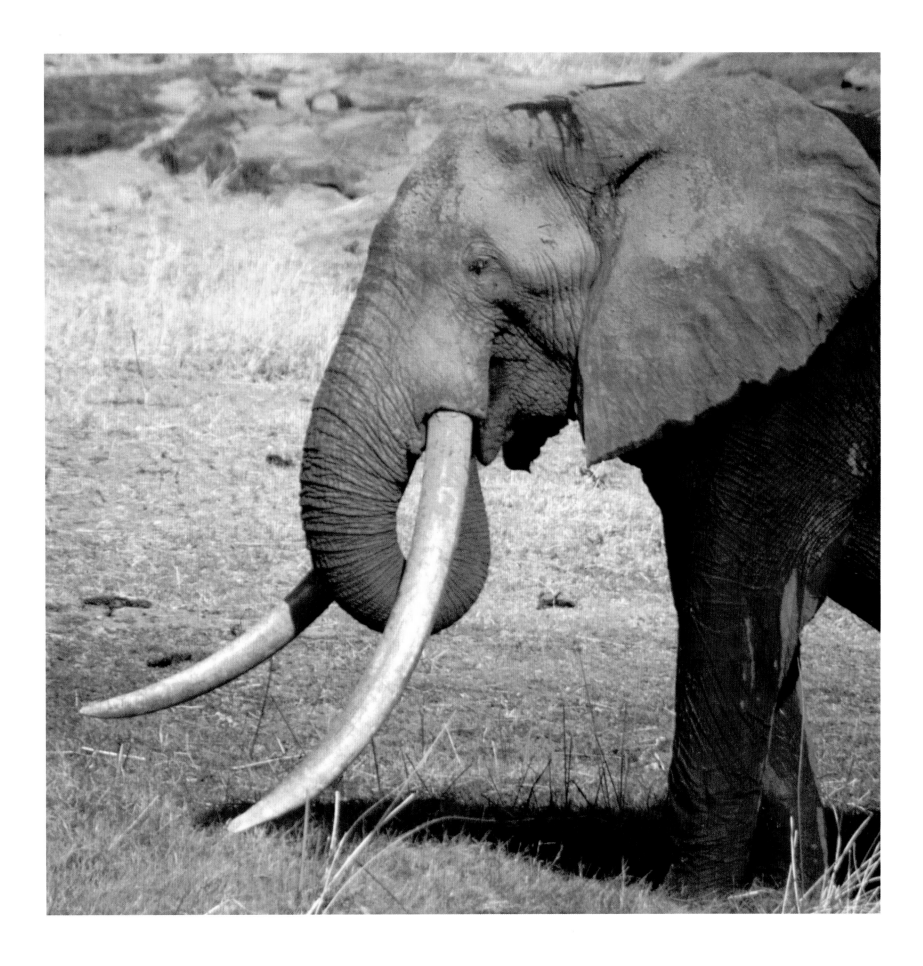

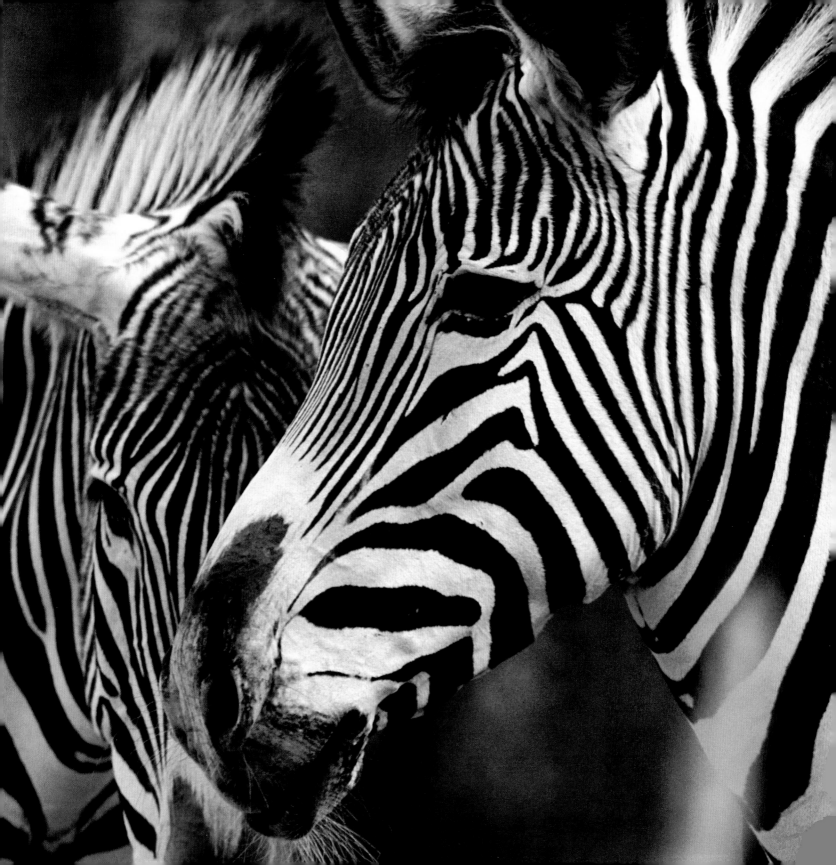

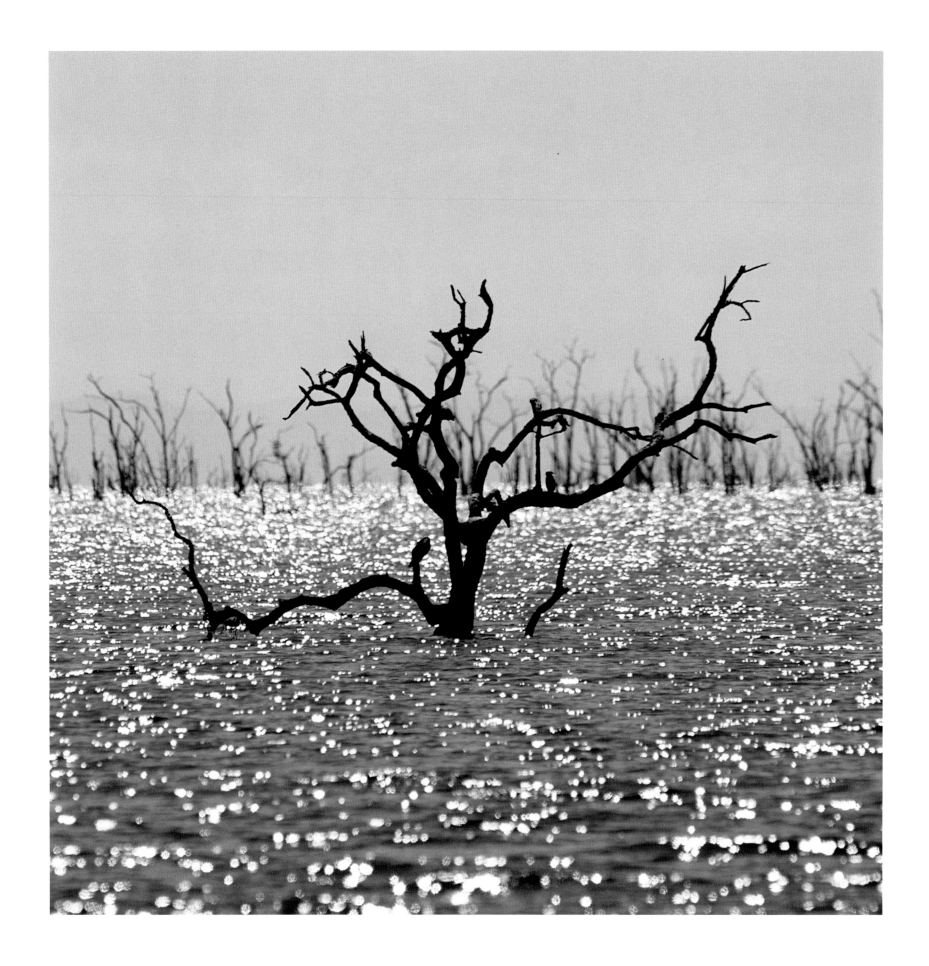

This is a land of contrasting landscapes, from the power of Victoria Falls, the world's largest single waterfall, to the subtle wonder of Lake Kariba, the second-largest man-made lake in the world.

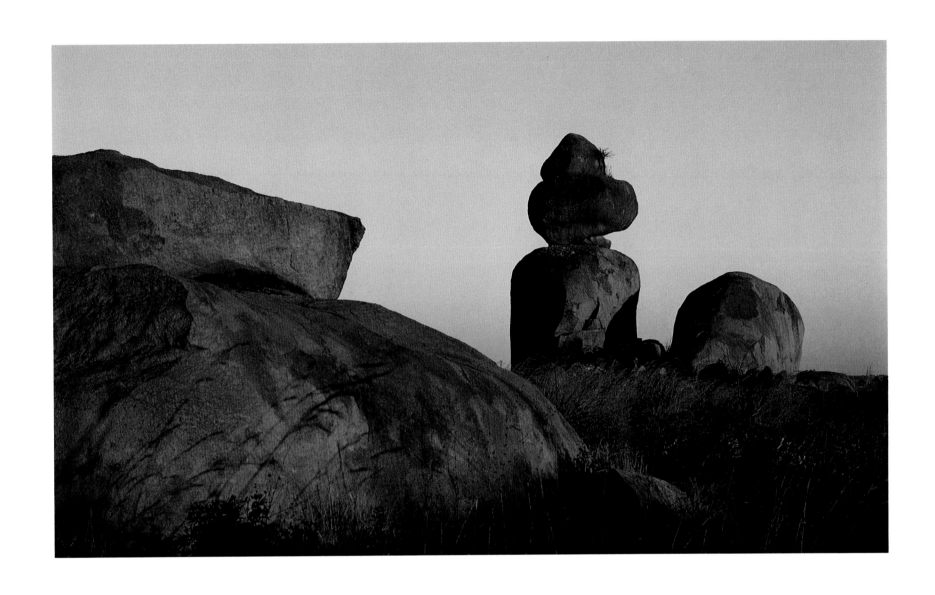

Curious balancing rocks and *kopjes* accent the tawny savannah.

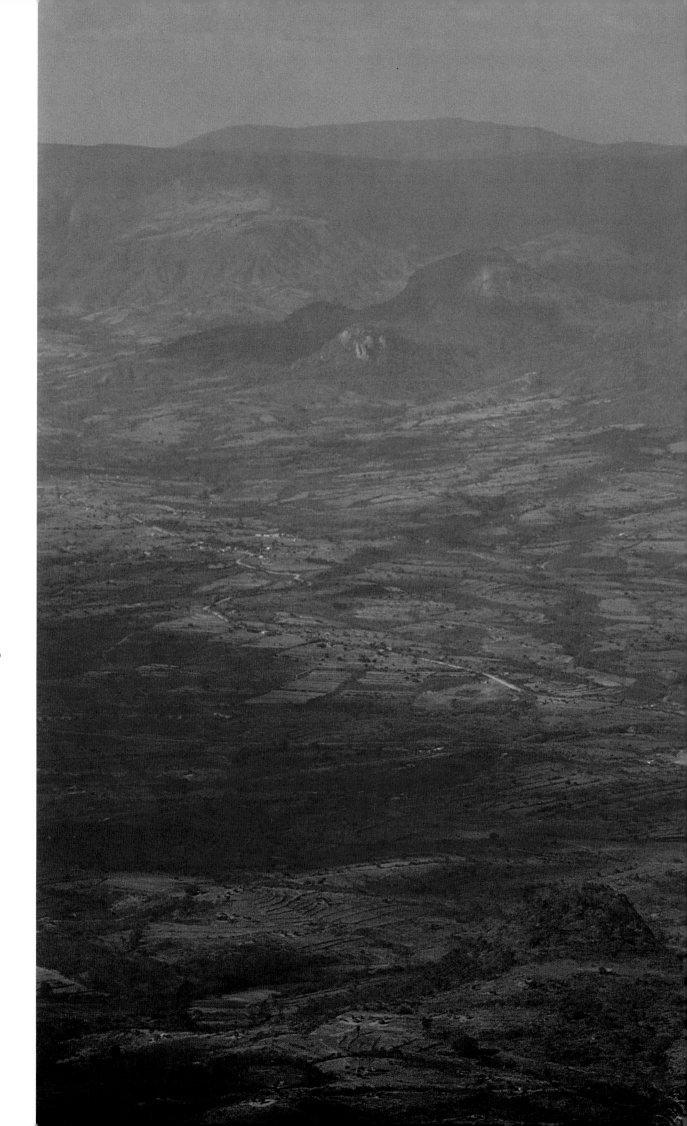

The mystical
Nyanga Mountains,
encompassing the
remote Honde
Valley, are home to
magnificent vistas
and sheer
escarpments.

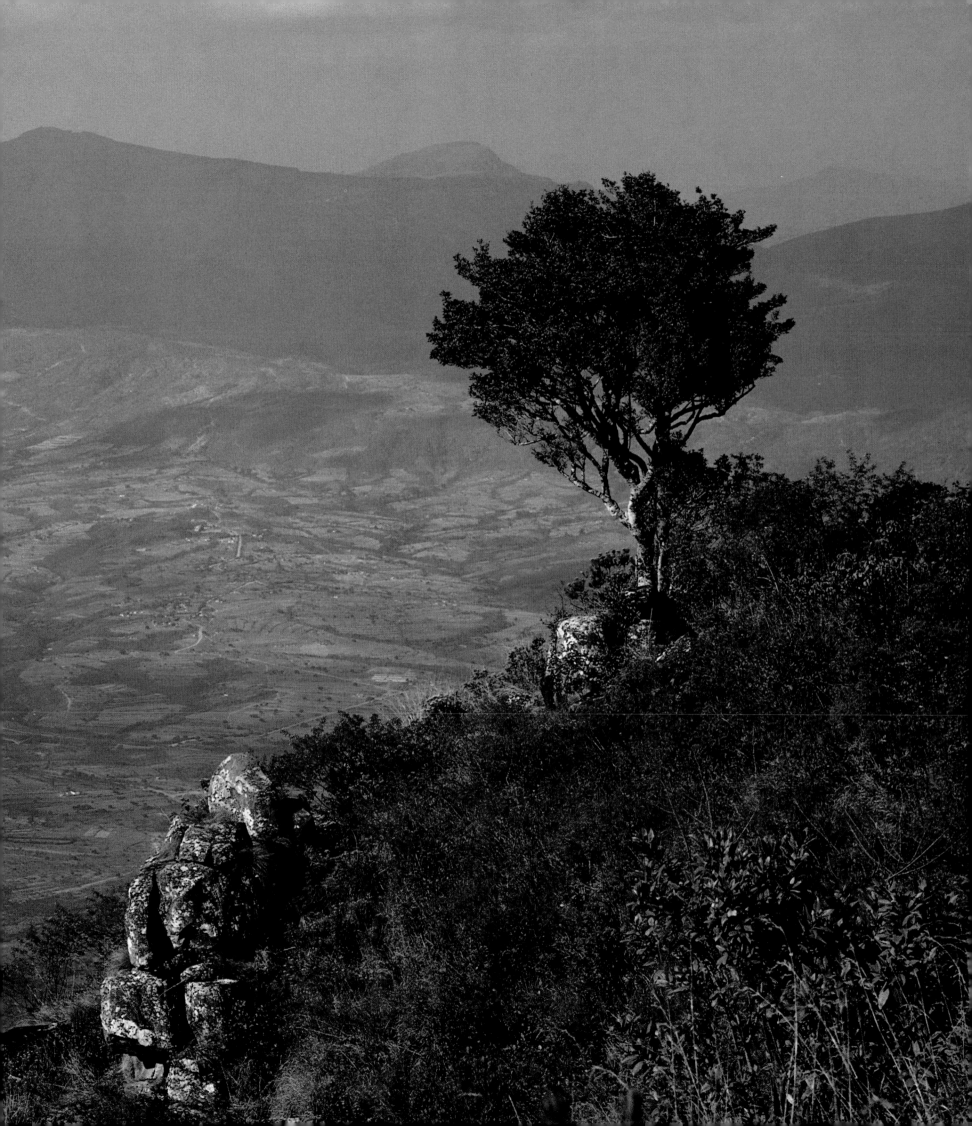

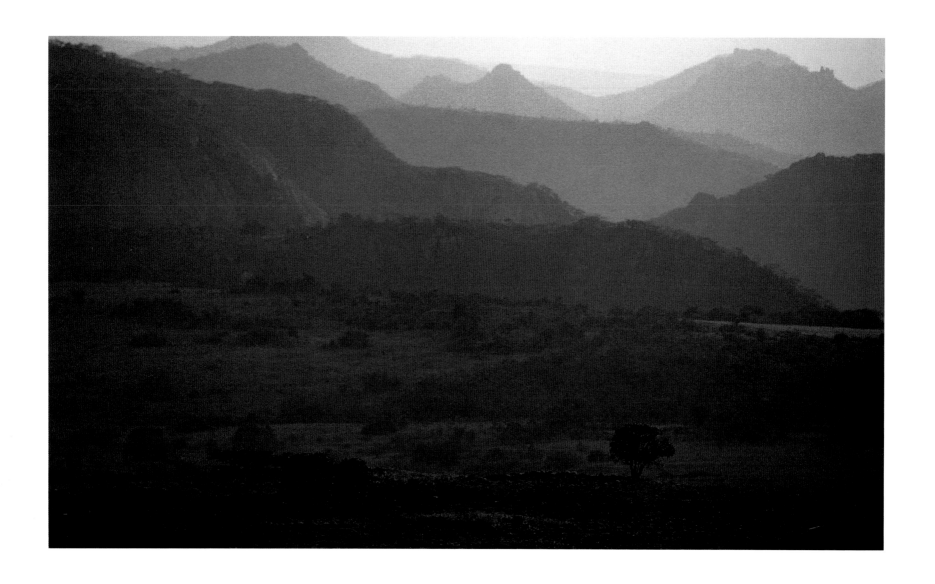

These powerful landscapes and their
natural elements—rocks, plants and
animals—provide the inspiring fabric
for the cultural tapestry of Zimbabwe.

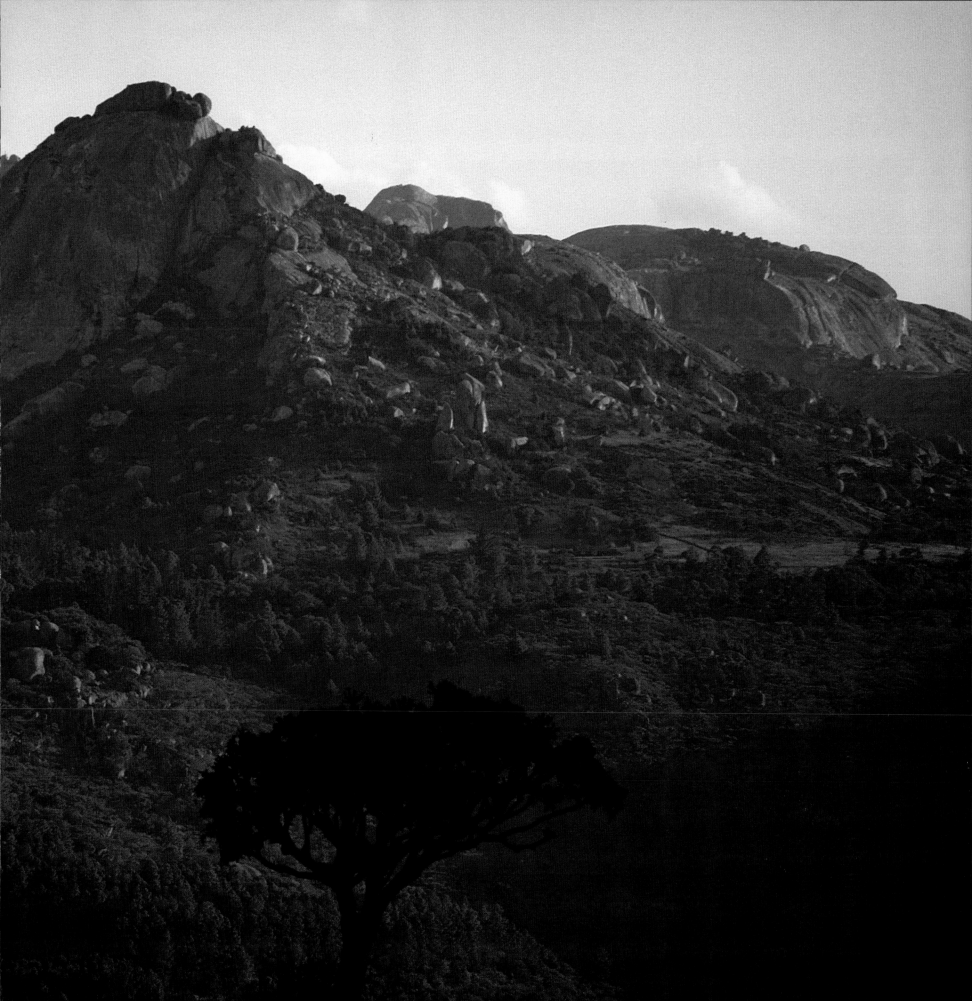

70

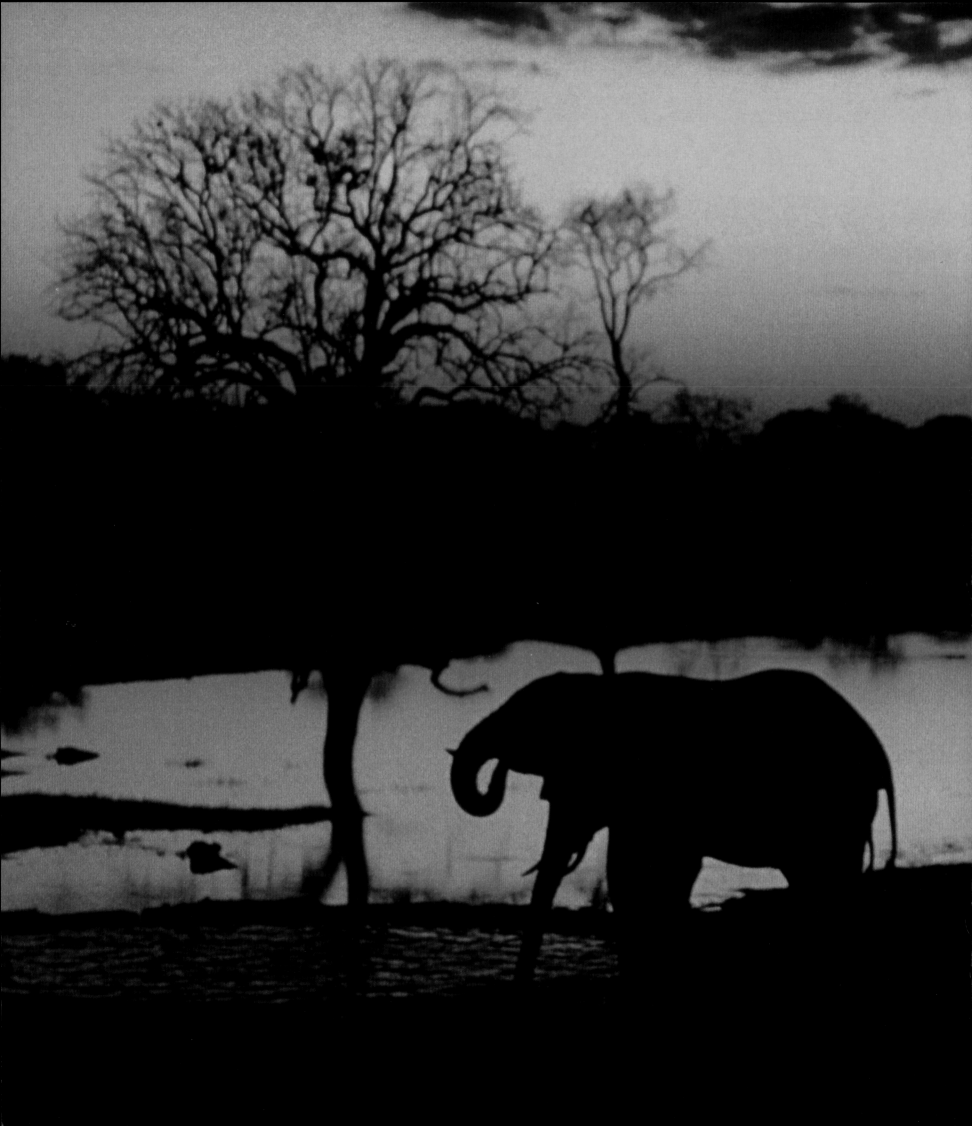

*"...if you do not understand the culture of the Shona, you
will not really understand what we sculptors
are saying."*

—Bernard Takawira
Shona sculptor

ENDURING TRADITIONS

FOR MORE THAN 1000 YEARS THE SHONA
and their ancestors have lived and died on
the land of Southeastern Africa. Though
generally a peaceful people who farmed
and raised cattle, the Shona have nevertheless
struggled for survival against armed invaders, natural
predators, disease, drought, famine and political
oppression.

Life for the individual was threatened on many
fronts. To live outside the community and its
protection was foolhardy at best. In this beautiful, but
potentially hostile environment, survival depended on
membership in a cohesive group, where everyone was
willing to lend a hand in times of need.

To combat the forces that threatened to tear them
apart, the Shona developed myriad intricate and

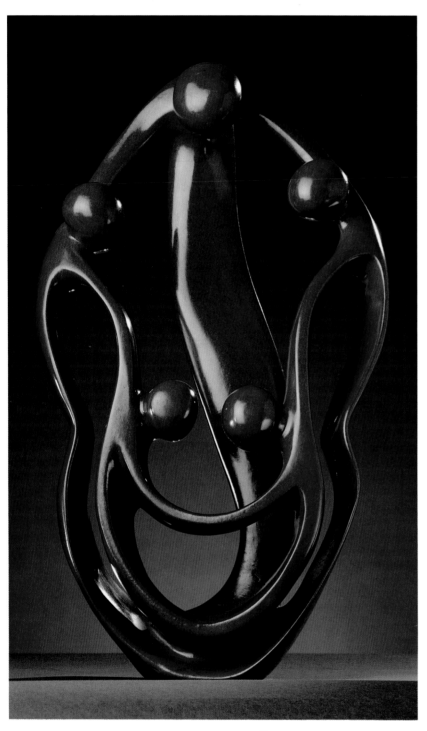

Ukama
Charles Chaya
32"

sophisticated social customs and beliefs, all of which still support one basic tenet: Live together and the culture will thrive.

UKAMA

Ukama, which means living together in close family relationships, is a central belief and practice in traditional Shona culture. Family ties are all-important to these people, and from birth through death and beyond, Shona families are bound together in the mutual respect, support and love that is the greater extended family—*ukama*.

These family relationships, extending to aunts, uncles, cousins and even more distant kin, form the foundation for communities all over Zimbabwe. Although the mother, father and children are still considered the primary family unit, the lines between immediate family and extended family often blur.

Uncles and aunts, especially paternal uncles and aunts, are often referred to as father and mother and are treated with the same honor and deference. Cousins, too, are respectfully acknowledged as brothers and sisters. In some cases, to call someone 'cousin' would cause insult or estrangement.

Clan relationships of the greater extended family are acknowledged through the use of totems, or *mitupo* —a central law of the ancestral spirits that tells the long history of one's family. In a society without written records, the totem system served to identify people and create order. From a very young age children are taught games which help them memorize and understand the lineage of their family totem.

Children are born into their father's totem and women maintain their paternal totem even when they marry. In fact, marriage partners must be of a different

totem to ensure genetic diversity. Usually an animal, or a part of one, the totem identifies those who belong to the same clan through the generations. For instance, a man who belongs to the *chipembere*, or rhino, totem knows that he is related to all others who claim the rhino as their totem; he cannot marry another of the rhino totem.

People honor their totem animal in a variety of ways, including trying to embody the positive qualities of the *mutupo*. For instance, those of the *shumba* totem sing praise poems extolling the strength, dignity and stateliness of the lion. People of the *nzou* totem sing of the size, power and loyalty of the great elephant.

It is taboo to kill or eat one's totem animal. Indeed, in most cases one would not even touch one's totem animal for fear that evil would follow.

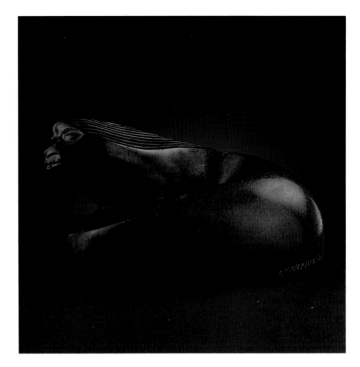

Lion
Albert Mamvura
7"

Elephant Mother and Child
Robert Kwechete
20"

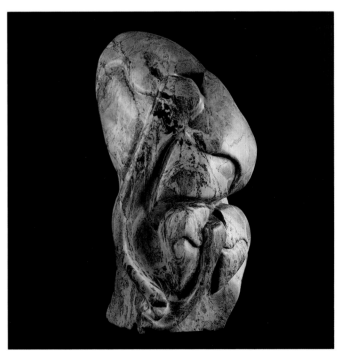

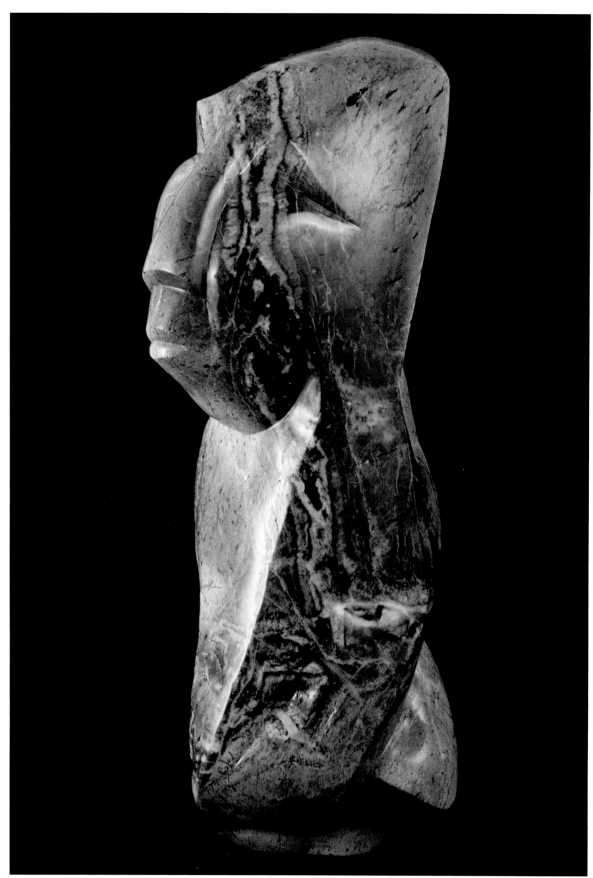

Ancestral Spirit Rising
Moses Masaya
36"

ANCESTRAL GUARDIANS

Spirits, both good and evil, play a vital role in the lives of all Shona. The Shona spirit world is rich with ambiguity, regional differences and apparent contradictions. Still, the essential truth is that nothing happens accidentally; spirits are everywhere and are responsible for all things.

All spirits are graded in terms of lesser or greater importance. The hierarchy of spirits stretches from the personal and protective ancestor spirits, called *midzimu*, to the family spirits, called *vadzimu*, through the *mhondoro* or clan spirits, up to the all-powerful *Mwari*. *Mwari* is the God who created the sun, the moon, the stars, the trees, the mountains and the sky, but he is far removed from the people. In spite of his role as creator, he is generally believed to be indifferent to individual problems and concerns, and is unapproachable.

In times of need, the Shona turn to lesser, but nonetheless powerful ancestral spirits. Just which spirits they turn to depends on the scope of the problem. For instance, the *mhondoro* focus on community concerns, while more personal, individual problems are the concern of the *midzimu*.

The provincial spirits, which govern large geographical areas, were extremely important in the recent war of liberation. *Nehanda* in central Mashonaland and *Chaminuka* in southeastern Mashonaland are credited with guiding the liberation forces to victory. (*Nyami-nyami* is the provincial spirit in Kariwa or north Mashonaland). The Shona believe that the provincial spirits worked through the many spirit mediums to direct the freedom fighters in how and where to fight. The spirit mediums, or *masvikiro*, are not only oracles able to foretell the future, but they also are the human link between the ancestors and their descendants. The blessings and guidance of the ancestral spirits, as communicated through the *masvikiro*, were the foundation for the victorious war of liberation.

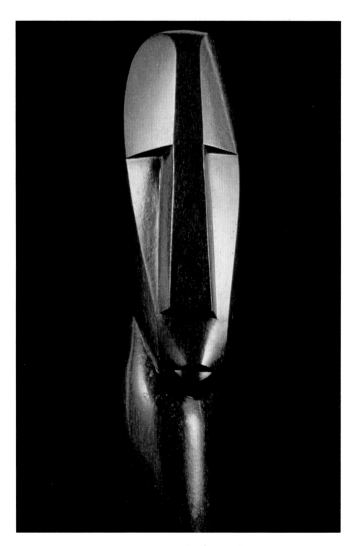

Guardian Ancestor
Moses Masaya
28"

Because most concerns are immediate, dealing with the health and happiness of close family members, the most important spirits are the ancestral spirits, or *midzimu*. They are sometimes called guardian spirits because they protect the family from harm. These wise guardian ancestors know everything that has happened in the past and will happen in the future. In times of trouble or urgency the *midzimu* can speak through the *svikiro*, but more often they communicate directly with their sleeping descendants. Thus, the Shona believe their ancestors speak to and instruct them through their spiritual dreams. Along with guiding family members to live a moral life, the *midzimu* protect against witches and bring good fortune, particularly the rain. However, ancestral spirits are sometimes responsible for bad fortune as well.

Svikiro
Kennedy Musekiwa
32"

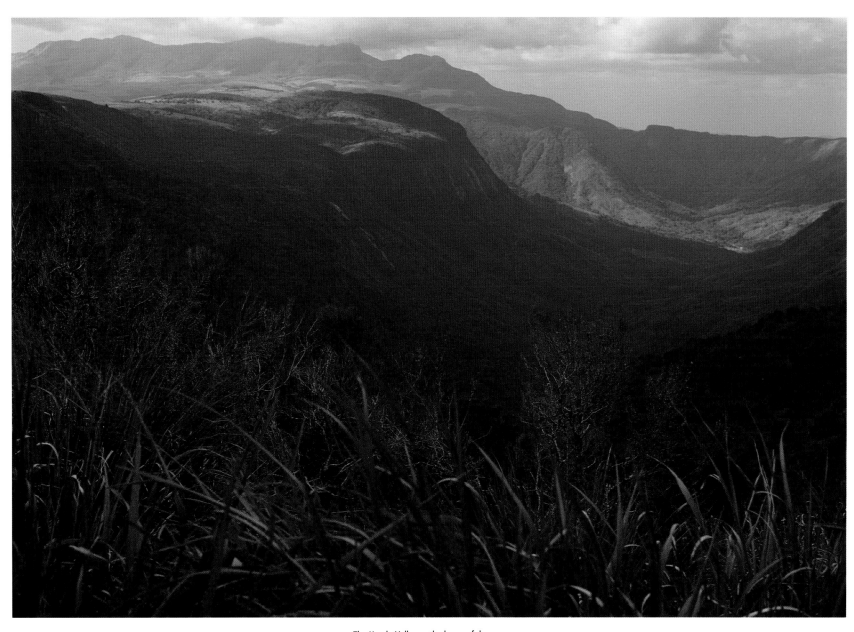

The Honde Valley—the home of the
Shona ancestors of Nyanga province.
Traditionally, the Shona revisit the
homeland of their clan ancestors in order
to restore their spiritual link with the past.
Not returning would separate a Shona
from his soul and ancestral bonds.

NGANGA

During times of illness or misfortune, one might ask an *nganga* or traditional healer for help. Skilled in the use of herbs and folk medicines, the *nganga* attempts to determine the spiritual explanations for illness, disease or misfortune. The *nganga* can sometimes communicate directly with the ancestor spirits, and sometimes uses the *hakata*, or divining bones, to foretell the future. If the *nganga* can determine what the afflicted person did to bring on the misfortune, he can prescribe a course of action for making amends. Making amends usually includes the *nganga* or the elders conducting a *bira*, or ceremony to appease the ancestor.

Healing and divining abilities are not born to the *nganga*. According to folklore, a chosen child is carried off by the *njuzu* or waterspirit to learn the magic healing arts. Later, the child is returned to the village to fulfill its destiny.

Although Shona today use a modern healthcare system to prevent and cure illnesses, the traditional healer has not been forgotten. Ever practical, many Shona will visit both the local clinic and the village *nganga* if the need is great. Increasingly, Western-trained doctors are recognizing the importance of respecting time-honored beliefs and remedies. Instead of ignoring or ridiculing traditional ways, the doctors work with them.

If the cause of an illness is not obvious, it's usual for a person to visit a

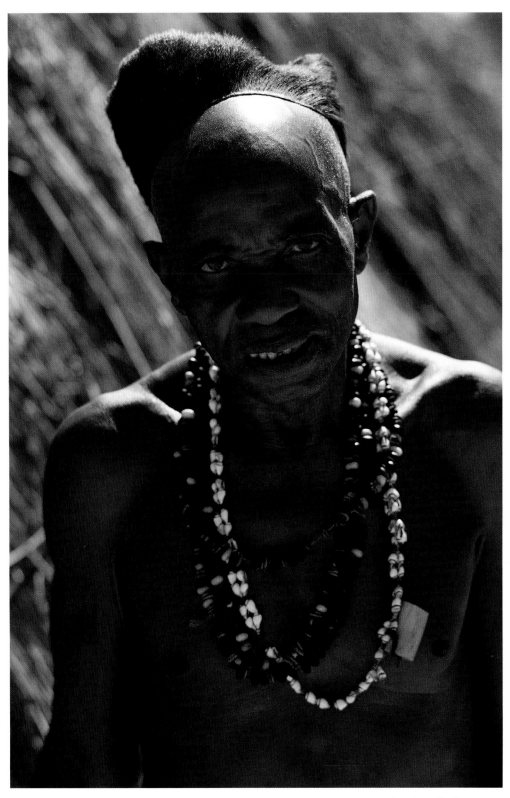

Nganga—the traditional healer

healer first. For instance, if a woman is having difficulty becoming pregnant, she would approach the *nganga*. Since maternal ancestor spirits are believed to control fertility, the *nganga* would try to divine if the grandmother spirit has been offended. If true, then the *nganga* would tell the infertile woman what she must do to make amends, and hopefully pregnancy would soon follow.

Maternal spirits are generally believed to be protective, and are sometimes accorded more importance than the spirits of the patrilineal ancestors. Since mothers give life, suffer the pains of childbirth and nourish and

(Upper left)
Ambuya—the grandmother

(Lower left)
My First Child
Shadu Chatsama
17"

(Right)
My Grandmother
Kennedy Musekiwa
66"

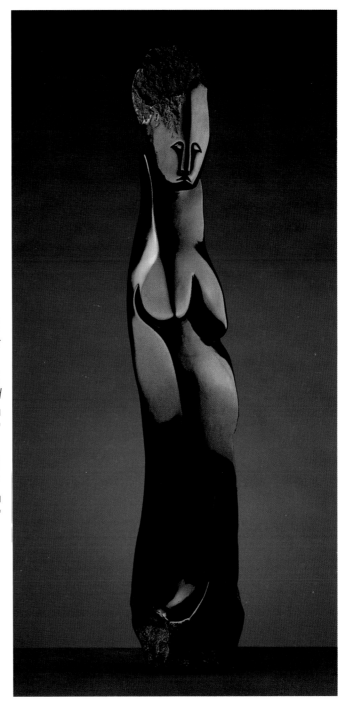

care for their children when they cannot care for themselves, they deserve great respect and are honored by their children throughout life and especially after death. Once a mother passes on and becomes a maternal spirit, she is believed to have the same absolute power over her children as she did when they were infants.

Fertility is paramount in Shona society because children make it possible for one to become an ancestral spirit after death. If a person leaves behind no descendants, then that person's spirit either dies with him or her, or becomes an angry or evil spirit called the *ngozi*.

NGOZI

Sickness or misfortune, including barreness, are often attributed to these *ngozi*. These evil spirits are those who have been wronged in some way, either during life or after death. For instance, if a man is murdered, his spirit might demand retribution, and so it would possess a member of the murderer's family and cause grave misfortune. Only remuneration can assuage the spirit.

If a person believes he or a family member is possessed by the *ngozi*, he would send for an *nganga*. The *nganga* would prescribe a course of action to appease the offended spirit and, hopefully, the misfortune would end. For example, the afflicted person might be ordered to brew *hwahwa* or beer in honor of the ancestral spirit, sing a praise poem, drum music, dance or ululate.

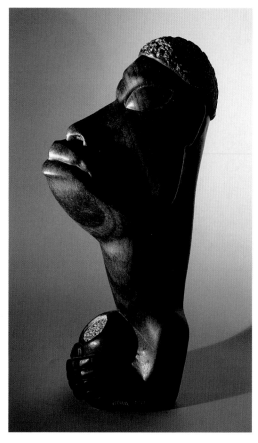

Ancestor Rising From Beer Pot
Boira Mteki
22"

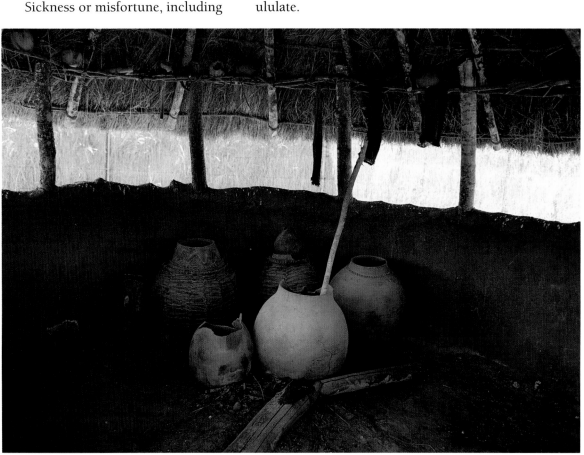

Drought struck cruelly after independence in the early 1980s. The elders believed that because the bodies of the liberation fighters had not been given an honorable burial in the traditional manner, disaster had fallen. A large *bira* or ceremony to appease the ancestral spirits was held. It included the brewing of beer (*hwahwa*) and drinking it in ritual form. The government also embarked on a nationwide hunt for the deceased fighters so they could be buried in an honorable manner. Soon the drought was broken and the rains returned.

Hwahwa Pots

Sculptor and oral historian Edronce Rukodze explained the ritual like this:

"If you have a problem our elders must prepare the pot (ceremonial *hwahwa* beer) which they bring to the lion spirit so that the matter can be solved. If it is a bigger one (problem), then the beer is brewed and the other spirits will be invited to come in and attend such a meeting. So, all the problems will be solved through that period—through dancing, the women's ululating and men's clapping their hands and the spirit will be praised and it will tell us who did something wrong."

If the offense was particularly egregious, the afflicted person might have to kill a cow as a sacrifice or make some kind of monetary tribute to the appropriate party. Paying homage and performing penance coaxes the forgiveness of the ancestral spirits.

FAMILY WEALTH

From a spiritual point of view, a large family is evidence that the ancestral spirits are pleased and have protected the family from misfortune. From a practical point of view, large families mean more hands to tend the crops, to care for livestock, to cook, clean and care for the young children and the elders. The survival of the family unit today still is the purpose of *ukama*. For instance, should a man die, his brother will immediately offer to marry his widow in order to provide for her safety and the needs of the children. This tradition of widow polygamy was considered barbaric by the early missionaries and colonials who could not understand the pragmatism of this custom. The widow and her vulnerable children were not left to

Farmer and sculptor, Mackenzie Kapisa, sits with his family on their bountiful maize harvest.

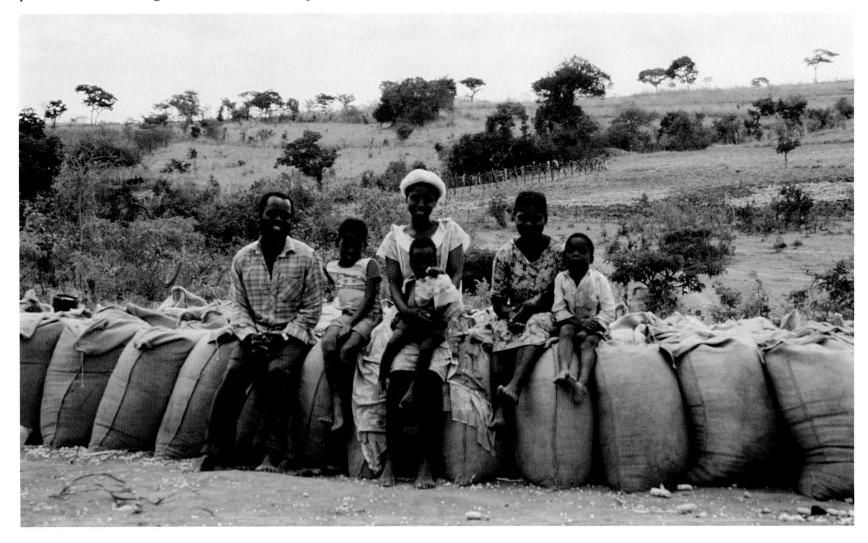

fend for themselves in a harsh environment, but were embraced by the family support system.

In that system, a life-long process of acculturation ensures that children will grow up to respect and honor their elders and ancestors, live humbly, and preserve the traditions that have ensured the survival of their people for more than a thousand years.

knows his or her position. For instance, one's social status increases as the age of one's grandchildren increases. The grandfather and grandmother grow in importance as they become older and even the very youngest toddler, in the scheme of the hierarchy, soon learns that he must respect his six-year-old sister. Understanding these roles binds their culture.

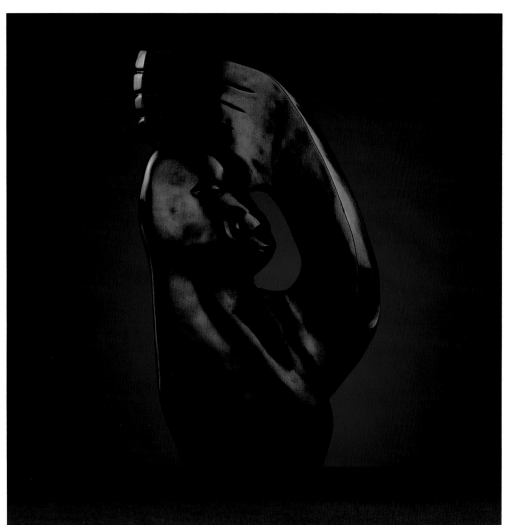

The Salute or Ritual Greeting
David Chirambadare
36"

Shona society is highly ritualized and based on strict adherence to traditional customs and beliefs. Within what appears at first glance to be a simple rural African village, the Shona have developed an astonishing, elegant and elaborate social etiquette that would confound most Westerners.

Life is lived within a strict hierarchy and everyone

In the hierarchy there is no room for arrogance, pride or greed because every member is important to the survival of the community. The old must respect and nurture the children because they are the future; and, the children must also willingly respect the elders because their experience and wisdom will protect and sustain the societal values and family fabric.

THE ELDER

The role of the elder, or grandparent, in family life cannot be overstated. The paternal grandfather, or *sekuru*, is the head of the family. In all spiritual and ritual affairs, he acts on behalf of the family to offer prayers and sacrifices to ancestral spirits. All family problems or disagreements are brought to him to resolve. If a compromise cannot be reached quickly, the aggrieved family members can bring

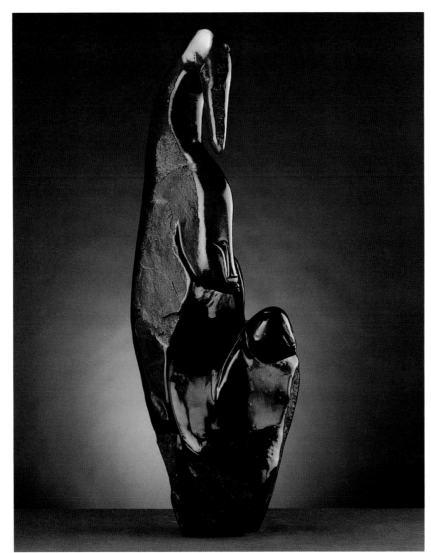

Spirit Elder Protecting The Child
Kennedy Musekiwa
50"

their problem to the more formal family court, or *dare*, over which the grandfather presides. Family conflicts are only taken to a higher council of elders if the *sekuru* is unable to resolve the conflict.

TEACHING THE CHILDREN

From the moment of birth children are carefully taught the beliefs, rituals and behaviors that are expected of everyone in the community.

In general, the rules and rituals ensure that proper respect and deference are paid to those who have earned that respect because of their age, family position or station in life. There are hundreds of specific and carefully prescribed daily rituals that govern all aspects of daily behavior from greeting one another to preparing, serving and eating meals and even to how one sits and addresses another.

Most Shona children who grow up in traditional families spend the first two years of their life in a blanket sling neatly tied to their mother's back. Wherever she goes, the child goes too. The sling or *mbereko* (from *kubereka,* to give birth) represents the womb. The Shona feel that the baby must be carried in some kind of womb because it still needs protection. On the back of the mother, the child's initiation into lifelong *mhuri,* or family bonding and kinship, begins.

Once a child begins to walk and talk, his or her education is the responsibility not only of the parents, but of the entire extended family. Grandparents are particularly influential in teaching traditional values and beliefs, and in some areas it is customary for children to live with their grandparents for several years during their childhood.

The grandfather teaches the boys about their natural surroundings, farming, herding and sexual manners. The grandmother or *ambuya* teaches the girls farming, cooking, weaving, pottery and also their sexual manners.

Social manners and etiquette are taught by the grandparents as well. For instance, looking someone directly in the eyes is considered aggressive and arrogant. So, the children learn to express proper humbleness by averting their eyes.

The simple act of eating also becomes an elaborate statement of social status. Before the meal begins, the

men arrange themselves according to age, totemic status and kin relationship. The older men sit on stones, but the younger men and teenagers must sit on the ground with their legs crossed. Women bring each man a bowl of water for washing his hands and when done, each man claps quickly to signal that the meal may now begin. Sitting improperly would insult an elder's revered position.

Children are also taught the proper way in which to receive a gift. After clapping one's hands together in a thankful gesture, the gift is taken in both hands. This shows the giver that the gift was truly wonderful and too large for just one hand to receive. Likewise, a gift is always presented with the right hand, never in the left as the left is believed to be unclean.

If a child disobeys his or her grandparents, punishment is swift and severe, but it is usually meted out by a parent. The grandparents teach and point out transgressions, but the parents are responsible for punishment, ensuring that the bonds between grandparents and grandchildren remain strong. Grandparents teach by example and also through poems, proverbs and riddles. In *Growing Up in Shona Society*, Michael Gelfand transcribes dozens of proverbs that are familiar to many Shona children.

PROVERB: *Kudada kwavari mugomo kukumbira vari pasi mapfihwa.*

Translation: Hill-dwellers (who have an abundance of hearthstones) mock those who live in the plains (where there are few stones) by asking them for

(Far left)
Child with self-made wire toy
(Below)
Baby wrapped in mother's *mbereko*

hearthstones.

Meaning: The privileged taunt the under-privileged.

PROVERB: *Kufugira mumwoyo rwendo rwembwa.*

Translation: To think secretly is like the journey of a dog.

Meaning: It is foolish not to confide in anyone nor to consult anyone concerning one's decisions.

PROVERB: *Anyumwa bere kurira ndouyo akazora manda.*

Translation: He who is made uneasy by the cry of a hyena is one who has smeared himself with fat.

Meaning: Conscience makes cowards of us all.

PROVERB: *Nzou hairemerwi nenyanga dzayo.*

Translation: An elephant does not

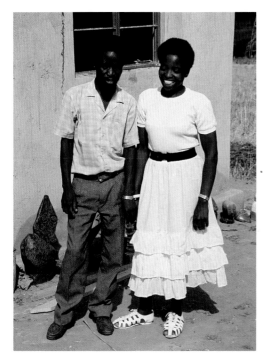

Newlywed sculptors
Leah & Richard
Katinhamure

find it difficult to carry its tusks.

Meaning: A man with many children or possessions shoulders his burdens without complaint.

When the harvest is over and work is less pressing, the evening hours are often spent around a fire singing songs, telling folktales, playing games or posing riddles. While children learn accepted behaviors and beliefs from proverbs, they also learn how to reason by solving riddles.

"Riddle me this: What is invisible, cannot be heard or smelled, is behind the stars and below the mountains, in the valleys and kills people?" "The wind."

"What accompanies you like a mad person?" "Your shadow."

A child's training always stresses humbleness, respect and fulfilling one's duties. These qualities prepare the children for the next step in Shona society: the sacred bond of marriage.

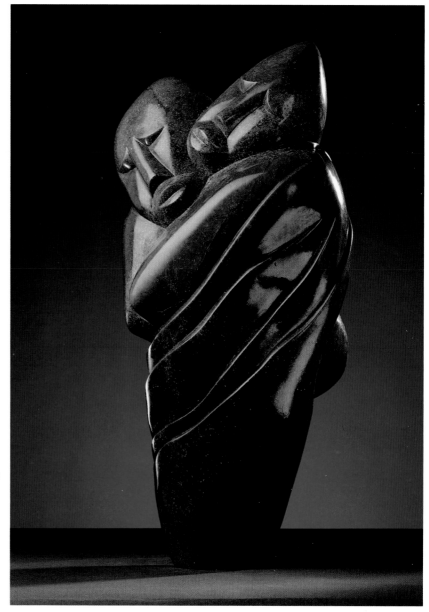

Lovers
Edi Shereni
36"

MARRIAGE

Marriage is probably the single most important ceremony during the life of the Shona. From a young age, the children are instilled with the concept of the sanctity of marriage. Marriage leads to the fulfillment of the purpose of life—continuing the family lineage.

Marrying his wife and fathering his children is a man's greatest achievement. A wife and children give him status in this society and in the family. Without them, all is lost. If his wife dies or leaves him, the husband might cry out in anguish, "I have been emptied." This is the worst possible loss, besides the loss of his children.

BRIDEWEALTH

By tradition, the groom offers *roora* (bridewealth) to his in-laws. Often paid in *mombe*, or cattle, the bridewealth is determined by the status of the wife's family and is intended to appease her family for their loss. The amount is negotiated through family messengers, usually the nephews.

Shona do not view the bridewealth as a crass commercial transaction, but rather as a token of the young man's love and gratitude to his new family. The marriage benefits both families: his because they gain a daughter-in-law who will bring them children and comfort in their old age; hers because the marriage allows her to fulfill her destiny as a 'good woman' and earns the blessings of her ancestors for herself and her family. Together the husband and wife can begin their new roles as adults in the community.

FIRST BORN SON

After the marriage is consummated, it is the wish of every Shona parent to birth a son. This eldest son, or *dangwe*, has the privilege and responsibility for caring for his aging parents and ensuring the safety and livelihood of the entire family. By Shona tradition, the eldest son or the wealthiest member must attend to any family member who needs help. Should problems arise, the eldest son will be called upon first for assistance. This responsibility is shouldered as a privilege, not a burden. Also, when the family elder becomes ill or too old to carry out his duties to the family, the first-born son takes over those responsibilities. If the first-born son cannot act, the responsibility falls to the next son in succession.

Additions to the family are always joyous occasions among the Shona. At the time of birth, many Shona parents name their children for feelings or emotions surrounding the experience. *Tafara* means we are happy. *Fadzai* brings happiness. *Tatenda* expresses gratefulness and thanks. English names such as Lovemore, Gift, Sure Try, God Knows, and Never are also used. One tired mother, exhausted from a difficult birth, named her son Agony.

Wealth within the Shona family is not measured by material possessions, but by the health and joy of the children. All family members share in the care of these precious gifts. As stewards of the future generations, parents, aunts, uncles and older siblings perform their duties seriously in order to receive the blessings of the ancestral spirits. This caring for the family is the most important quality of the 'good person.'

THE GOOD PERSON

Initially good character is a gift from one's ancestors, but if one adheres to the traditional values of honor, humility and responsiblity for the family, he or she further pleases the ancestor spirits and is further rewarded by them.

The 'good person' or *munhu chaiye* is what every Shona strives to become throughout his or her life. *Munhu chaiye* is one who can live with others, is generous with his wealth and time, and helps his

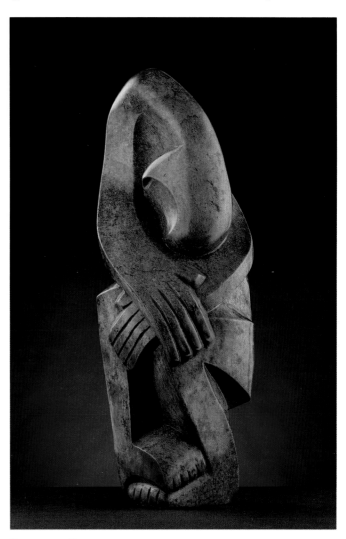

Kuzvipeta (Humbleness)
David Chirambadare
30"

neighbors willingly and without thought of repayment or reciprocation. The good person is never boastful or arrogant. This egotistical behavior would be an anathema to the virtue of humbleness. Being brash or ostentatious is not the quality of a good person. In fact, the Shona strive for *kuzvinyorovesa* which means to soften oneself and not offend others. This behavior ensures peace between family members and neighbors.

Sharing of wealth or riches, called *pfuma,* promotes harmony in Shona society. Hoarding is traditionally discouraged because it causes jealousy between one brother and another, between one neighbor and another. Instead, what one brother has is shared by all brothers. If hoarding or jealousy occurs, it is considered by the Shona an illness that has befallen this person. So, the *nganga* or healer is called upon to cure the poor stricken individual.

While the Shona do possess a material culture, traditionally there is no word in Shona for individual or exclusionary ownership. If one man needs food and his brother has food, it is understood that the food will be willingly shared. Although the concept of personal property is basic to Western society, the Shona prefer to balance the

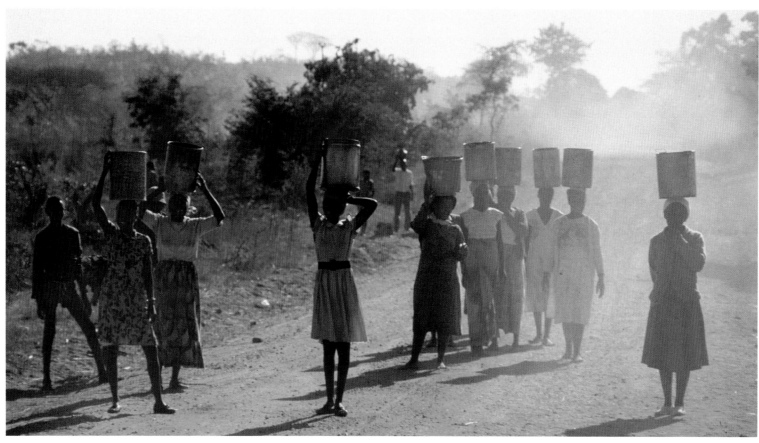

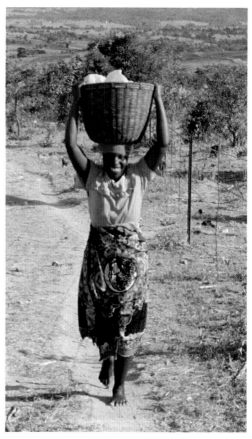

rights of each individual with the needs of the community.

Though the duties of a 'good woman' differ somewhat from a man in traditional homes, many of the qualities are similar. She too is humble, respectful and conscientious about caring for her family and her clan. Although Zimbabwe is a patriarchal society, women have much more authority in the community than might appear. The community is dependent not only on her ability to bear children, but also on her work in the fields and in the home. She tends crops, carries water, cares for the children and the aged, cooks meals and embodies the ancient traditional values.

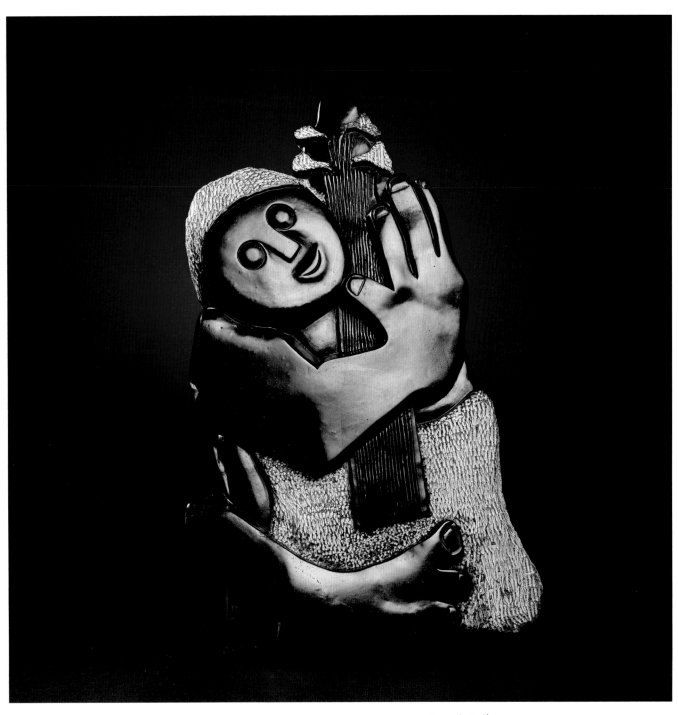

Joyous Guitar Player
Maxwell Agony Shangwa
34"

RUFARO

The good man and the good woman who are happy in their work and content with their lot in life are said to have *rufaro*. Rukodze, the oral historian, explains that "when one has *rufaro* the happiness feels so complete that, at that moment, nothing in the world can hurt or disturb one's spirit or physical well-being."

Acquiring possessions for a better way of life does not necessarily contribute to *rufaro*. That would be *rugare*—having the basic amenities for a comfortable life. While basic comforts are certainly desirable, true happiness and tranquility are only possible when the family is harmonious and the village prospers. The greater harmony of the clan is referred to as *kunzwanana* and exists when all possessions and wealth are shared equally. Nurturing this harmony by striving to be the 'good person' means receiving the blessing of the ancestral spirits and being welcomed into their realm.

SPIRITUAL METAMORPHOSIS

One who has lived life as the 'good person', as defined by traditional values, will most likely become a valued ancestral spirit after death.

When death occurs, the Shona say, "*Munhu wafa*," the human being has died. But when asked about the deceased, the Shona will reply "*Ave mudzimu*," meaning the individual has become an ancestral spirit, the culmination of a life dedicated to *ukama* or the greater good of the family. The deceased relative is not lost to his family, but remains integral to their daily lives as an ancestral spirit.

As David Lan writes in *Guns & Rain*, "All women and men are expected to provide for and protect their families as best they can. Even when they die and leave their bodies in the grave they do not cease to care for their descendants. The richness of their personalities and depth of their experience do not come to an abrupt halt and dissipate for all time. Death is like a weir in the river. For a while the flow of life is held up. The current eddies round and round, and streams back on itself as the processes of dying and burial get under way. But then the weir gates are winched open and the flow of life continues, though now on a different level. Women and men with their limited powers, their ignorance and weaknesses have been transformed into ancestors or *midzumu* who know the future before it happens and can cure every ill. Ancestors make perfect parents. Human life, paradoxically, is greatly enhanced by the ending of it."

The Shona ceremony of death celebrates their spiritual and cultural history by reaffirming their beliefs, pays homage to their ancestors and maintains their community order. Releasing a person into this ancestral realm is the most crucial passage in the cycle of Shona life.

Child Emerging From The Earth
Kennedy Musekiwa
14"

Lovers Tranforming Into Elephants
Shadu Chatsama
14"

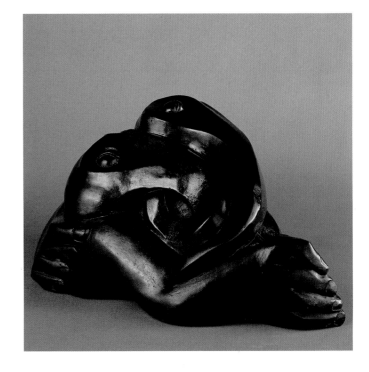

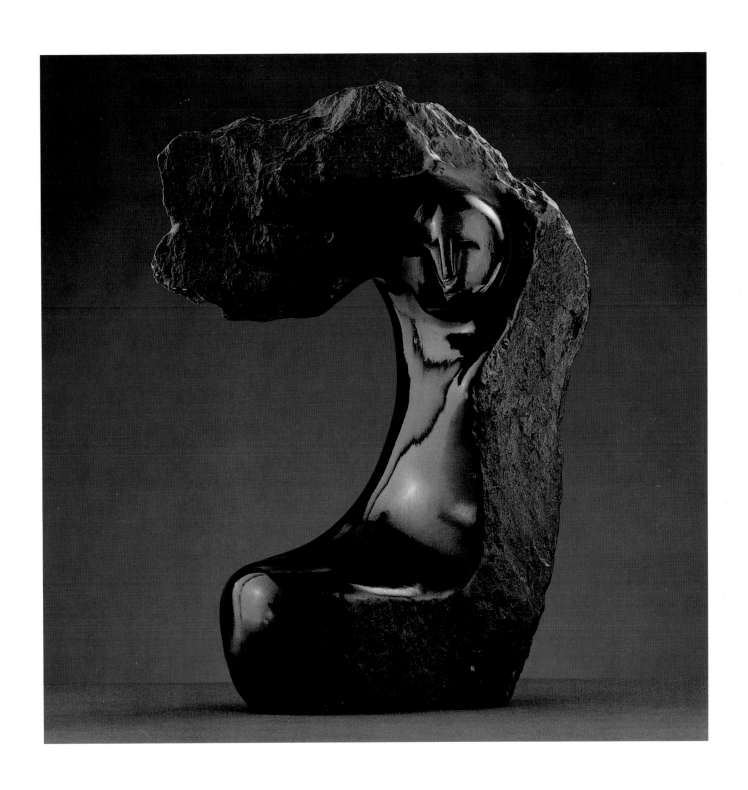

BURIAL CEREMONY

Because the passage from the flesh to ancestral world is such an important one, the rituals associated with death and burial are among the most elaborate and carefully followed. Failure to properly honor a person at the time of death could block or delay the spirit's entry into the revered realm of the *midzimu*.

The Shona believe that you have two shadows—white and black. These shadows separate upon death. The white is considered the *mweya* and represents the soul or the air. The black, *nyama*, is of the flesh. As Lan wrote, "The form an ancestor takes is *mweya*. Ancestors have no material form and so can be in all places at the same time. But they continue to have sensory experience. They can see and hear, they have emotions and desires. But they are never frivolous or mean. The welfare of their descendants is their sole concern."

Acceptance into the spirit realm begins with the all-important funeral ceremony. The intricate ceremony is dictated by tradition and differs from man to woman and also status in the community. Relatives gather from near and far to honor the deceased. Prized cattle are slaughtered and prepared for the feast. The ceremony may last up to three days (a week for a chief), to honor a revered family member. For example,

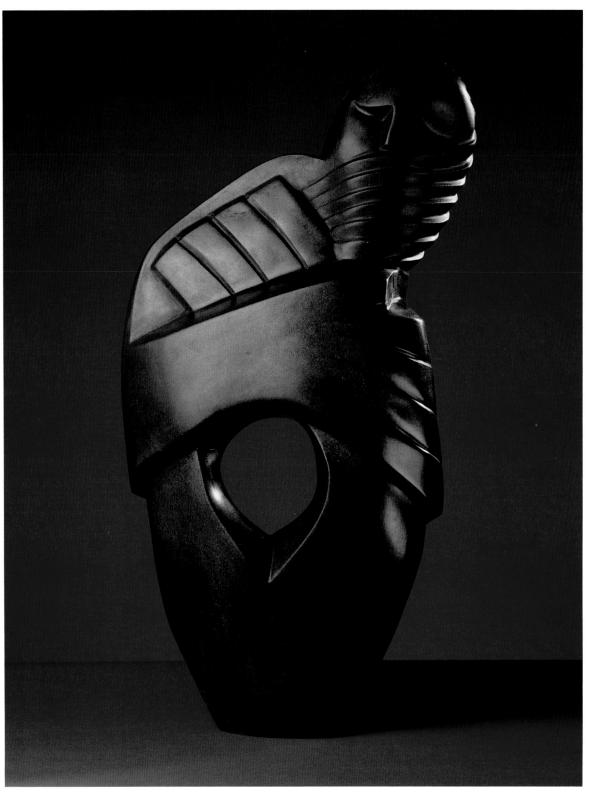

Mweyo Mwando
Raymond Chirambadare
28"

98

when a revered grandfather dies, the eldest son arranges the ceremony and cares for all the family members who attend the ceremony. The burial site is usually situated close to the home. For a chief, the grave must be on a hillside and burial must be in the evening. Other people are buried only in the morning or the afternoon.

During the grandfather's funeral, various relatives play important roles. The widow is never left alone. The wife sits near the body which is washed and kept in the sleeping room for three days. Her mother-in-law and her *sahwira* stay close by her side during mourning. (A *sahwira* is a life-long friend assigned during a ritual ceremony in one's youth.)

The most important role is played by the deceased's *sahwira*. There is singing, clapping, drumming, dancing and celebrating to comfort the family in their loss. A cow is killed by the eldest son or son-in-law in order to feed the mourning family. The *sahwira* dresses as the deceased and acts out all of the deceased's habits and behaviors. This is done so that the family does not feel the loss so greatly. They feel that the deceased is still among them. It offers a gentle transition of separation.

The grandchildren, nieces or nephews, also called *vazukuru*, plan the burial ceremony with the help of brothers and other relatives. The *muroora* or daughter-in-law shoulders all the responsibilities and chores of the wife so she may have time to properly mourn. The *muroora* cooks, cleans, tends the fields and cares for the children during this mourning period.

Traditionally, the body is prepared for burial by being wrapped in a blanket. Then the *rupasa*, a reed mat used in daily life for sitting and sleeping, serves as the funerary wrapping. The modern urban Shona place the body in a white gown which cannot be touched by needle and thread. Instead, holes are cut into the shroud and torn strips of material are used to bind the gown to the body.

During the procession to the gravesite, friends of the deceased sing and clap to honor the deceased's spirit while the family mourns freely. Leading the procession, the daughters-in-law sweep the pathway with traditional brooms called *mitsvairo*. In some instances, the daughters-in-law precede the deceased by walking on their knees and carrying a pot of water, or *hari*, on their heads.

If able, the mother of the deceased accompanies the widow and stays by her side throughout the procession. The *sahwira* may also be chosen to accompany the widow. If a man dies, his male friends and brothers carry the body. If a grandmother dies, only the *vazukuru* and male relatives may have this honor. It is also their duty to place

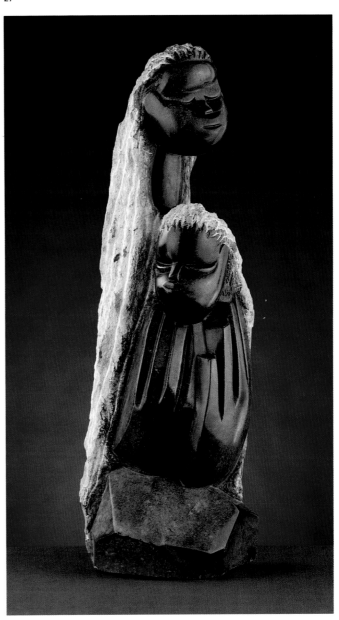

The Sahwira
Luxon Karise
27"

the body into the grave. If the deceased is a twin, the surviving twin is not allowed to witness the burial.

The eldest son assumes the role of the father and can share the responsibilities of the funeral with the oldest remaining brother of the deceased. Thoughout this process, the men organize the ceremony and the women carry out the tasks, except for killing the ceremonial cow. That is the duty of the eldest son or son-in-law.

The body then is buried in a shallow grave near the family home. A relative of the deceased, appointed in charge of the burial ceremony, will visit the grave from time to time looking for a sign that the *mweya* or soul has been accepted into the spirit world. If all is well, the *mweya* will appear as a *chihonye*—a worm, that awaits discovery upon the grave. That is the first sign. The *sahwira* will visit the grave repeatedly over several months to check on the worm. If the worm has crawled away unmolested into the bush then the *sahwira* can report to the bereaved family that the deceased has finally been accepted into the ancestral realm and ill-fortune will not befall the family.

Although the *midzimu* are unceasingly generous and concerned only with the welfare of the living, their protection is not automatic. It must be won by performing certain rituals, the most important of which is *kurova guva*—the procession to the grave. This must be performed within one year from the death. The *kurova guva* literally means "to strike the grave." It is the process through which the spirit of the deceased is united with the ancestral spirits of the clan. Only after this ritual will an ancestor perform its destiny or *vanotichengeta*—to protect the living family. The ceremonial beer, *hwahwa*, must be brewed from time to time and distributed in the ancestor's name. By this act, the *midzimu* is assuaged for it will feel revered.

Children who die or adults who die childless are not integrated into the *midzimu* or protective spirit world. At their death the *chihonye* or spirit worm does not appear at all nor does anyone look for it. With no

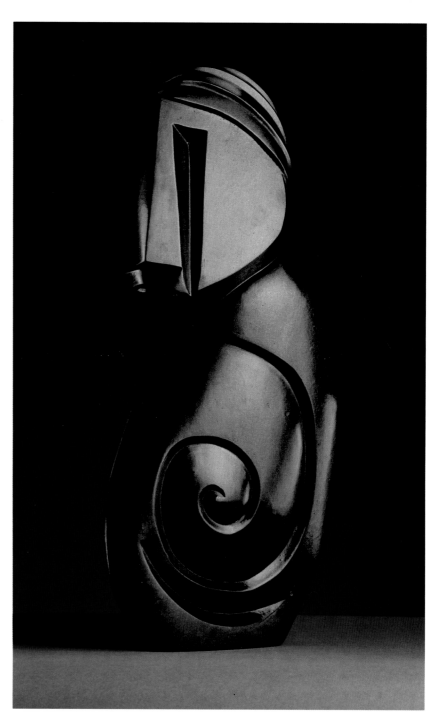

Ancestor in Spiral Time
Moses Masaya
30"

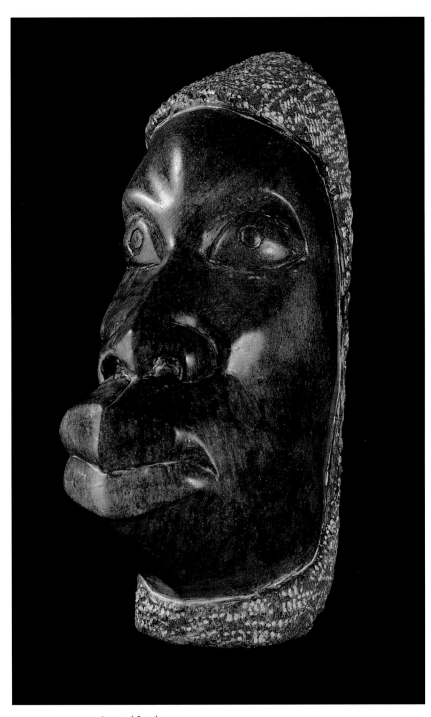

Ancestral Guardian
Boira Mteki
18"

descendants, there would be no point in attempting to express a continued existence. However, if these childless people are discontented or offended in some way, they enter into the realm of the aggrieved spirits or *ngozi*, a term which also means a disaster or revenge. These angry spirits may choose to wreak havoc and ill-fortune upon the living. Because of their evil deeds, another category of people who cannot become ancestors is the *muroyi* or witch.

Upon acceptance into the spirit world, the ancestors cross into a new dimension that transcends time as we understand it. This is the dimension of spiral time. Here, the past, present and future exist simultaneously in what the Shona refer to as 'now' time. All people and spirits exist in the 'now', not the past or the future. For the past and the future is all a part of the 'now'.

This is an important concept for the Shona, and a most difficult one for Westerners to grasp. While acknowledging its usefulness in daily life, the sole existence of linear time progression as structured in our Western Gregorian calendar is not their only understanding of time. Rather, time circles for them in an unbroken spiral. Material reality and spirit are not conceived of as separate existences. On the contrary, everything is felt to be in a state of cohesion, of unity, as if the cosmos were a sea of fluid forces vibrating and manifesting themselves in particular times and places, and in specific ways, of which material manifestation is only one. Comprehending this dimension of time is most confusing to Westerners familiar only with a simple linear concept. However, the spiral dimension explains much of the point of view of the Shona mind and of its complex spirit world.

Understanding these Shona concepts, ranging from the spirit world to their intricate social structure, offers a tantalizing glimpse into a rich cultural tapestry. Shona is far more than just a religion or a people, it represents both an ancient culture as well as a present-day way of life.

MODERN ZIMBABWE

The multiple stresses of modernization, urbanization, industrialization and liberation have all placed pressure on the traditional values. They are creating life changes in Zimbabwe at a dizzying rate. The Shona, through their deep spiritual beliefs in the extended family or *ukama,* are striving to preserve those same values and traditions that have ensured their cultural integrity for more than 1000 years.

Once startled at the rapid erosion of traditional values among the young, Rukodze, a direct descendant of the Monomotapa King, is pleased that today Shona history and cultural values are being emphazised in schools throughout Zimbabwe. He feels that this important action will ensure that future generations can call upon those ancient beliefs to help them untangle and place in perspective the increasingly complicated and encroaching world around them.

Change and outside influences are no stranger to the Shona. It would be naive to believe that they ever existed in a hermetically sealed cultural universe. They have, in fact, been influenced over

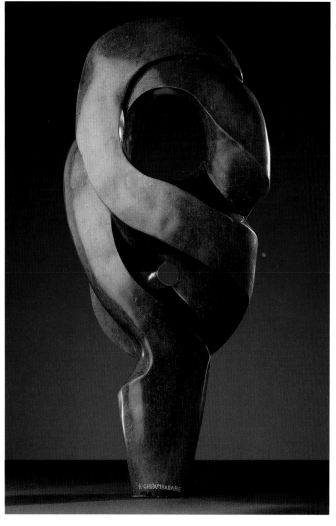

Kunzwanana (Community Harmony)
Richard Chirambadare
44"

hundreds of generations by other peoples, such as Arab traders, and more recently, our Western world. However, it has been the continuation of Shona traditions—*ukama* and *kunzwanana*—which up to now have maintained their cultural integrity. The Shona believe that change itself is not an evil. But the ability to maintain the important elements and spiritual core of one's culture can, in the face of precarious change, steady one's course.

The urgent challenge is to reconcile the two cultures—modern and ancient—and recognize their new dependence on each other. One does not preclude the other, and it would be unrealistic and retrogressive to assume that all new influences are counterproductive.

In the past, many developing nations sacrificed the very soul of their traditional culture at the altar of Western modernism. It is so very encouraging to see a young nation like Zimbabwe honor its heritage, while melding it with a modern tomorrow. The old and the new both have their place in Zimbabwean society, and the safeguarding of the traditional values will ensure a strong future foundation for them to participate in the New World Order.

Modern Zimbabwe has many challenges yet to face. While acknowledging the importance of traditional culture, it is too easy to romanticize its place in 20th century Africa.

Zimbabwe has now begun a vigorous and expanding campaign for family planning and managing the development of the nation's precious resources. The challenges faced by the government are clearly enormous. But it is committed to the attainment of an egalitarian state, with a more equitable distribution of wealth and natural resouces, not unlike the time honored tradition of *ukama.*

102

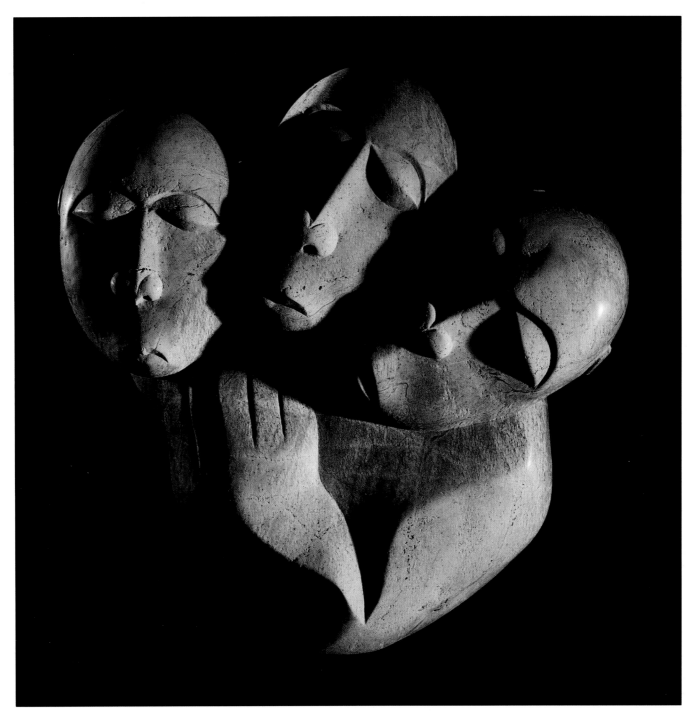

Ukama
Francis Mugavazi
15"

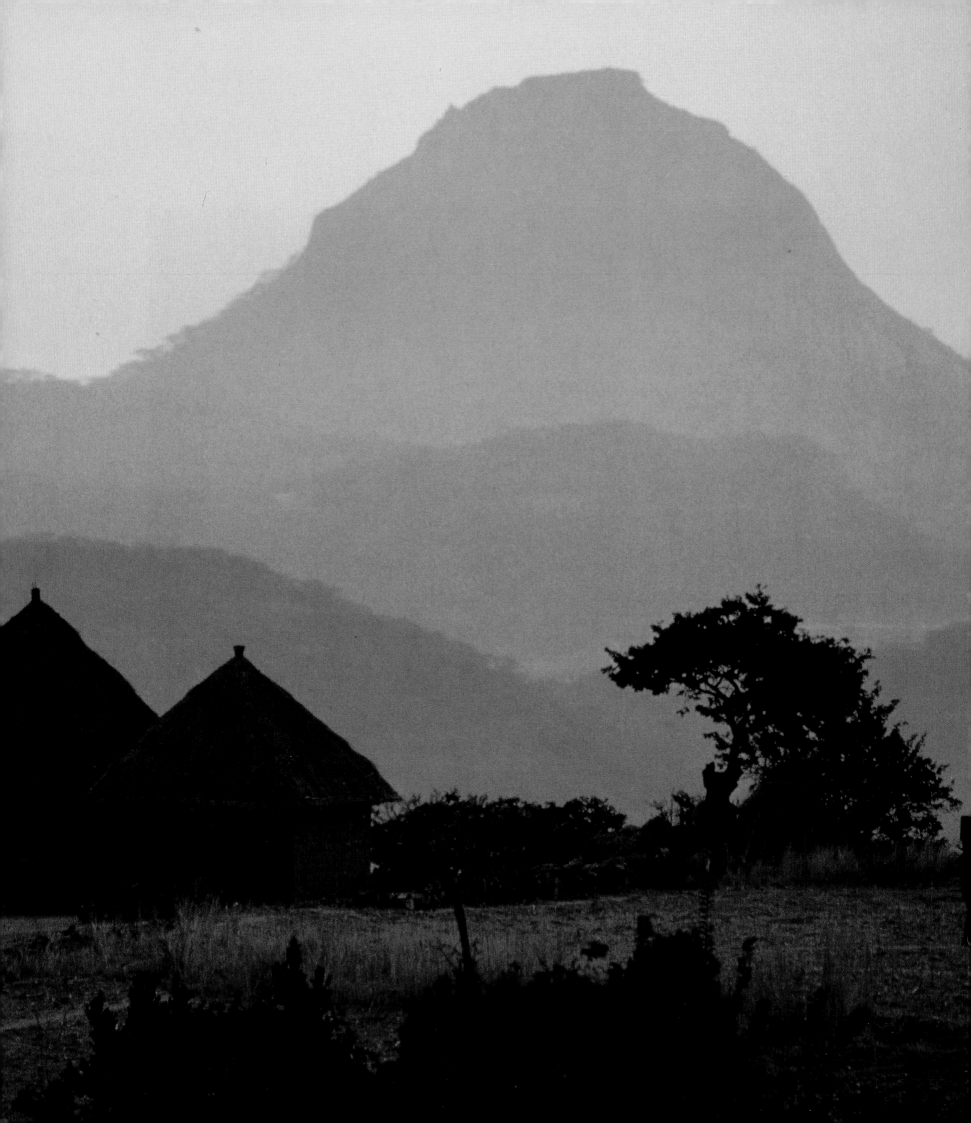

"Vukuzenzele!"
"Wake up and help yourself.
Make this drought-stricken patch of bush
into a working farm!"
—Patricia Cheney
The Land and People of Zimbabwe

DAWN TO DUSK

DAWN BREAKS on the Zimbabwe savannah with the melody of birds awakening to a new day. Before the sun is on the horizon, soft voices join the songbirds as the villagers begin their day's work.

Always there are meals to prepare, buckets of water to fetch, children and elders to care for and crops to plant, tend or harvest.

In Zimbabwe there is a saying: If you want to plant something, throw down the seed and jump back quickly or you will be struck in the face by the sprouting stalk.

When the rains come in November—if the rains come—the land produces bountiful harvests. Then the garden markets burst with the color of golden maize, green rape or chard, coffee and spices. Baskets are stacked with apples and oranges as well as the rich brown baobab fruit, amber pawpaws and fresh-cut plantains.

Nearly 80 percent of Zimbabweans live in rural areas, going about their daily lives in much the same way that their ancestors did for centuries. However, in areas where arable land is scarce, men have been forced into the city to find office and factory jobs. Women have long helped tend the crops, but in recent years many have taken on more responsibilities on the farms.

Despite growing urbanization and industrialization, the farmer remains the heart of Zimbabwe.

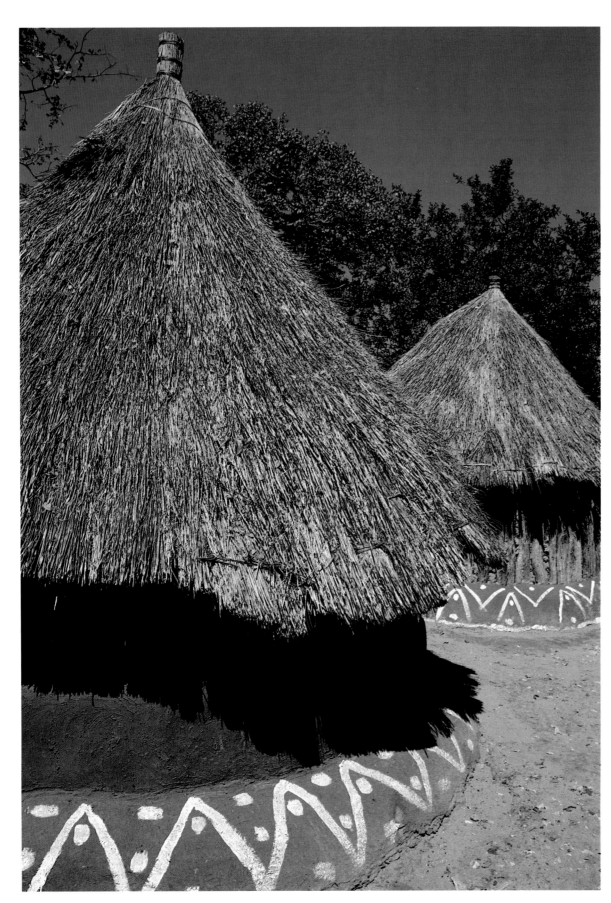

Traditional *imbas* or round thatched houses, are constructed with mud, wood poles and grass thatching. Each *kraal* or grouping of family *imbas* consists of structures for specific purposes: cooking, sleeping, storage, and so on.

The duties of the day begin at the new communal well, where typically the women pump for safe, clean water and carry five-gallon water cans back to the village. The trip—a distance of several kilometers—may be repeated a number of times.

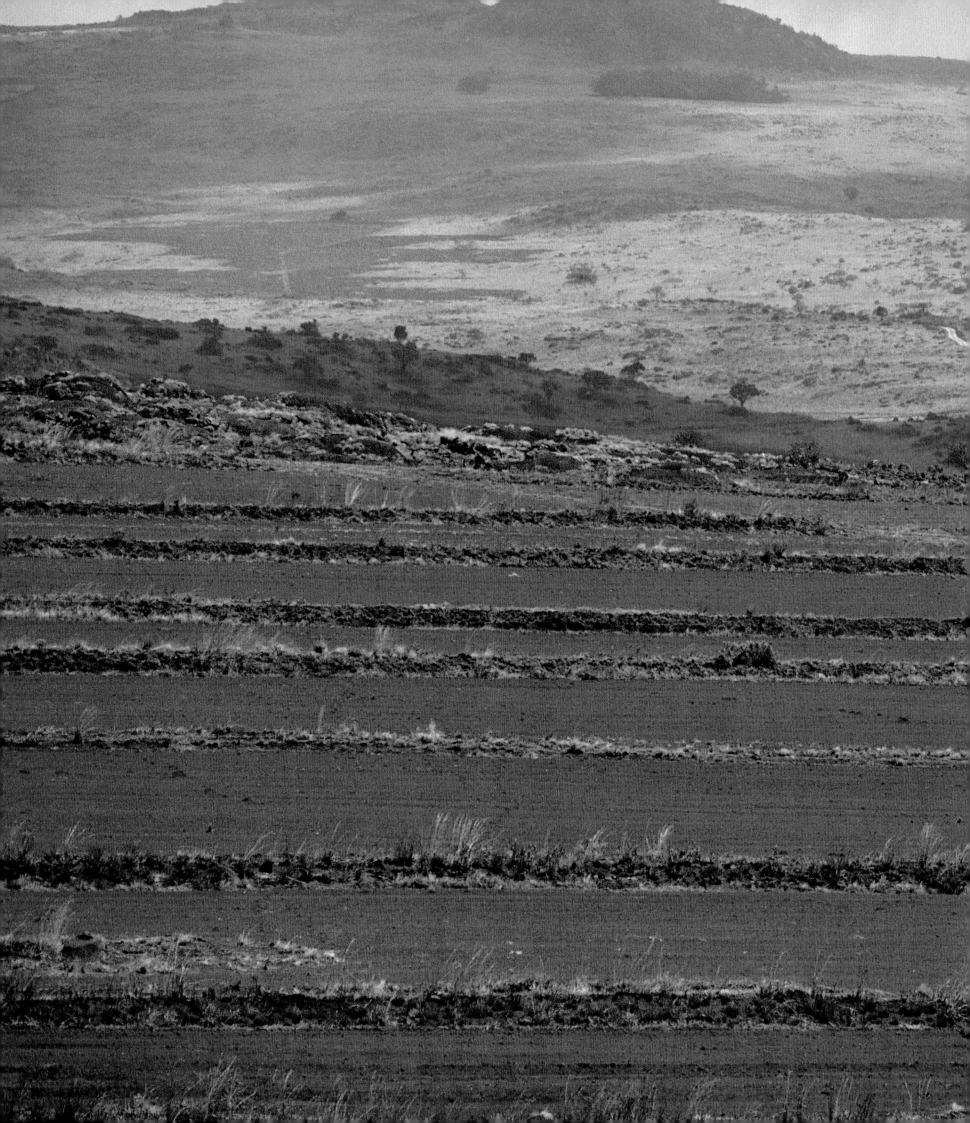

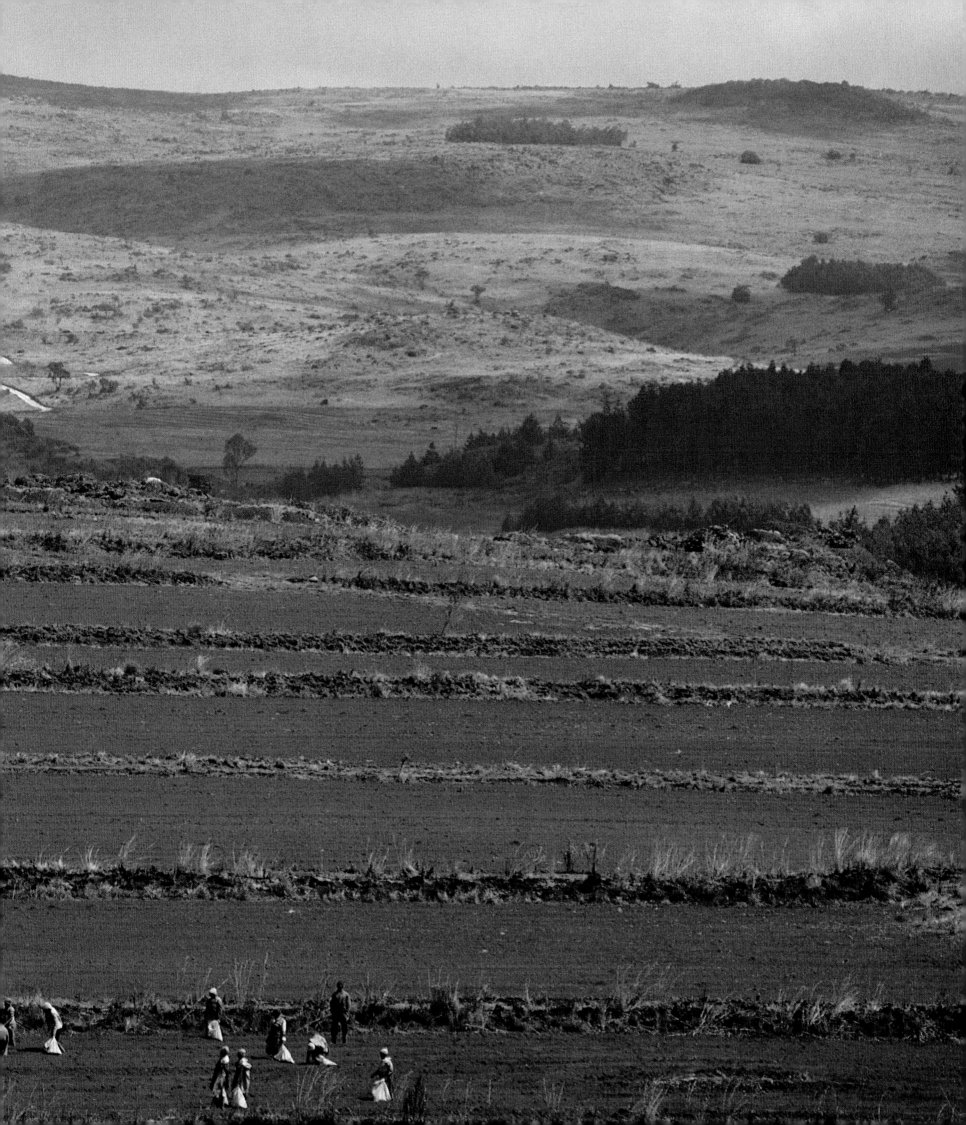

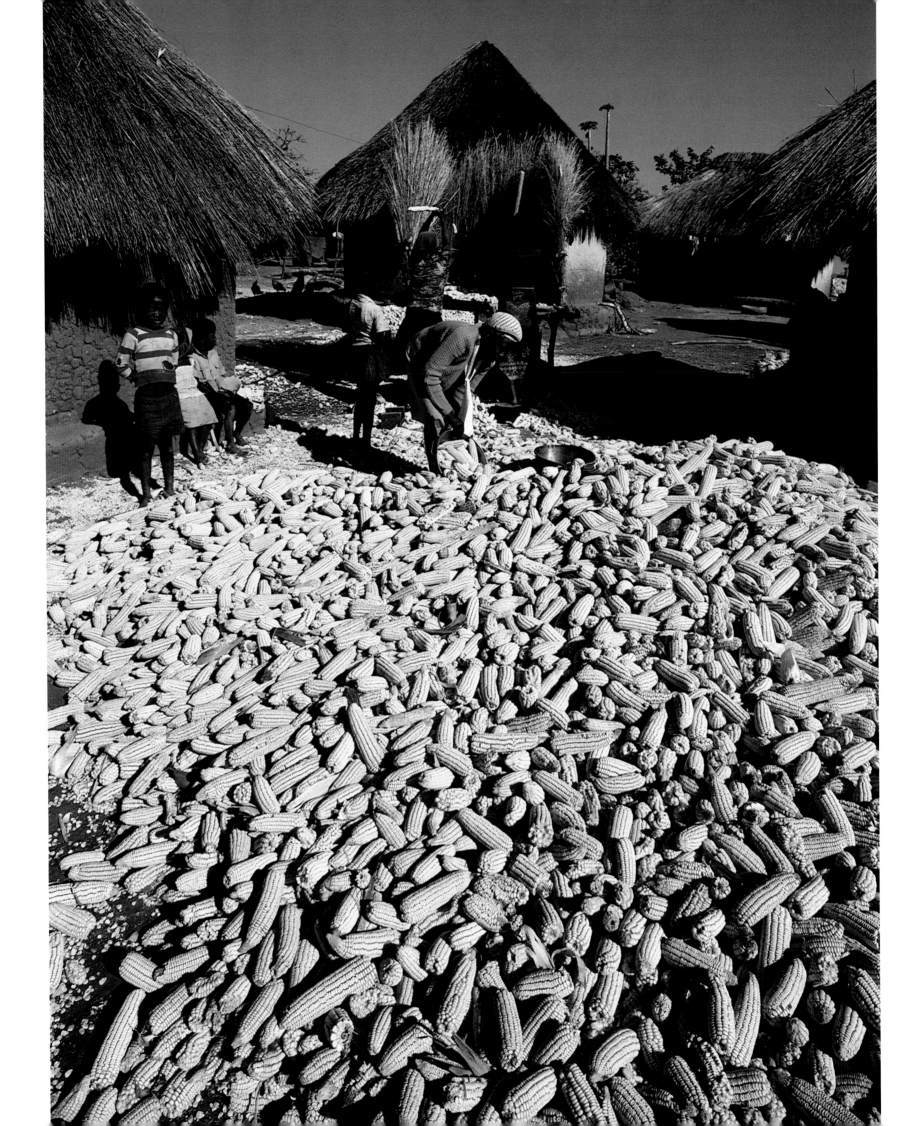

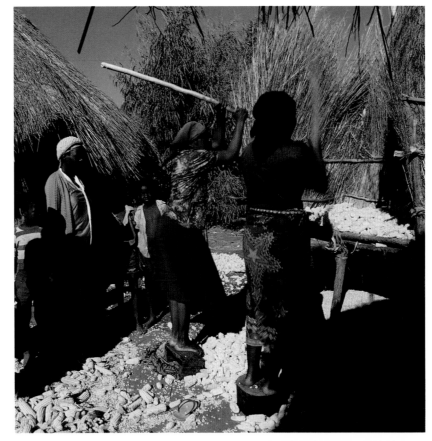

(Preceding pages)
After a successful season of rain which produced a bountiful harvest, the women prepare the iron-rich soil for a new crop of maize.

(These pages)
The maize is threshed and the kernels pounded into mealie for cooking traditional *sadza*, or porridge, the staple food.

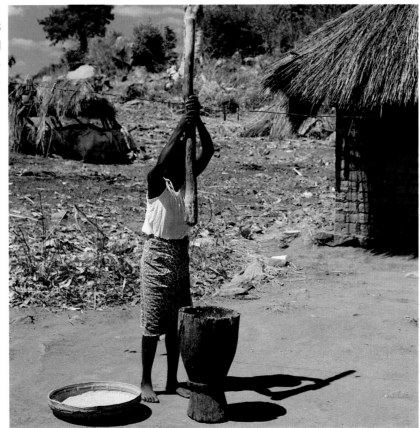

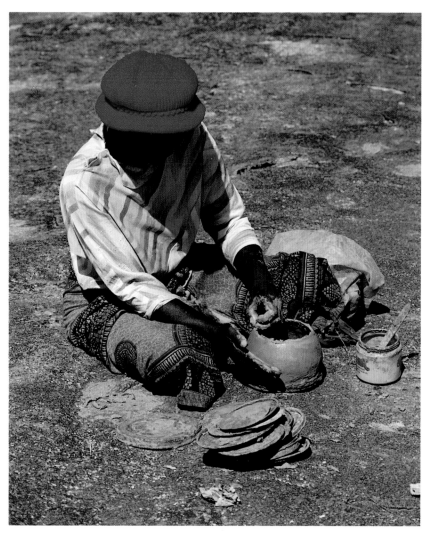

(Left)
Potting in the traditional manner.

(Below)
Hwahwa pots neatly stacked inside the *imba* ready to brew the ceremonial beer.

(Right)
Delicate fingers neatly weave a grass basket in the ancient fashion.

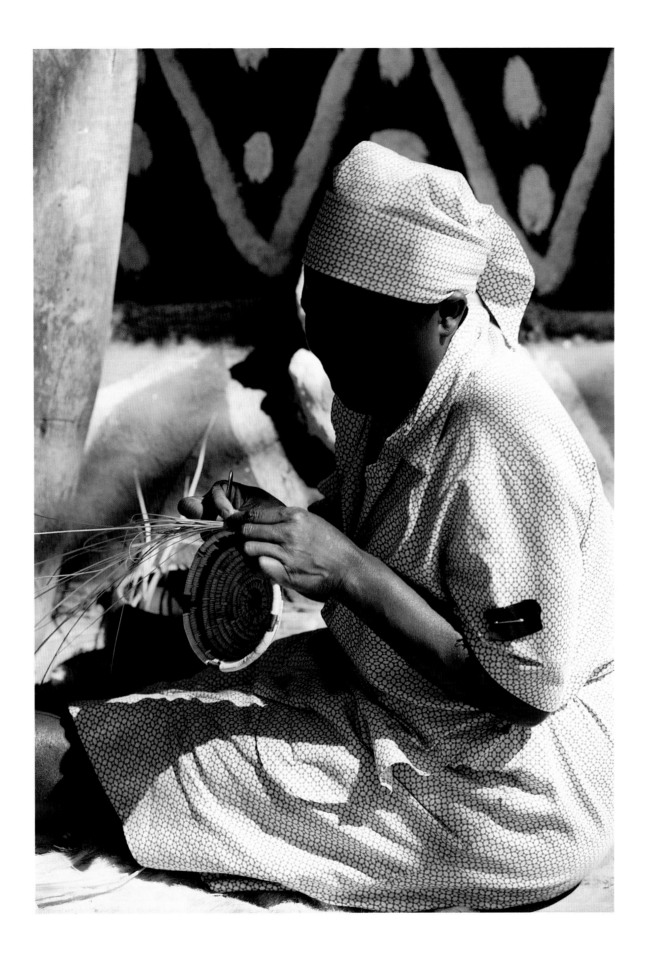

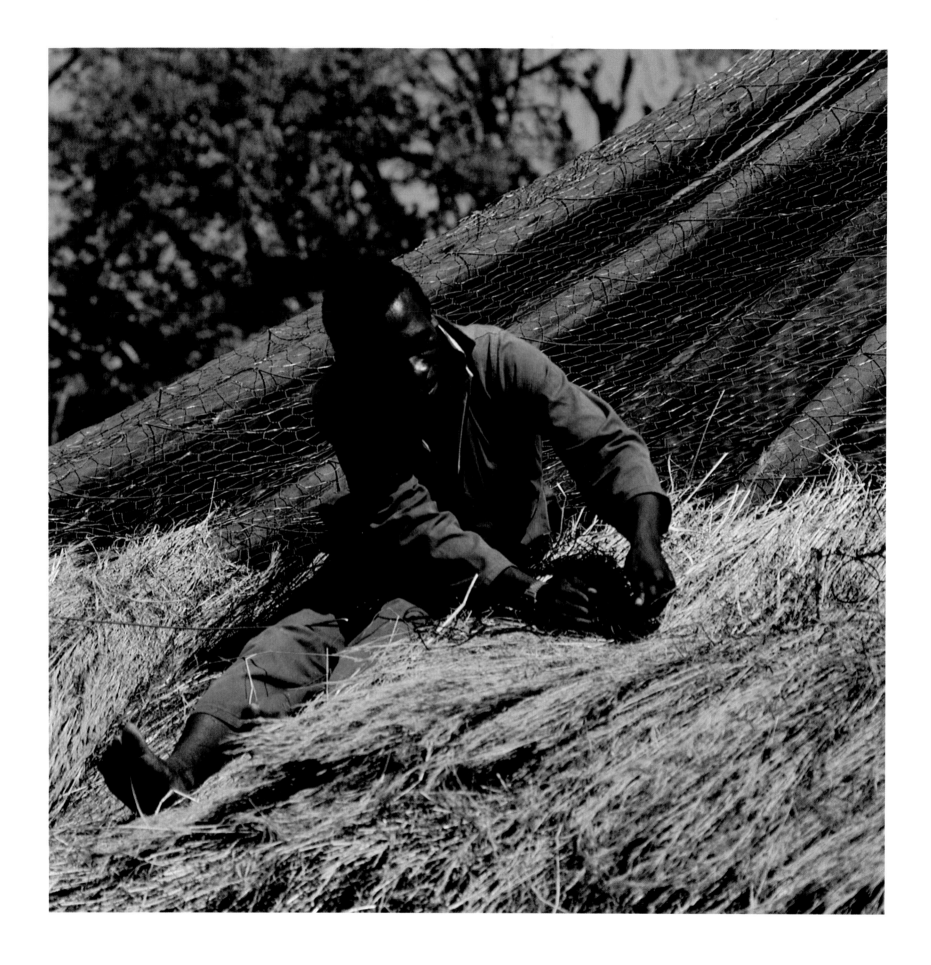

116

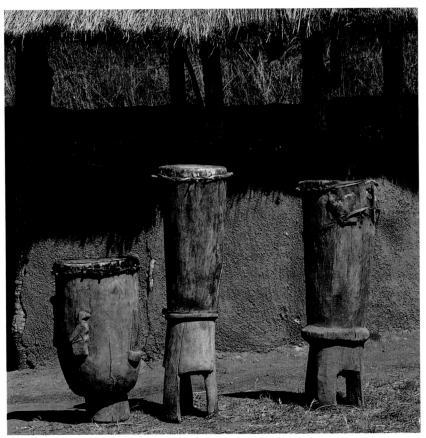

(Left)
Traditional wood
and cowhide drums
awaiting the next
ceremony.

(Right)
Woven fishing
basket, net and
hwahwa ladles
made from gourds.

(Left)
Thatching the roof
of the village *imba*.

Abundant home-grown vegetables, fruit
and spices sold at an open marketplace,
a common sight throughout Zimbabwe.

120

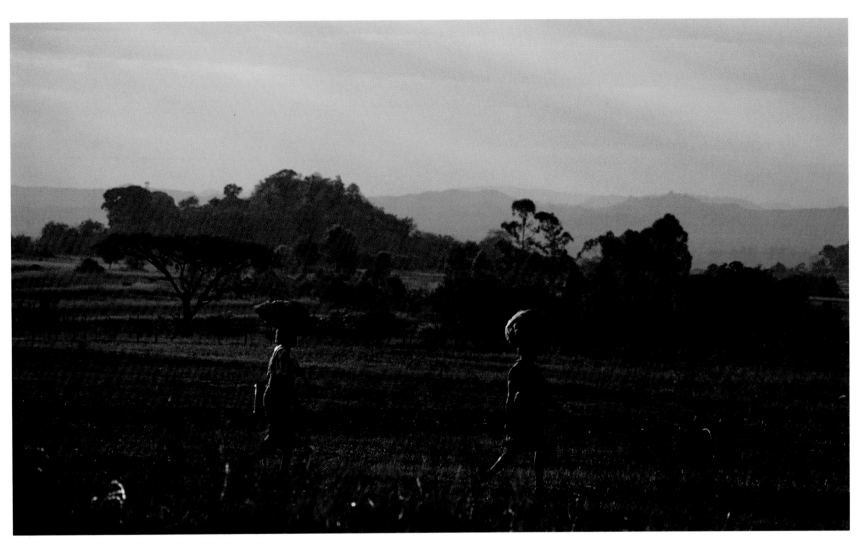

From the farmers to the market-sellers and
on to the buyers, the harvest produce finds
its way home.

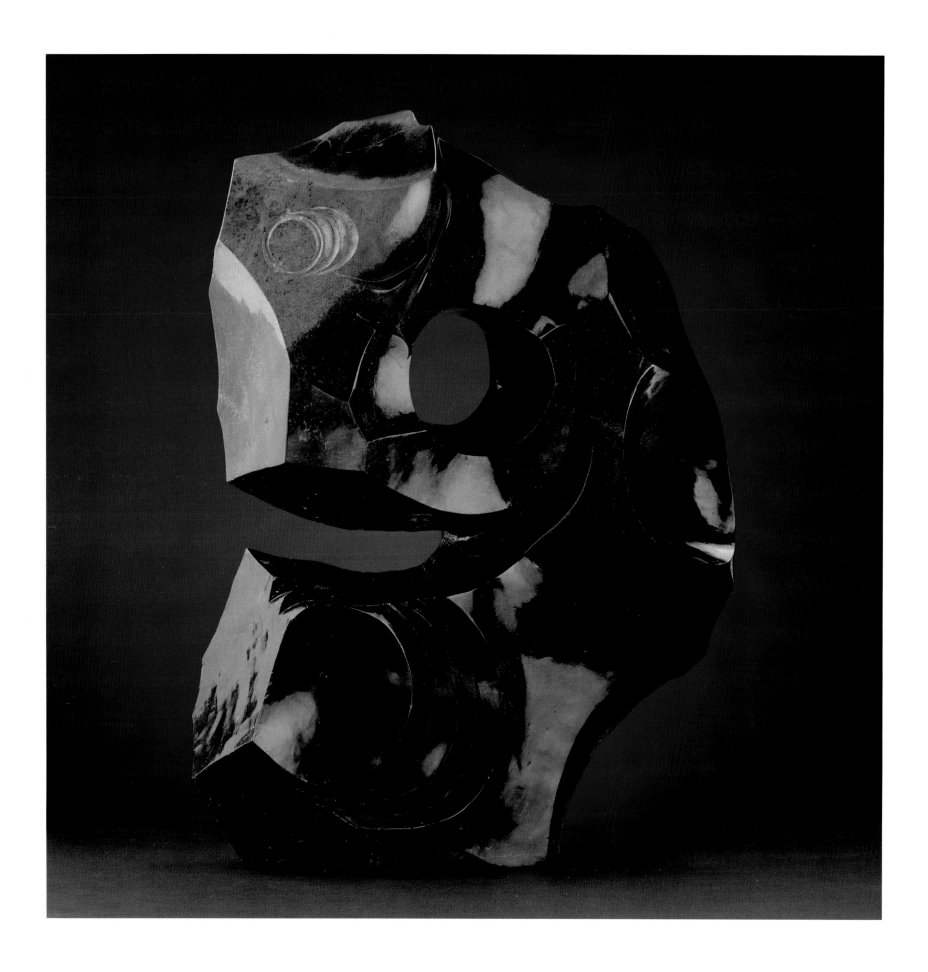

"All things are destined and controlled. For outside the forest, in the Beyond, are the powerful spirits of our Shona ancestors. They will always influence our lives."

—Bernard Takawira
Shona sculptor

THE SPIRIT EMERGES

T ODAY POWERFUL ANCESTRAL SPIRITS are still at the very core of traditional Shona life. These spirits are the nucleus of the family and the extended community, guiding every aspect of Shona life, from the most mundane to the most spiritual. Imbued with knowledge of the past, present and future, the ancestral spirits talk to family members in dreams and guide them on a path to a moral and spiritual life.

Dreams not only guide one's behavior, the artists say, their dreams also influence their sculpting. Through the sculptor's dreams, the ancestors reveal the spirits in the stone.

I am interested in spiritual figures. This is a belief originating from our ancestors, that maybe through them we can have our problems solved.

Great Chapungu
(God's Messenger Eagle)
Lucky Mupinga
48"

125

The same goes for art. If you want to do something, you pick up a stone, think about your spiritual ancestors, then you start working on the stone. An idea comes of it.
　　　—Victor Mtongwizo, third generation sculptor

Paradoxically, ancestral spirits are not the only sources of inspiration for the sculptors. Many times the spirit of the stone speaks directly to the sculptor, without aid of a spiritual intermediary, and enables the sculptor to chisel away the stone that does not belong.

Sometimes I follow stone, sometimes I force it. Every part of the stone, there is a sculpture. I take the dead out of the stone and find the sculpture.

Though Lazarus Takawira's words seem to echo Michelangelo's when he spoke of "liberating the figure from the marble that imprisons it," Lazarus goes further to describe the spiritual force that creates the sculpture:

Let me go back to the roots of the Shona. You see in our tradition, there is a spirit called the water spirit. Let's say I have the form of the water spirit (in my head). I get a piece of stone . Then I start working with the water spirit, with the stone. Imagine thinking of the water spirit into that stone. Then this time I'm forcing that stone to make a water spirit. But, you see, if that water spirit doesn't talk to me, it means it's not a water spirit. I change the title.

You see what will happen if it is the water spirit itself, the stone is going to come to me and say that is the water spirit.

If the sculpture doesn't talk to me, it means it's not a good thing. I break it into 15 pieces, then I make another one and I forget about it.
　　　—Lazarus Takawira, second generation sculptor

The artists do not experience angst in the creative or carving process. When a sculpture does not emerge,

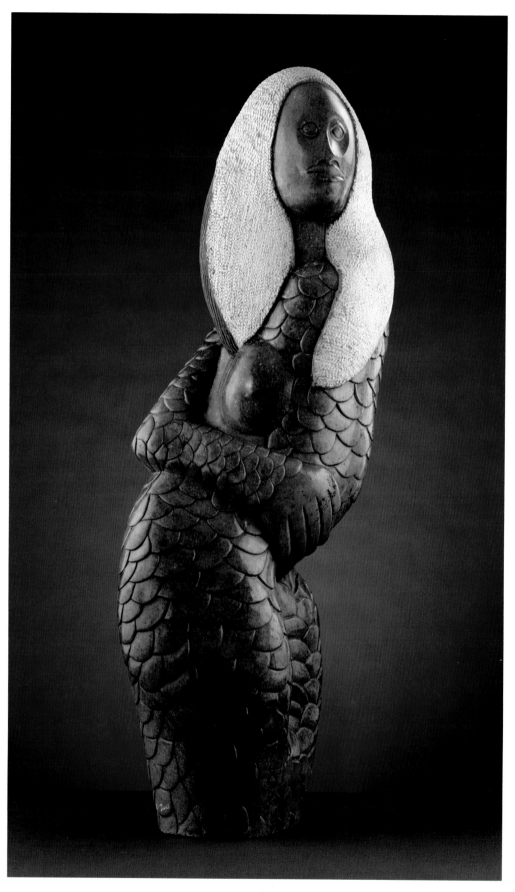

it is simply cast aside. There is no regret. When a carving exploded during the firing process, destroying more than a month of work, artist Crispin June Mutambika said simply, "It wasn't meant to be." Shrugging off any disappointment, he picked up another stone and began anew.

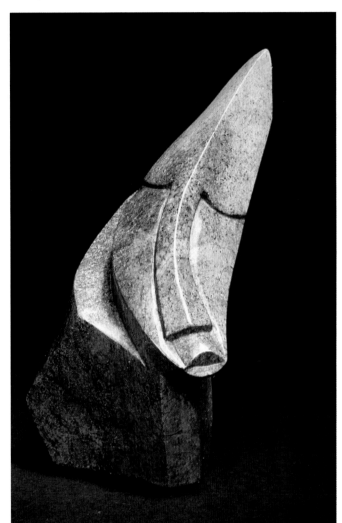

Spirit Rising
Obert Marime
12"

THE STONE

The landscape of Zimbabwe is dramatic and colorful: the steel grey and tawny streaks of the kopjes, the red plateaus, the gold dry grasses on the lowveld, the violet-blue of the Eastern Highlands as seen from a distance and the emerald grasses on the banks of the Zambezi near Victoria Falls.

(Opposite)
Njuzu or Water Spirit
Crispin June Mutambika
60"

Well traveled footpath skirts one of the many natural rock formations that abound throughout Zimbabwe.

Just scratch the surface and all of these colors and more are found below ground. From scintillating white granites to brilliant serpentines—reds, greens, maroons, greys, yellows and strong oranges—the country is a depository of incredible mineral wealth. It is the complex combination of these minerals that create the colorful palette so unique to Zimbabwean carving stone. Leaching through the strata over millions of years, these minerals melded one into another. This produced a myriad rainbow of color variations throughout the countryside. To date, over 200 different stone colors have been geologically catalogued in Zimbabwe.

The hardness of the stones ranges from soft soapstone (1 out of 10 on Moh's hardness scale, 10 being a diamond) through tougher serpentines in the 2 to 5.5 hardness range and onto granite at 6.

Naturally abounding in the landscape, the colorful carving stones, unsurpassed in all the world, also include rare semiprecious verdite. Also known as Africa's green gold, verdite is prized for its rich, deep emerald color, swirling striations and hardness that rivals rubies.

Forming the backbone of the country is the Great Dyke, a 310-mile ridge of 2.5 million-year-old hills laced with chrome, platinum, gold, copper, emeralds and other precious minerals. The dyke stretches from the Guruve Region in the northeast to Mberengwa in the southwest. Some believed this fabulous repository to be the fabled wealth of legendary Ophir. Though many came looking for gold, most were disappointed. The gold never lived up to expectations, but the carving stone is plentiful. Everywhere one looks the rocks and stones abound. For a sculptor, Zimbabwe offers unlimited resources of stone, color and inspiration—a perfect crucible for artistic creation.

SELF-TAUGHT SCULPTORS OF ZIMBABWE

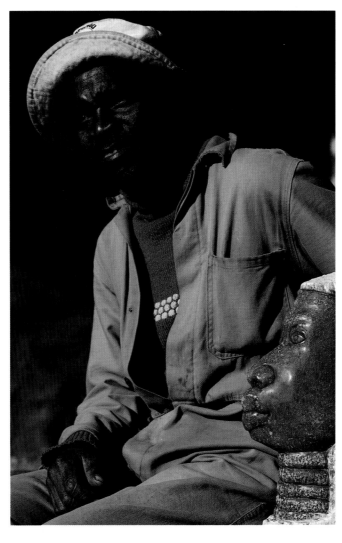

Boira Mteki, first generation sculptor, and also one of the first Shona sculptors to be exhibited at the Musée Rodin, Paris.

When one looks at great Shona sculpture—its powerful mass, sharp edges, delicate balance, straight masterful lines—the technical mastery of the one who carved it is obvious. Admiration turns to incredulity and awe when one realizes the context in which it was carved. Despite the incredible proportion and balance many artists achieve, there is no pre-sketching, pre-drafting, or pre-shaping of their work. It issues from deep in their mind's eye. Many of these carvers, working outside their rural *imbas*, simply sit in the dirt and begin with a crude tool in their hands and a vision in their head.

"We celebrate here the highest achievements of Zimbabwean artists who over the years have struggled to attain skills without any formal training," states Dr. Joshua Nkomo, vice president of the Republic of Zimbabwe. "Like Brancusi, Michelangelo, and like Moore, the sculptors of Zimbabwe have established their own direction, but without formal art education."

Even today, there are no formal sculptural art schools or classes in Zimbabwe of any importance. The University or the National Gallery of Zimbabwe might offer some occasional art classes, but nothing on the formal basis of a Western art school that demands years of apprenticeship and formal undergraduate study.

The sculptors, with their natural talent and ability, would be confounded at such a contrived and formal process. Instead, the spiritual nature of the sculpture, which Western artists anguish to return to, flows freely.

Generally referred to as Shona scuptors, the stone artists of Zimbabwe have always included people who have come from neighboring countries such as Malawi, Angola or Mozambique. Some critics argue that the term Shona sculpture is therefore a misnomer since it so closely defines only one ethnic group. Instead, this art movement should be called Zimbabwean stone sculpture. Carver and oral historian Edronce Rukodze disagrees.

Though a small fraction of the sculptors may have been born in other countries, he said, most have lived in Zimbabwe for a generation or more.

We speak the same language. They were born here, grown here and live their culture here. Also, they crossed cultures because their fathers married our sisters which means they are now Shona. So, there is nothing like any mix of culture. The sculpture is totally Shona.

— Edronce Rukodze, second generation sculptor

FIRST GENERATION SCULPTORS

Moses Masaya

(Far Right)
Henry Munyaradzi

(Center)
Bernard Matemera
with *African Queen*, 30"

Stones have been carved
in Zimbabwe for a thousand years or
more, but the carvers lived and died in
anonymity, their passing marked only
by the stone monuments they left behind.
Public recognition of the sculptors
came in the mid-twentieth century.
Those who first attracted international
attention in the 1950s and 60s are
known as *first generation sculptors,* while
the younger sculptors of today are part of
the second and third generations.
A more complete listing of the three
generations of Shona sculptors can be
found in the Appendix.

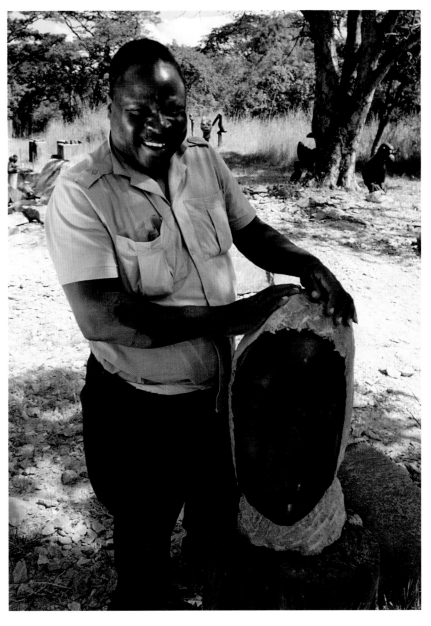
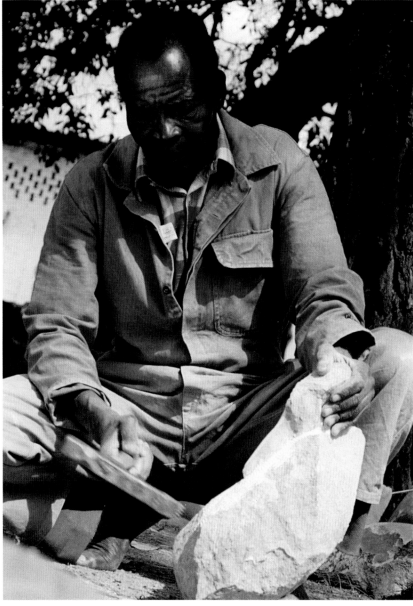

(Right)
Peter Mandala

(Far Right)
Philip Mseteka

(Below)
Lazarus Takawira

(Below Right)
Albert Mamvura

SECOND
GENERATION
SCULPTORS

132

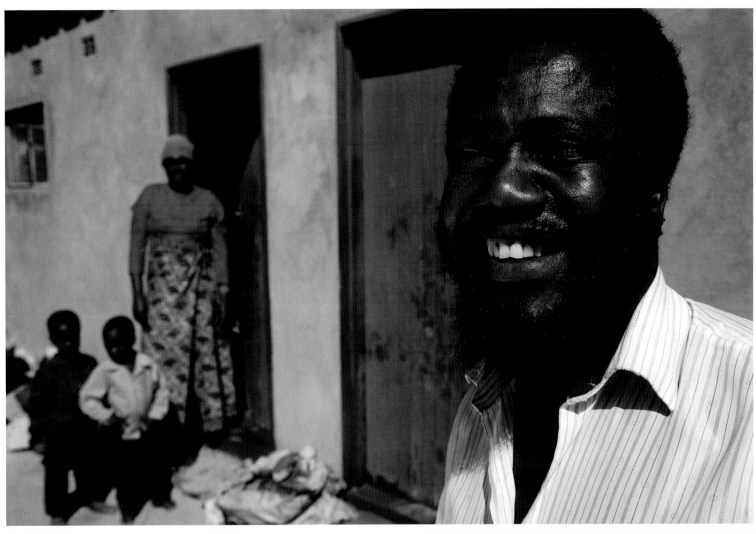

(Above)
Edronce Rukodze

(Left)
Phineas Kamangira

(Right)
David Gopito

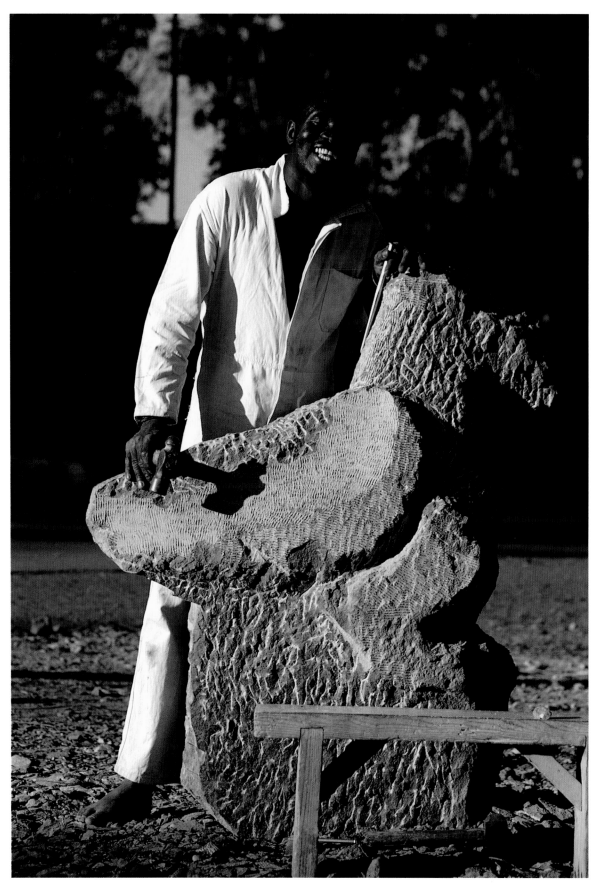

Richard Mteki

THIRD
GENERATION
SCULPTORS

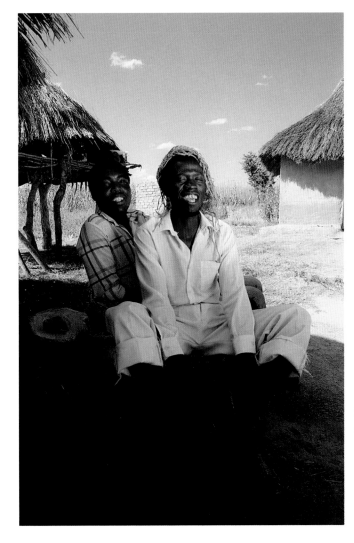

Sure Try Katinhamure
and Lovemore Chitaunhike

(Upper left)
Obert Marime

(Lower left)
Ernest Chiwaridzo

(Upper right)
Moffat Chitaunhike

(Lower right)
Stanley Shadreck

(Opposite)
Lovemore Chitaunhike

136

Victor Mtongwizo

138

(Upper left)
Peter Mstrozo

(Lower left)
Leonard Chitanda

(Upper right)
Gift Muza

(Lower right)
Mackenzie Kapisa

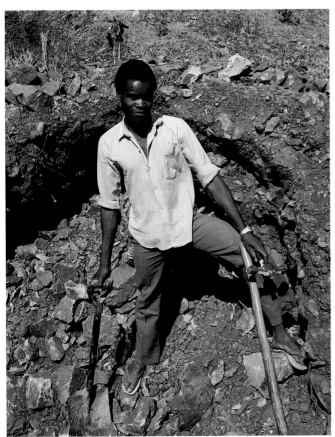

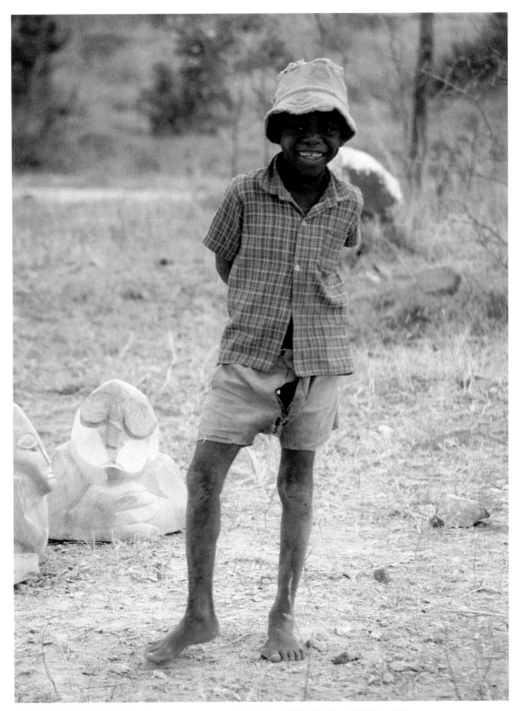

(Upper far left)
Ernst Marime

(Lower far left)
Robert Kwechete

(Upper left)
Lucky Mupinga with mother and daughter.

(Lower left)
Biggie Kapeta

THE GENERATIONS TO COME

A CLOSER LOOK

In a small village sequestered in the Guruve Region, a simple sign welcomes visitors. The clan of the zebra or *tembo chihota* identifies the home of sculptors Richard and Leah Katinhamure. They stand as an example of a rare Shona couple. It is still unusual for women to carve, however their role is changing. Leah, a successful rural school teacher, was encouraged by her husband to express her feelings in stone, thereby breaking with cultural roles. Further, Leah has received heartfelt support from other carvers in the community. The elegant and smaller carvings she creates express her burgeoning talent while her master-carver husband continues to sculpt in monumental proportions.

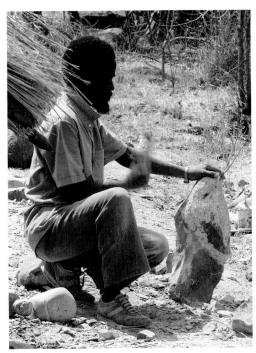

(Left)
A photograph of
Richard in 1987.

(Lower left)
A proud Leah
displays one of her
first works.

(Right)
Richard and his cousins
building his first brick and
mortar house from the
proceeds of sculpture sales.

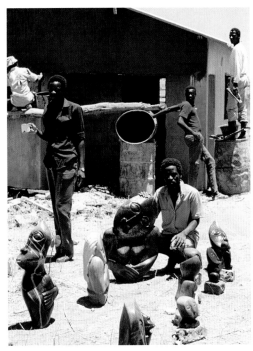

(Lower right)
A 1991 photograph captures
Richard carving a new sculpture.

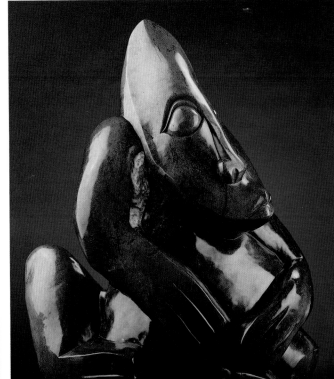

Richard's *The Elder Chieftain* —
a monumental sized sculpture,
some 50 inches tall and weighing
over 1000 pounds.

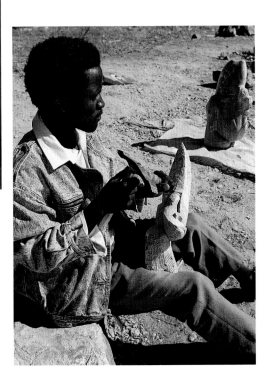

143

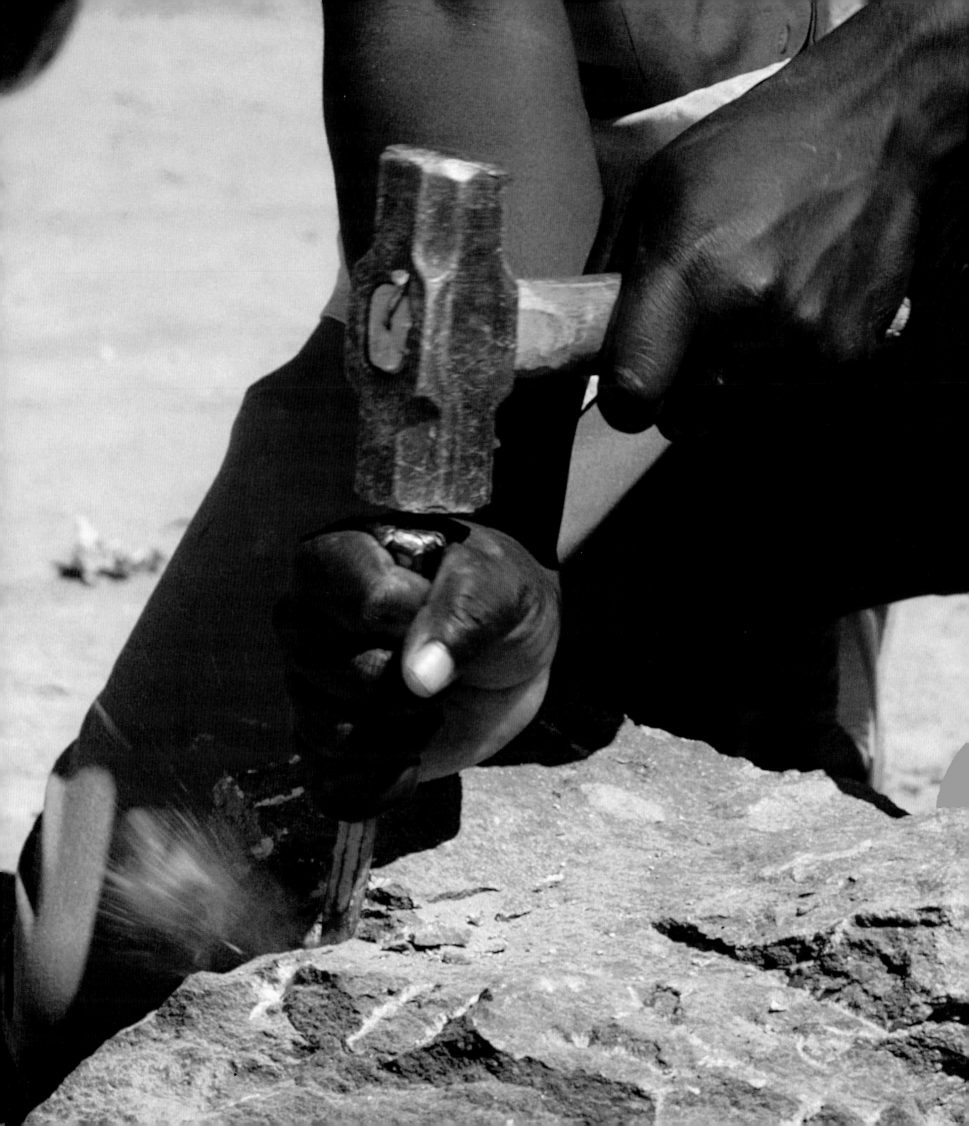

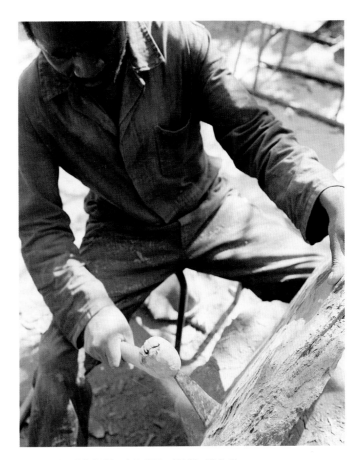

CARVING AND TOOLS

Carving techniques are not necessarily passed down from father to son. While many carvers are related to each other, often as brothers and cousins, the only prerequisite for learning seems to be desire and time. The skill is not hoarded, but shared openly with anyone wanting to learn. However, many carvers in remote areas simply pick up tools and begin with no influence, except the ancestors'.

After the crops are harvested, six or seven young men might gather together under a shade tree in the Guruve Region. *Badza* or small iron hoe in hand, they work the stone while listening to an accomplished elder speak of their ancient traditions and folklore.

Similar scenes are not unusual throughout the rural countryside. Though some artists do live in urban Harare, or in nearby Rusape, the majority of artists still live in the country. Major carving areas stretch from northern Guruve through the Eastern Highlands and

down through the Mutare region.

Carving tools are highly prized in Zimbabwe. In the early years it was common to see sculptors using a hatchet and hoe, known as *adze* and *badza*, to carve stone, even though these iron tools are primarily used for chopping wood or tilling the soil. Out of necessity, sculptors have had to become inventive. They scavenge metal from junked cars and rusting abandoned farm equipment. Flat chisels are formed from truck springs. Old railroad spikes become point chisels. Empty cans held in the palm of the hand become chasing or scraping tools. Pot metal forks and knives etch detail in the stone's surface. Today, some sculptors use wood files, rasps and miners' chasing hammers, but very few, if any, have power tools. In

Traditional carving tools have changed little over the centuries. The community toolmaker (*lower right*) still tends the smelting furnace, or *vira*, (*upper right*), forges the iron and carves the wood to produce the *adze* and *badza* (*below*) so essential to the farmer and sculptor alike.

fact, most carvers live in areas without electricity. Whatever the tools, the carving maintains the integrity of its inspirational roots.

Until very recently, lack of time has been a barrier to women carvers in Zimbabwe. They were simply too busy

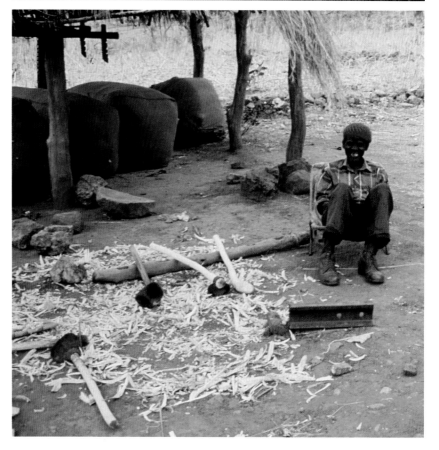

146

caring for their families to spend time carving. However, as time-saving devices such as water pumps in the villages are added to the rural landscape, more women are finding the time to pick up a chisel and carve their visions of life and the world.

ART FOR ART'S SAKE

Though these visions are influenced by the ancestors, the sculpture is not used in ritual or ceremony. In the West, most African art is defined as consisting of either religious icons or practical artifacts, meaning tools used in daily life. But this definition has been imposed on Africa by outsiders and certainly does not fit Shona sculpture or other contemporary African art forms. Shona sculpture is neither worshipped nor functional. It is purely decorative—art for art's sake. One of the first anthropological criteria for being "civilized" is that people adorn their surroundings. Sculptures are often found standing outside a carver's home, enriching the lives of those who work and play in their shadow.

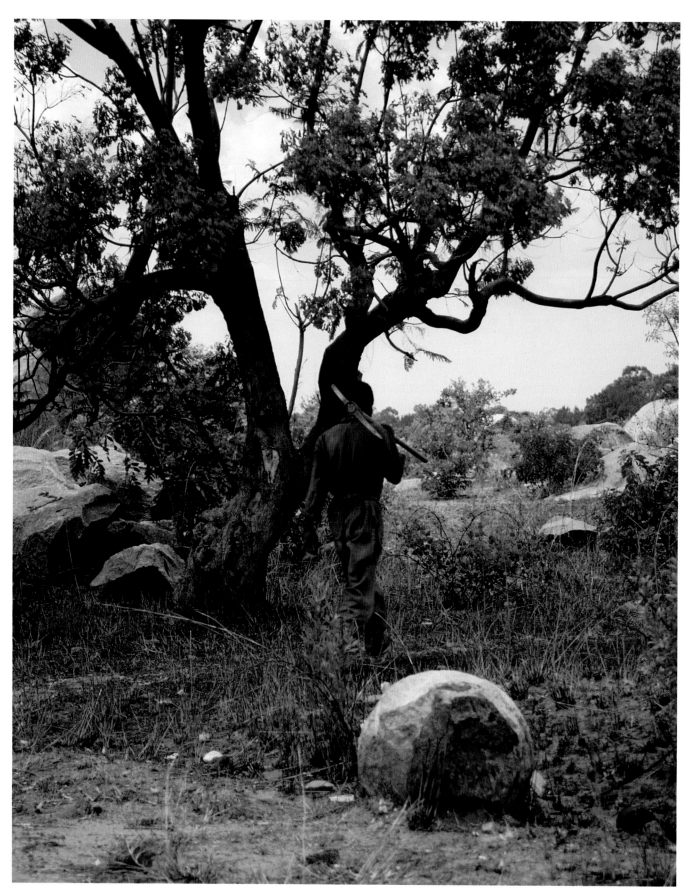

Under the vibrant purple blooms
of the Jacaranda tree,
artist Crispin June Mutambika
strides with pickaxe over his shoulder.
The search for an inspiring stone begins.

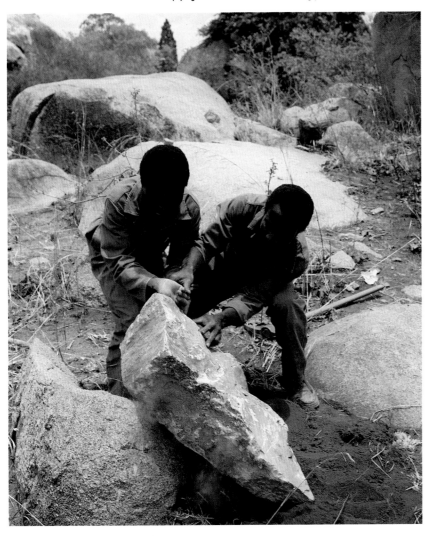

Crispin June and his younger cousin, Peter Mstrozo, slowly and laboriously work the earth around the stone prying it loose from its ancient resting place.

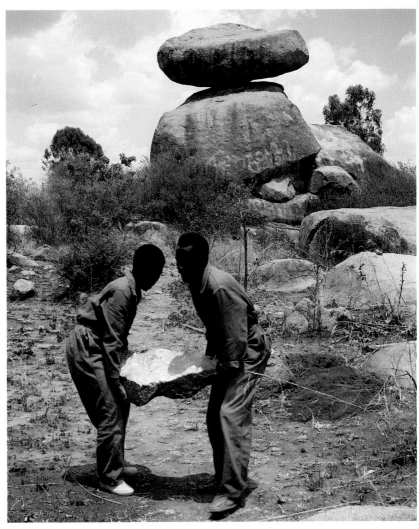

Against a background of Zimbabwe's famous balancing rocks, the two Shona men laboriously carry the 200 lb. stone to Crispin's village.

THE CREATION

The journey from ephemeral dream to a completed stone image is a long and arduous process.

Like most other acts in Shona culture, the carving is not capricious, but is destined from its beginning. Finding, shaping and finishing the sculpture all require the blessing of the ancestral spirits. Even though the countryside is full of stone, artists will sometimes travel great distances searching for a particularly powerful stone

spirit. Still, when the artist digs the stone out of the dirt, and even later when he hammers his chisel into the dull serpentine surface, he has no idea what color is hidden inside. The stone's colorful soul is only fully revealed in the final washing stages, just before firing and polishing.

The following photographs capture the sculpting process of Crispin June as "The Antelope Woman" emerges from raw stone.

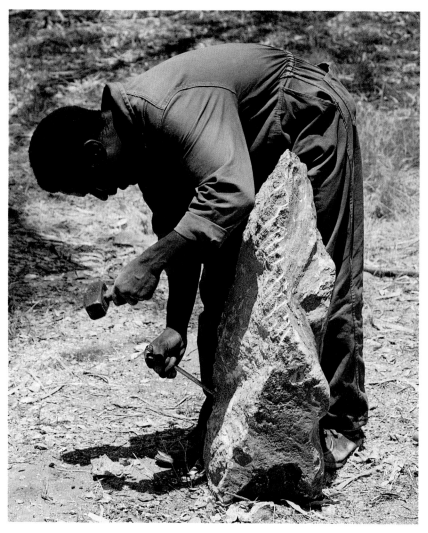 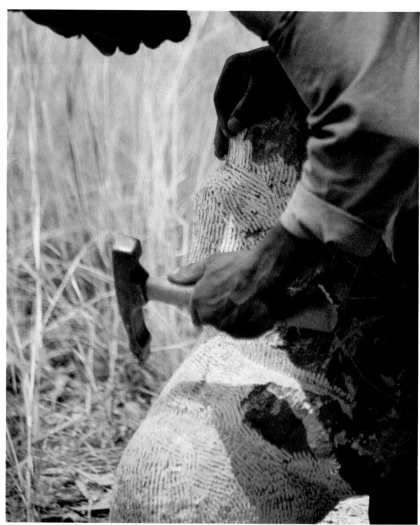

With a broken mallet and spike, Crispin June begins the careful chiseling that removes the unwanted stone from its intended form.

In the next step, the artist carefully chases the sculpture's shape with a mining hammer. This process may take weeks or months depending upon the size and hardness of the stone. Also, the many duties of a Shona may take precedence over carving, delaying the completion.

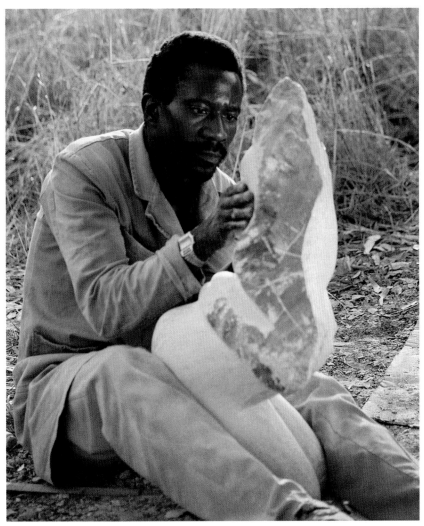

Clasping the sculpture between his knees, the artist carves the finer details of the facial features. The sculpture takes on the image of the artist's precise vision.

With water, sandpaper and circular hand-rubbing, the stone submits to the smoothing of its surface. This process takes many quiet hours.

The 'firing' or heating of the stone's surface (unique to Shona sculpting), allows the stone's veneer to expand. This prepares the stone's porous surface for the waxing which reveals the stone's natural color.

The sculpture is heated progressively, one side at a time. This allows for safer expansion of the stone's surface and prevents dangerous explosions. All stone can explode when heated due to the dissimilar elements within it.

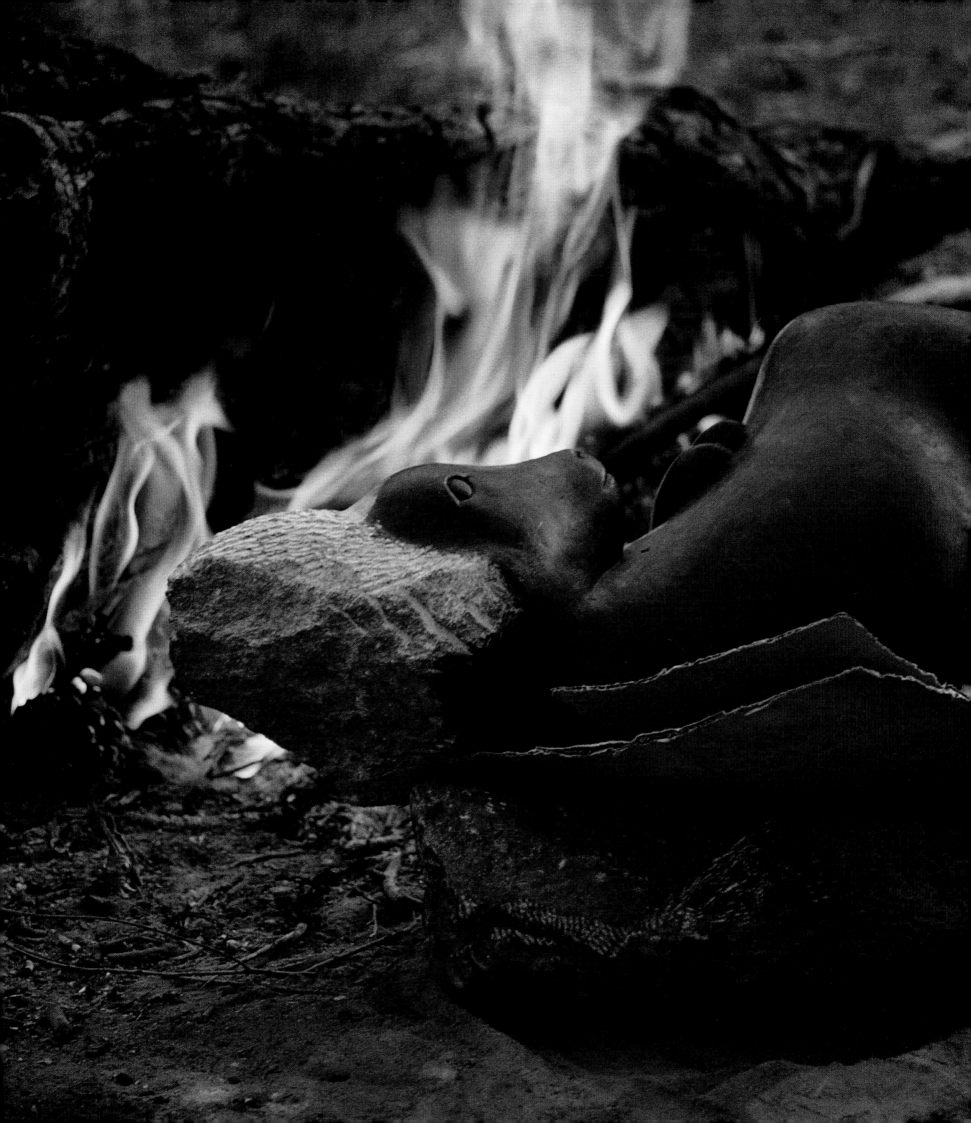

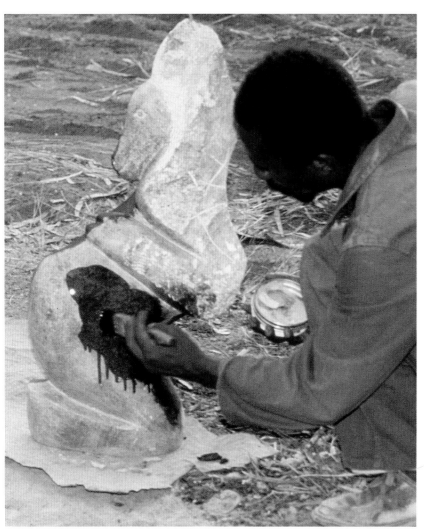 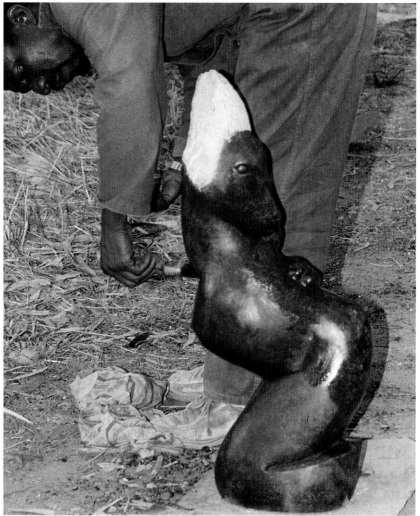

While still hot from the fire, the sculpture receives the natural wax—beeswax, carnauba plant wax or other. In a process that can take hours, layer after layer of wax is applied as the sculpture gradually cools. Once cooled, the sculpture's waxed surface will be hand-buffed with rags until the artwork reaches its fine gleaming finish.

THE THEMES

One does not become a Shona sculptor simply by learning how to handle a hammer and chisel. One must express 'truth to culture'—integrity to one's cultural spirit and heritage.

While some critics have attempted to define 'truth to culture' by looking to the past, many third generation artists are creating works that go beyond the parameters set by the first and second generation artists. When sculptor Biggie Kapeta created his powerful sculpture of a woman's torso, her chest thrust upward, he titled it "Don't Burn Women's Rights." Though this explicitly political theme was certainly a break from the main body of Shona sculpture, who can say it is any less an expression of life in Zimbabwe than

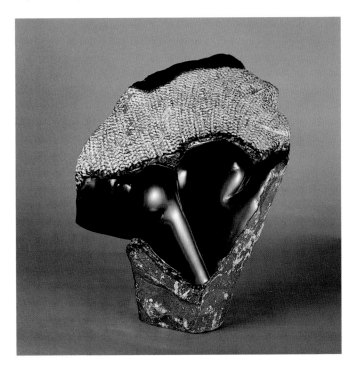

Don't Burn Women's Rights
Biggie Kapeta
12"

the more traditional "Mother and Child" theme?

Though the sculptural themes are still overwhelmingly traditional, women's rights, along with industrialization, politics and conservation, are just a few of the modern concerns that are finding expression in stone. The work of these younger artists reflects their willingness to embrace the modern world while

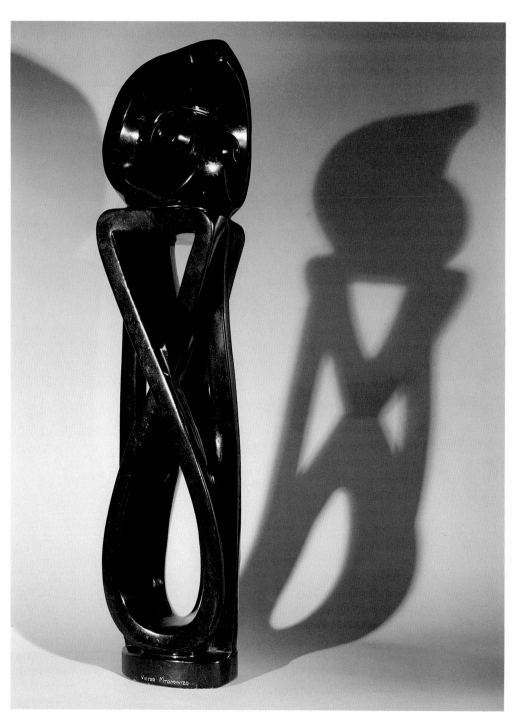

Optical Illusion
Victor Mtongwiza
34"

maintaining strong spiritual ties to their culture.

Sometimes I find myself doing modern pieces. You know, like one piece I'm doing now called "Optical Illusion." This piece is showing through the eye what we can see and sometimes what we cannot see well. That's why sometimes I want to go for abstract art, but it all originates from the Shona spirits.
— Victor Mtongwizo, third generation artist

While recognizing the tremendous obstacles and problems that face their country and the world, the artists seem to remain remarkably optimistic. One sees very little of the tortured artist syndrome amongst the sculptors of Zimbabwe. There is joy in their lives and the joy in the carving is quite apparent.

EARLY SUPPORT

When art critics recount the renaissance of Shona sculpture, they often start with the contribution of Frank McEwen, who became director of the National Gallery of Zimbabwe in 1956. Determined to encourage an indigenous art movement free of the artifice that he experienced as both a museum director and art critic in Europe, McEwen created gallery workshop schools where Shona could explore and develop their own artistic abilities. Vukutu is perhaps the most famous of these schools and was an early home of many important first generation artists including Bernard and John Takawira and Boira Mteki. Boira, in fact, had already been carving in stone before finding his way to the National Gallery workshop. He states that one day, he arrived at the workshop with several carved pieces in hand to show to the other sculptors.

McEwen's name is often followed by Tom Blomefield, a colonial tobacco farmer from Tengenenge in the Guruve Region (northern Zimbabwe). Unable to sell his tobacco because of international economic sanctions against Rhodesia, Blomefield took a hard look around him and saw stone. Nestled against the foothills of the Great Dyke, his farm in the north-central part of the country was chockablock with stones ready to be carved and sold. Under the guidance of an early Shona carver, Crispen Chakenyoka, Blomefield began carving in 1966 and invited his workers to do the same.

Initially Tengenenge sculpture community was associated with the National Gallery workshop schools established by McEwen, but it soon became independent. It has been home to some of the country's most acclaimed artists, including Matemera.

But long before McEwen and Blomefield began supporting stone sculpture, wood sculpture was being taught at mission schools by men such as Canon Edward Paterson of Cyrene and Father John Groeber of Serima. Though the skill and artistry of their students is widely recognized in Zimbabwe, at least two factors limited the growth of this art form.

First, wood is scarce in Zimbabwe. Secondly, students at these mission schools created scenes and symbols taken from Bible teachings, rather than drawing on the culture of their traditional lives.

Still, many of these carvers were able to adapt their wood-carving skills to stone, an abundant resource which had been put to magnificient use by their ancestors.

With their return to stone, they also returned to the symbols of their ancient and spiritual culture.

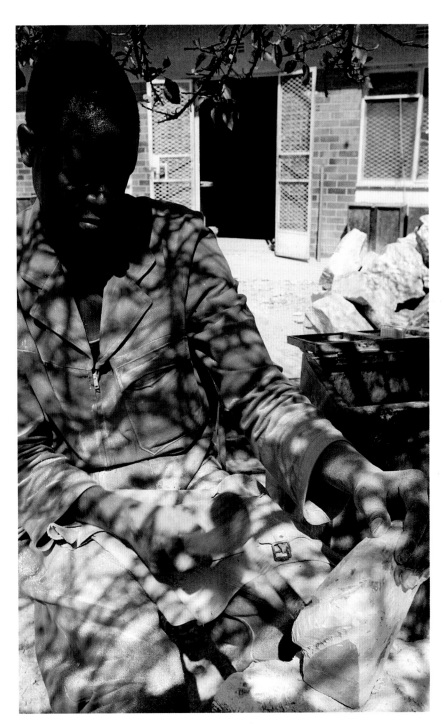

Kizito Rwanza beginning work on a new sculpture at Canon Paterson Workshop.

ANCESTRAL SPIRITS

One of the most powerful symbols of the Shona culture is the *mudzimu* or ancestral spirit. The ancestral spirit is part of a host of spirits who control every aspect of Shona life. The *midzimu* are personal or family spirits, while the *mhondoro* are spirits of the clan.

Shona sculptors often say that they are inspired by their dreams. The spirits of their ancestors speak to them in their dreams, and allow the sculptors to release the spirit within the stone. Spirits not only reveal themselves in the sculpture, they guide the entire sculpting process. And not only the ancestral spirits, but all forms of spirits since they exist everywhere: in stone, in water, air and trees and in animals. This animism permeates mundane objects as well. For instance, a water glass can have a spirit too. If a glass breaks and no one purposefully caused it to break, then the Shona believe that the spirit of the glass caused itself to break. Nothing happens accidentally in Shona culture; everything is controlled by the spirits.

Luke Mugavazi, a Guruve region sculptor, describes his sculpture of Spirit Lovers—two powerful, yet gentle faces looking upward with hands stretched out in supplication:

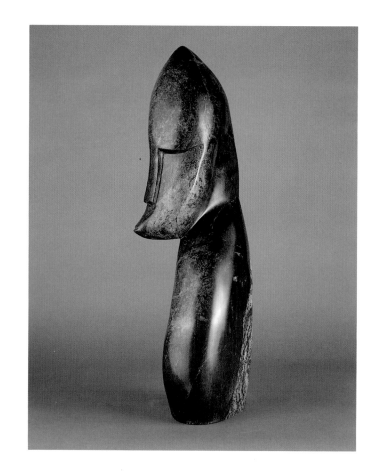

This is just my imagination of spirits. You know in Zimbabwe for the past several years we have not been receiving enough rains so what I'm imagining these days, I already see it, is spirits coming together to discuss the rains, so that they might come to a conclusion whereby they have one unity and pray to god so that they might have rains. So these are the lovers coming together.

— Luke Mugavazi, third generation sculptor

In addition to spirits, other common themes in Shona sculpture involve the family: Mother and Child, Family Embrace or *Ukama*, Lovers, Brotherhood, Sweet Children, and *Kunzwanana*, or Harmony.

Westerners sometimes ask whether these themes are chosen with a Western audience in mind, as if these 'feel-good' themes are chosen for their marketability. They are not.

The Shona find inspiration throughout their natural surroundings. Through exfoliation, this granite boulder reveals a hidden spirit face remarkably similar to the abstract forms expressed by Shona carvers.

(Far Left)
Resting Spirit
Edronze Rukodze
24"

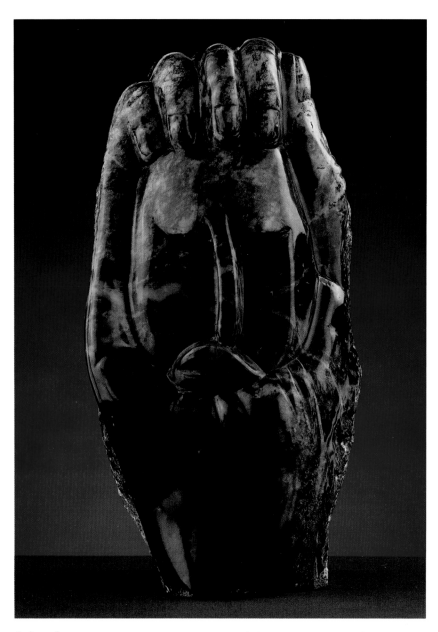

Ruokorunofunga
Kizito Rwanza
16"

Most of the artists want to show exactly what is in their hearts. They show it through the stone. You see, mother and child, this is one thing that the Africans believe in. For a married couple to be together forever they have to have a child or children. That is why mostly you find mother and child pieces, maybe in animals too. They are representative of the African belief.

— Victor Mtongwizo, third generation sculptor

The following examples illustrate some centuries' old spiritual folklore handed down in oral tradition.

MWARI The omniscient God of Shona folklore who created all things. He sees the complex noble and base spirit of humankind. However, a straight nose and mouth express that he holds no judgement of our actions. It is said that after Creation, *Mwari* stood back from mankind's actions. *Mwari* knew that mankind would reap what it sowed, both good and evil.

NJUZU In Shona lore, the beautiful water spirits or *njuzu* inhabit all lakes and rivers and are the sacred teachers of *ngangas* or healers. They will lure a child into the water to teach the sacred knowledge of divining and healing. The child is then released back into the village to carry out his or her sacred healing duties.

CHAMINUKA The greater provincial spirit that inhabits northeast Mashonaland. When thunder is heard, the Shona say that *Chaminuka* walks upon the earth. During the war of liberation, the *masvikiro* or spirit mediums depended upon *Chaminuka's* guidance to orchestrate the freedom movement. Highly revered, *Chaminuka* is second to only *Mwari* and at many times *Mwari* is referred to as *Chaminuka*. Regardless of the name, he is the dominant spirit force in Shona belief.

NGOZI An unsettled spirit that cannot enter the realm of the ancestors because it has not left children behind among the living. Its anger is left behind to plague the living with mischief and havoc.

ZUZU A quasi-human spirit that inhabits water whirlpools and draws unsuspecting humans into the swift moving pools to drown.

RUOKORUNOFUNGA The hand possesses its own soul separate from your spiritual mind. The hand, a powerful source of creation, is able to create on its own as if guided by another spiritual source.

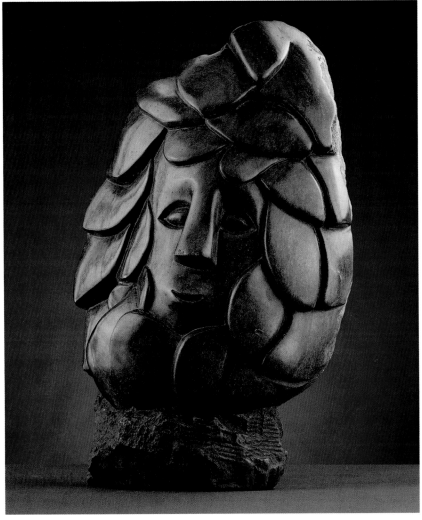

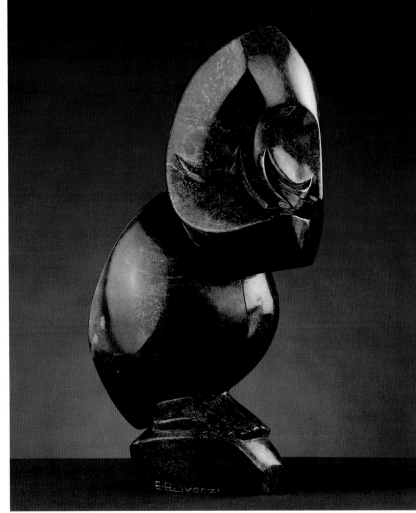

Leaf Spirit
Crispin June Mutambika
20"

Man Transforming Into Owl
Edronze Rukodze
18"

METAMORPHOSIS

Metamorphosis, so important to the Shona cosmology, often shows up in the sculpture—an animal transforming into another, frozen in the act. Neither elephant nor man, but embodying qualities of both. Living so close to nature, the Shona observe constant changes in their environment: birth, maturity, pregnancy and death along with the cycle of the seasons and the harvest. Humans and animals can change form both temporarily or permanently to transform into spirit hosts. The sculptors recognize that these changing forms can be metaphors for spiritual themes, especially those that explain creation, ancestral power and everyday life.

In our eyes, you understand, you often see people converting into animals. You can hear the sound of the drums… and the body you see may be a person but he is really a bird… Sometimes I make my dreams. So, of course, I will make things that are sometimes frightening—so much about animals changing into people.

161

The Vulture Man. He came to me out of my dreams. It took me a month to make him.

I have also made a woman with four eyes. More than twice the size of an ordinary human. And yes, all the people around get frightened. But still they come to my house to see what I am doing.

—Sylvester Mubayi, first generation artist

This might also account for sudden changes in character or behavior. Intervention by the ancestral spirits, or spirit possession, may not necessarily alter a person's visible form but will, more importantly, influence his or her conduct. Induced by the spirit possession, this trance state is often the subject of many Shona sculptures.

A possessed man can also be a spirit medium, able to prophesy and communicate directly with ancestor spirits. Luke Mugavazi explored this theme in a piece titled *Possessed Man*, an abstract moon-shaped face of green and orange serpentine.

I imagine those people who were here during the war. These people were possessed by the spirits who were controlling our people who were fighting (the war of liberation). They were going to the places of our guerillas and teaching them the way to fight and how they can get here coming from other places... telling them how we can go on our way in order to free Zimbabwe.

—Luke Mugavazi, third generation sculptor

The spirit and not the individual is responsible for any actions during possession. Should someone be injured in a physical brawl, the Shona would argue that since these combatants never harmed anyone before, the incident must have been caused by *ngozi* or evil spirits. In fact, most tragic consequences are believed to be sourced from witchcraft or the evil spirits. (Most Shona sculptors do not carve themes of the *ngozi* or witches for fear the act of carving them would bring catastrophe upon themselves or their families.)

While much of Shona sculpture is abstract, incorporating themes of metamorphosis, spiral time and spirits, some sculpture is quite realistic. Sculptors turn to what they know and carve exquisitely detailed elephants, chameleons or hippos. (Remember, highly detailed or realistic carvings are not traditional.) Sometimes the artists choose to carve their totem animals, but sometimes they seem to carve a particular animal simply because they like its shape or the quality it represents. Nearly all of the animals represent a quality or characteristic desirable, at least in moderation, in human nature.

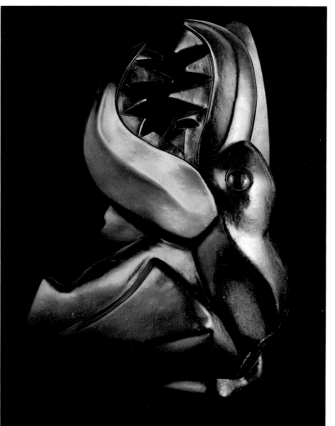

Bird Transforming Into Crocodile
Agony Shangwa
36"

SHONA FOLKLORE

"In all countries, myth has an historical, cultural and social significance," Dr. Nkomo explains. "A belief in myth can, in a sense, be equated with faith which is essentially a belief in the intangible and what cannot be proven. Myth is articulated in Africa mainly through folklore which can provide a cosmological rationale for a world view which is believed, but which cannot be subjected to scientific proof. Myth plays an important part in the life of all people and in Africa it provides the link between the mortal and invisible worlds, the living and the dead, the visible and the invisible universe."

Inspired by landscapes, animals, plants and trees, the Shona created rich folk stories that taught children important social manners and customs.

According to oral tradition, many of the natural animal characteristics portray moral or ethical qualities to be emulated. The animals also take on human characteristics such as the capability to reason and talk.

(spirits) or the witch is coming. The Shona then implore the *nganga* or healer for assistance to ward off these terrible demons. They are also the symbol of clear and penetrating vision, able to see even through the great darkness of the African night.

GUDO (the Baboon) This animal represents wit, fertility and prosperity. It is a good omen when a baboon steals your corn since he has chosen your field to rob above all others. *Gudo* will bring you excellent crops, happiness and growing wealth throughout your years. Any Shona farmer seeing a baboon steal corn from his field is reassured a good harvest with this lucky little thief.

In his personified role in the animal folktales, the baboon is also a symbol of stupidity and foolishness

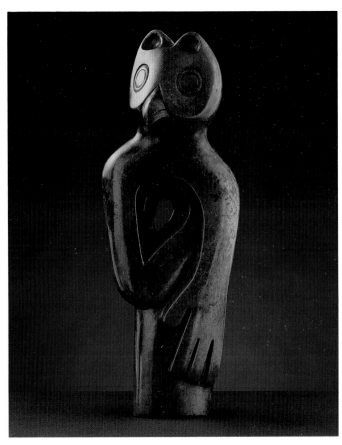

(Above)
Owl
P. Mhondorohuma
16"

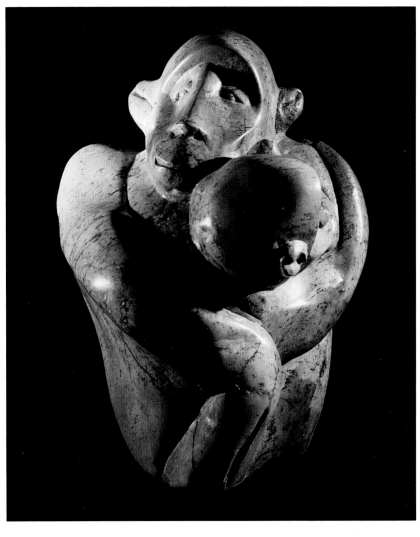

(Right)
Baboon Family
Crispin June Mutambika
20"

The following examples illustrate some Shona animal folklore.

ZIZI (the Magical Owl) As the legendary and powerful messengers, the owl carries the truth, good or bad, to the villagers. If he flies near the village at night, he is also warning the inhabitants that evil *ngozi*

and is constantly made the target of the hare's sly tricks. However, the Shona attitude to the baboon is ambiguous because he is also accepted as a beast possessing ancient knowledge and as being useful to man. It would seem that the baboon as an animal is respected, but folktales provide an opportunity to denegrate the animal in order to reassert man's superiority over a beast which bears a resemblance to man's physical appearance.

CHAPUNGU (the Bateleur Eagle) One of the most highly regarded spirits is the great *Chapungu*. As a protective spirit who can travel swiftly, he views the world from a great height, detects danger and warns man. He carries away the spirits of dead chiefs, communicates with the ancestors and is greatly esteemed by man for his role as messenger and intercessor with the spirits. When lightning is seen, the Shona believe that the great *Chapungu* is bringing a powerful message from God to man. When seen, he must be saluted by handclapping as a mark of respect.

SHUMBA (the Lion) To the Shona, the lion signifies authority, order and tradition. This animal acts as a host to the clan and small *mhondoro* or family spirits. It is believed that when a lion is possessed by a *mhondoro* spirit it becomes docile and will not harm man. The lion is falsely regarded by colonials as the king of beasts. Although possessed of power and prestige, it can be outwitted by more intelligent animals particularly the hare, or *tsuro*.

TSOMBE (the Tiger Fish) In Shona folklore, when someone dreams of fish he or she will soon be the recipient of wealth. It is a good omen and the Shona anxiously await the magical dream fish that heralds prosperity.

IDYANYOKA (the Kudu) Shona consider the kudu a 'good' spirit since it acts as a food source and has a 'practical' purpose. The horns are also considered magical and are used for healing potions and casting spells to ward off bad spirits. This graceful and shy animal embodies the female spirit.

HUNGWE (the Fish Eagle) Lightning portrays the passage to earth of the mysterious and magnificent fish eagle, also called the *chapungu*. The bird flashes across the sky and strikes the earth with a

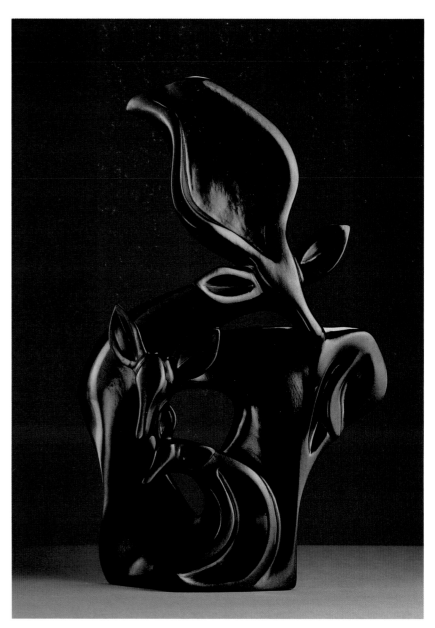

Kudu Family
Robert Kwechete
16"

(Opposite)
Chameleon
Crispin June Mutambika
15"

164

resounding crash. As the bird leaves the earth it often passes through some object which injures it; if the lightning bird strikes its victim on its downward path it will penetrate through it to the ground and be unable to rise again.

MVUU (the Hippopotamus) The Shona say that when God created the hippo, the animal was so embarrassed by his size and visage that he asked God if he could hide in the water all day so not to be seen by the other more beautiful animals. God agreed on one condition— the hippo could not eat any of His fish. So, the hippo remained in the water all day long and surfaced on the riverbanks only by night. To prove to God that he has not eaten any fish, he rapidly wags his tail to spread his spoor over the ground so God can see there are no fish bones.

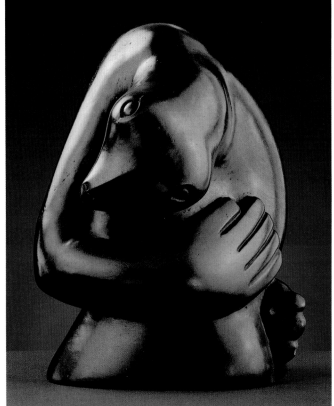

TSURO (the Funny Rock Hare) This animal signifies quick intelligence and planning. The Shona have great respect and affection for the hare and in their folktales he is a rogue, wit and hero. Despite looking small and weak, he is regarded as being very clever and symbolizes adept skill and mischief. Many stories are told of situations in which the hare's capacity for thought and trickery enables it to outsmart animals of greater strength like the elephant, hippo, lion and even the cunning baboon.

DACHA (the Magical Frog) The frog or *dacha* possesses wonderful magic. The ancestral spirits, wanting to protect the dreams of their children, called upon the small timid frog to sing his bold and joyous songs only at night. The simple frog agreed that if the Shona were to respect him, he would frighten away the evil spirits from entering the childrens' dreams. So, to this day, the Shona call out a welcome greeting to the frog for the bold singing he performs at night to protect the children.

RHWAVI (the Magical Chameleon) The Shona will not touch a chameleon for love or money. This is because their folklore teaches that one day a curious child saw a chameleon changing colors and was so fascinated that he picked up the little creature—whereupon the startled and angry lizard promptly stole the color from the palms of the child's hands. Upon seeing what had happened, he pleaded with the chameleon to put the color back, but the little lizard would not, for he said, "that will teach people not to go about picking things up without permission!"

KAMBA (the Tortoise) The Shona personify the tortoise as an exemplary and moral animal who mediates in the animal kingdom and ensures the well being of society. An incorruptible and profound wisdom dwells inside his soul. He is the symbol of righteousness, perseverance, common-sense and conscience. He is also known as *Zigwande* (Old Shell) and there are hundreds of proverbs about this fine creature. Tortoises are praised because they seldom do harm—except in self-defense. And when the tortoise does hit out, his aim is not destructive, but rather intended to teach others a good lesson in humility.

CHIPEMBERE (the Rhinoceros) A mighty and strong animal, the rhinoceros symbolizes vigilance and calm. These formidable animals with their grand grey eminence carry great dignity while traveling their solitary way. They are as unperturbed as a mountain in a hailstorm. Rhinos are also thought of for their maternal loyalty, caring and voracious protection of their young.

The Shona legend tells another wonderful story of the rhino and the porcupine. The rhino, after having torn his skin on a thorn bush, asked to borrow one of the porcupine's quills and the porcupine said, "Yes, only if you promise to return it to me." The rhino thanked the porcupine and held his prized quill between his lips. Then, to his

sudden dismay, the rhino swallowed the quill while munching his grass. With great concern the rhino scraped through his spoor with his hind feet searching feverishly for his friend's quill in order to return the object and keep his promise. To this day, the rhino still stamps his spoor and spreads it over the ground, looking constantly for the swallowed quill to return to his good friend, the porcupine.

TWIZA (the Gentle Giraffe) The folktale of *Twiza* centers around the animal's natural curiosity. After God created all the animals, he spoke to each one and told them of their job on earth. While God spoke to *Twiza*, the animal became so fascinated by God's voice that he stretched his neck as far as possible to listen more closely to God's message. The giraffe listened so intently and strained so hard that God was pleased by his efforts and elegantly elongated the giraffe's neck to show all other animals that extra effort in life can be rewarded.

THE SHAPE AND SPIRIT TO COME

Creating sculpture by the Shona has always been a dynamic process. There are purists who yearn for the 'good old days' when the carving was totally uninfluenced by the West. However, these purists forget that, like many great civilizations, the entire history of the Shona has been influenced by many peoples and many cultures and will continue to be in the future.

Carving techniques have remained remarkably similar over the years, but as Zimbabwe adapts to its role as the leading economic success of the majority-ruled countries of Africa, it is inevitable that the artists' experiences and senses will find new themes to explore. Life is not static in Zimbabwe. It reflects the dynamic changes in their social, political and spiritual realms.

In Zimbabwe's emerging future, the ancestral spirits will continue to guide and protect the visions of a people, their land and their sculpture.

As President Mugabe has stated, the sculptors are "the precursors of history." Just as the ancestral spirits inspired the liberation of their country, the spirits will continue to guide the wellspring of creative talent, both in the stone that gives it shape and the spirit that emerges.

Embracing The New Generation
Kennedy Musekiwa
28"

166

"My husband would not support my early sculpting…
and tried everything he could to discourage me…
even giving away my pieces in my absence."
—Locadia Ndandarika

BEYOND TRADITION

Locadia Ndandarika—mother of the
Shona womens's sculpting movement.

S HONA SCULPTURE TODAY IS ALIVE,
flourishing and infusing itself with greater energy
and momentum than ever before. There has never
been such excellent craftsmanship and outpouring
of creative talent. And now, many of these artists are
drawn from the ranks of the Shona women, who are
literally breathing new life into this sculpture movement.
They create from an intriguing, invigorating and new
perspective.

As the unsung heroines of the continent, for millennia
the African women have been the mainstay and substance
of the family core, village life and farming. After
independence, the spirit of emancipation for Zimbabwean
women was born and carried on into the creation of their
new country. Having passed its equal rights law in May
1980, the year of independence, Zimbabwe is experiencing
a new-found source of creative energy in its women.
Making up over 50% of the country's population, women
are entering into new vocational, educational, political
and artistic frontiers.

Agnes Nyanhongo stands with two of her
masterpieces, daughter Chiedza
and *Proud Woman*

Traditionally, women's artistic endeavors were focused on weaving, pottery and other utilitarian crafts. Now, many women sculptors are being encouraged by their male counterparts. As early as 1969 the first woman picked up her carving tools and began to sculpt. However, Locadia Ndandarika, married to celebrated first generation sculptor, Joseph Ndandarika, did not receive any support from her husband. In fact, Locadia has said that, "He had little or no respect for my artwork. He would just give it away." So, after successfully selling her first works, she divorced her husband and began raising the family alone. "Women must help each other to learn so they can become free," Locadia exclaimed. With determination, she insisted that her daughters proficiently learn stone sculpting. In a few short years, she received acclaim from the Zimbabwe National Gallery for her individual artwork.

Now, a new cadre of younger women have followed in her footsteps. Endowed with significant talent, producing elegant images, these women astound sculpting enthusiasts and collectors alike. Traditional folklore, spiritual and cultural values and issues central to Shona women infuse their stone art works with abstract images that challenge the viewer.

New names such as Agnes Nyanhongo, Mavis Mabwe, Junior Mhembere, Stella Nyandoro, Angeline Rukodzi, Colleen Madamombe, Beverly Ndlalambi, Shaileen Hozo, Mercy Masose, Leah Katinhamure and so many others keep emerging (*see Artist Listing, page 205*).

Now, many of these traditional women, encouraged by fathers and husbands, have chosen to pick up the tools long used by their male counterparts and begin carving. Far away on the Guruve plateau in the early 1990s a seed was planted that slowly grew and which nurtured a small group of women to begin carving. This timid genesis was actually fostered by male sculptors such as Edronce Rukodzi, Richard Katinhamure, the brothers Mugavazi, and Brighton Sango and many others. With no traditional 'role resentment' toward the women, these men actively offered their encouragement.

We experienced this support firsthand while visiting the Guruve artists in 1993. Proudly and eagerly the men presented the women's works and unselfishly insisted that we view and consider the women's beginning sculptures before looking at their own. And there was much reason for their pride. The women's sculptures were captivating and offered a new aspect on Shona spiritual and daily life from a female perspective. Four short years later, with new-found confidence and courage, the Guruve women now present their own works to visiting collectors from around the world.

Unlike the Guruve artists, many traditional men are threatened by this new found freedom. Some husbands have stated to us, "No, I don't want my wife to learn sculpting. She might become proud and leave me." Undaunted, the women of Zimbabwe are still picking up the carving tools and new sisters join their ranks everyday.

In Harare, young Agnes Nyanhongo and Mavis Mabwe led the new forefront with great carving enthusiasm. Born in 1960 in the high Nyanga mountains, Agnes spent much time helping her father, sculptor Claude Nyanhongo, by polishing his sculpture. In 1983, after beginning a three year workshop course in Harare, Agnes displayed great promise to her teachers. The sensitivity and seriousness with which she expressed her ideas and her respect for the material ignited into mastery. Although retaining her traditional beliefs, Agnes also offers insight into her newly emancipated womanhood. "I try somehow to express the role women play in society and the way they are being treated." For Agnes, it is important that others understand her struggle. Now, having gained international success, Agnes instructs several young men in the art and tradition of Shona sculpting. It has come full circle. A woman now teaches the men.

(Right)
Mavis Mabwe
(Below)
apprentice to
Agnes Nyanhongo.

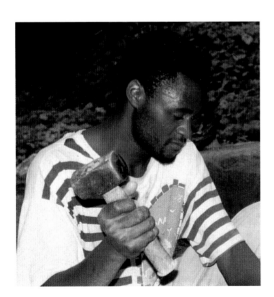

Mavis Mabwe, widow of sculptor David Chirambadare, was born in 1961 and began sculpting in 1988 while quietly watching her uncle, famed sculptor Nicholas Mukomberanwa. Most of her early years were spent assisting her sculptor husband. After her young husband's death in 1993 she picked up his tools and concentrated her energies. Mavis developed her own sublime style and in turn, mastered the stone to support and feed herself and her children. Out of the cruel early loss of her beloved David, Mavis rose to become a great and stunning talent.

Now, over thirty women have joined Zimbabwe's celebrated stone sculptors and more are on the way. We joyously welcome their courage, creativity, and craftsmanship. Having been among the very first to recognize and collect from this new movement, we continue to commend their new-found mastery of both stone and self-destiny.

171

(Left)
Colleen Madamombe
(Below)
Angeline Rukodzi

172

(Upper Left) Nyarai Musvamhiri
(Center Left) Stella Nyandoro
(Lower Left) Junior Mhembere
(Below) Queenie Sango

173

Third generation master sculptor, Kennedy Musekiwa.

THE NEW GENERATIONS

"It is good to see so much work by the younger artists here… my generation is not the future of Shona sculpture any more… that now belongs to the young sculptors. They are the new energy, the new force for us."
—Nicolas Mukomberanwa, leading first generation Shona sculptor, while visiting *Spirits in Stone Gallery*, Sonoma, California, October 17, 1996.

When the first edition of *Spirits In Stone* was completed five short years ago, the newest generation of upcoming artists was still in its infancy. Now that first tentative trickle of new talent has grown, surging forward like a powerful and unstoppable torrent. Gathering mass and momentum, the members of these newest generations have swelled to well over a thousand—with more artists, men and women, young and old, emerging every season.

In the past, many of these contemporary sculptors were encouraged by the older established sculptors, respectfully known as *madalas*, or wise elders. Others were assisted and inspired by well known second generation sculptors such as Richard Mteki, Edronce Rukodzi and others. Now, even the younger masters are mentoring their peers. In one instance, internationally acclaimed Kennedy Musekiwa initiated a learning cooperative where over twenty younger artists (some only five years his junior) could hone and develop their carving skill and creativity.

Today, we are astounded by the sheer pace at which this movement continues to expand—while still maintaining its veracity and variety. Every list of new young artists we compile immediately becomes incomplete as more young talent chooses to turn their tools to shaping the stone.

What a splendid problem to have!

(Top row, left to right)
Luxon Karise, Ephraim and Tonderai Katsande,
Jonathan Chingagaidze
(Left)
Tonderai Musvamhiri
(Right)
Eddie Masaya
(Bottom row, left to right)
Sure Try Katinhamure, Michael Chingagaidze,
Cains Chidhakwa

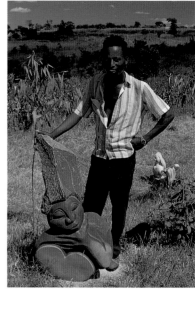
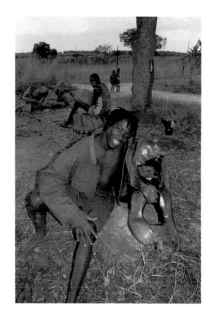
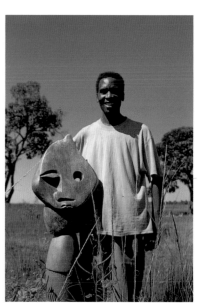

(Left)
Edgar Sahondo

(Right)
Robin Kutinyu

The rapid growth of the new artists has ruffled the feathers of certain self proclaimed "art experts." Although the rest of the world has long since recognized the efficacy of the new artists, these 'experts' with their unfortunate, self serving and exclusionary agendas still issue dire warnings that the excellence of Shona sculpture is being eroded by the work of those they indict as 'upstart' newcomers. But their brilliance cannot be denied—just one look at their creative carving proves beyond a doubt that this art movement is alive and flourishing. A champion of their cause, famed sculptor Nicolas Mukomberanwa, insists that the movement owes its present stunning strength to the new

lions (and lionesses) of the youngest generations of artists.

Every art movement is dynamic, always transforming itself—and Shona Sculpture is no exception. While honoring the power, courage and originality of their esteemed predecessors, the continuously evolving youngest generations are exhibiting indisputable innovation of style. They are not afraid to experiment, seamlessly fusing their fresh energy, strength, ideas and modern experiences with traditional thoughts and beliefs. They stretch, unfettered by narrow colonial strictures and old European prejudices.

Each successive generation truly is hammering its own distinctive mark into the stone.

The Shona sculpture movement is

highly unusual in many ways, but especially in how soaring out of Africa, it has become so rapidly prized by the world of contemporary art. Within the Shona art movement itself, the forceful expansion of the burgeoning recent generations is also highly unusual. In recent years— just as famed sculptor Henry Munyaradzi predicted to us in 1993—the most provocative, most collected sculpture has come from the vigorous and spirited new generation artists, with the work of the second, third and now even fourth generation sculptors constituting the preeminent part of most collections.

These talented artists, men and women alike, clearly are the future of Shona Sculpture. Without their vitality, the movement might have become stuck, lapsing into inertia and, finally, fading into oblivion.

(Opposite, top row, left to right)
Tom Hlupeko, Tendai Chidhakwa,
George Chitaunhike, Bryan Nyanhongo.
(Middle row)
Dominic Benhura, Safe Tawasika.
(Bottom row)
Thomas Zinyeka, Ernest Chimhapa.
(Opposite, far left)
Never Chitaunhike

(Right)
Miguel Kennedy Masaya

But happily, the opposite has happened. Since independence in 1980, the arts in Zimbabwe have erupted with intensity as the country itself has experienced new-found energy in its rush toward the future. Heady with new freedom and self determination, the youngest generation's creativity has likewise been ignited and catalyzed. Looking to innovative ideas, listening to and learning from the inpouring of new peoples from different cultures, and participating in their country's forward motion, they let these collective forces spur their creative talents. From just an initial few recognized artists, the simmering movement

(Above)
John Type
(Middle row, left to right)
Timothy Mupotaringa, Noel Mwanza, Charles Chaya
(Bottom row)
David Chikuzeni, Phineas Mlambo, Wengai Chilenga

(Canon Paterson Artists — opposite)
Front, far left in white shirt, Kumberai Mapanda.
Just right and slightly back, Myles Kudzunga.
Behind (partially obscured), Victor Mtongwizo.
To Victor's right, in cap, Nelson Rumano.
To his right, slightly behind, Kizito Rwanza.
To Kizito's right, Takesure Muzengeza.
To his right, David Gopito.
Front, far right, in light hat, Stephen Chatsama.
To his left in white overalls, Fanny Mupfawa.
Just behind and left of Fanny, Temba Gengheza.
In front of Fanny, in colorful shirt, Ngoni Mrewa.
To Ngoni's immediate left, Ernest Chiwaridzo.

has grown into a boiling cauldron of creativity.

For artist and collector alike, these are exciting times. From the Nyanga mountains, the Mutare highlands, the Chimanimani rain forests, the Guruve plateau, the outskirts of Harare, and yet other, smaller towns, more countrymen and women are daily joining the growing family of Zimbabwean artists. Some express regional styles, while others have developed individual, unique expressions of their spiritual dreams. Still others have chosen to interpret modern themes that reflect a new awareness of the challenges of independence, and of the socioeconomic quandaries and paradoxes of the increasingly modern world that surrounds them.

And what of the future? After these unpredictable, and exhilarating first years we would not hazard a prediction of the "shape of Shona to come!" But we are sure that whatever happens, whatever shape Shona Sculpture may take, these fascinating and intuitive artists will continue to surprise, captivate and intrigue all of us for whom Shona Sculpture holds such a powerful fascination.

His Excellency, Robert Mugabe, President of Zimbabwe, stated that: "Shona Art is something like the anthem of our freedom, and remains now at the center of our culture… (in fact) the artists are the precursors of our history." We wholeheartedly agree, for the artists reflect the conscious feelings and directions of a people which then, as a collective, can chart an entire country's path and destiny. Their renewed cultural and national identity has, literally, been carved in stone.

Some of the talented artists of the Canon Paterson cooperative. While their work is collected worldwide, their significant contribution to the Shona sculpture movement is often overlooked. (See facing page for artist identification).

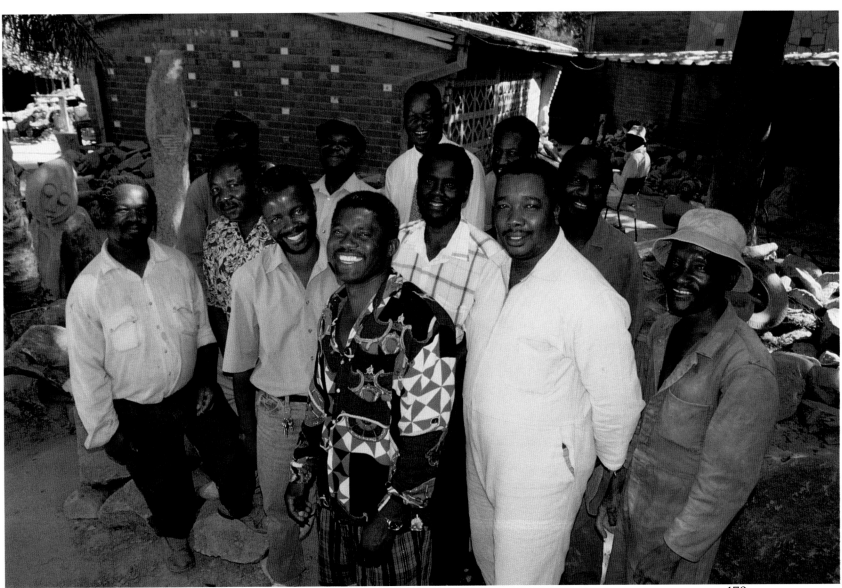

"So, take the hint: throw aside art-history ideas
of influence… and enjoy these as sculpture,
as in the language of sculpture discovered afresh,
under the chisel."

—Michael Shepherd
Art Critic for *The Guardian* and *The London Times*

FINDING ITS WAY HOME

Just arrived from Zimbabwe,
the sculpture still rests in its crate,
awaiting a new home.

Woman Asleep In The Stone
W. Luke
48"

T HERE WAS NO QUESTION THAT
Anthony and I would spend our honeymoon
in Zimbabwe. He was as eager to show me
his childhood home as I was to see it. He
spent months planning the trip, which would include
taking the famous Garrett steam train to Victoria Falls
and an extensive photo safari.

I was promised great herds of elephants lumbering
across the savannah, elegant giraffes reaching for the
tender leaves of the acacia trees and majestic lions
strolling through the grass.

I wanted Laura to love the country as much as I
did—its wild beauty, the graciousness of the people,
the timeless wonder of this ancient continent. I wanted
her to discover sparkling facets of Africa that few
tourists ever see.

On this, my first trip to Africa, I did discover the beauty, graciousness and timelessness of Africa, but not exactly in the way Anthony had intended.

The trip had been long and tiring, but as soon as I crossed the threshold of Anthony's father's house I felt relaxed and at home. Much of that had to do with father's warmth. Looking back, I believe his home was filled with welcoming spirits, too.

Even in my somewhat dazed state of mind, I noticed a wonderfully elegant sculpture sitting on a sideboard in the entry-way. It was a giraffe family. As we made our way out to the terrace for some tea, I noticed a powerful stone face on the stairs leading to the garden below.

Once outside I saw sculptures everywhere I looked, most of them buddha-like figures in various poses. In all of our long discussions of his life in Africa, Anthony had never mentioned that his father was an art collector.

"Mr. Ponter, I had no idea you had such a wonderful sculpture collection," I said. "You must have been collecting in Europe for years."

His eyes sparkled. "My dear, these were not sculpted in Europe."

"You mean there are European artists working here?"

He quietly smiled at my naiveté and, taking me gently by the arm, asked if I would like to take a stroll in the garden. Though I couldn't remember the names at the time, I know now that his garden was home to massive, powerful heads by Boira Mteki, animal figures by Robert Kwechete, Henry Munyaradzi spirit pieces, a rain bird by Lazarus Takawira… more sculpture than I could comprehend. As we ambled from piece to piece, father told me stories of the artists who carved them, their engaging folklore along with their fascinating history. It was obvious that his love for the sculpture and their creators was profound.

I've forgotten when during my tour he told me that the sculptures were created by the Shona, but I remember being embarrassed at my own Euro-centric assumptions and more than a little angry at the limitations of my Western education. My whole concept of African art—all I had been taught in all my art history classes—had been shattered. Not only had I never seen anything like this, but I had never even read about it before. Nothing in my education had prepared me for a contemporary African art movement.

As we walked, Father explained that not only were these artists not European, they had never seen the work of European artists. He said they were self-taught and often used primitive wrought-iron farming tools. When even those tools were scarce, they created tools out of scrap metal from junked cars.

Though their tools were primitive, the Shona and their sculpture are anything but primitive. My ears still burn when I remember father's scornful retort to my question about this 'primitive' art.

"Primitive art? Oh no, my dear," he said. "Their sculpture is anything but primitive. In fact, I deeply resent the use of such a term as primitive. After all, primitive refers to something unsophisticated and in embryonic development . . . like Western modern art, or a new budding country such as America. The Shona, my dear, have had hundreds of years to develop and, indeed, their art reflects those ancient roots."

Chastened, but still skeptical, I asked, "But this sculpture is so powerful, so sophisticated, so polished—how could it come out of the bush?"

My father had been collecting sculpture since before I was born. When I was very young, in the early 1950s, he used to travel frequently up to the Nyanga Mountains and I know that he would sometimes buy pieces there. More often though, sculptors would come to the house and show him their pieces. Invariably he would buy them. I first met Boira Mteki and Henry Munyaradzi as friends of my father's, never realizing that they were on their way to becoming internationally-recognized sculptors.

When Laura turned to me and asked incredulously why I had never told her about this wonderful sculpture, I was at a loss for words. The sculpture had simply always been there. My father never boasted

Abstract Eagle
Isaiac—a new third
generation sculptor
12"

182

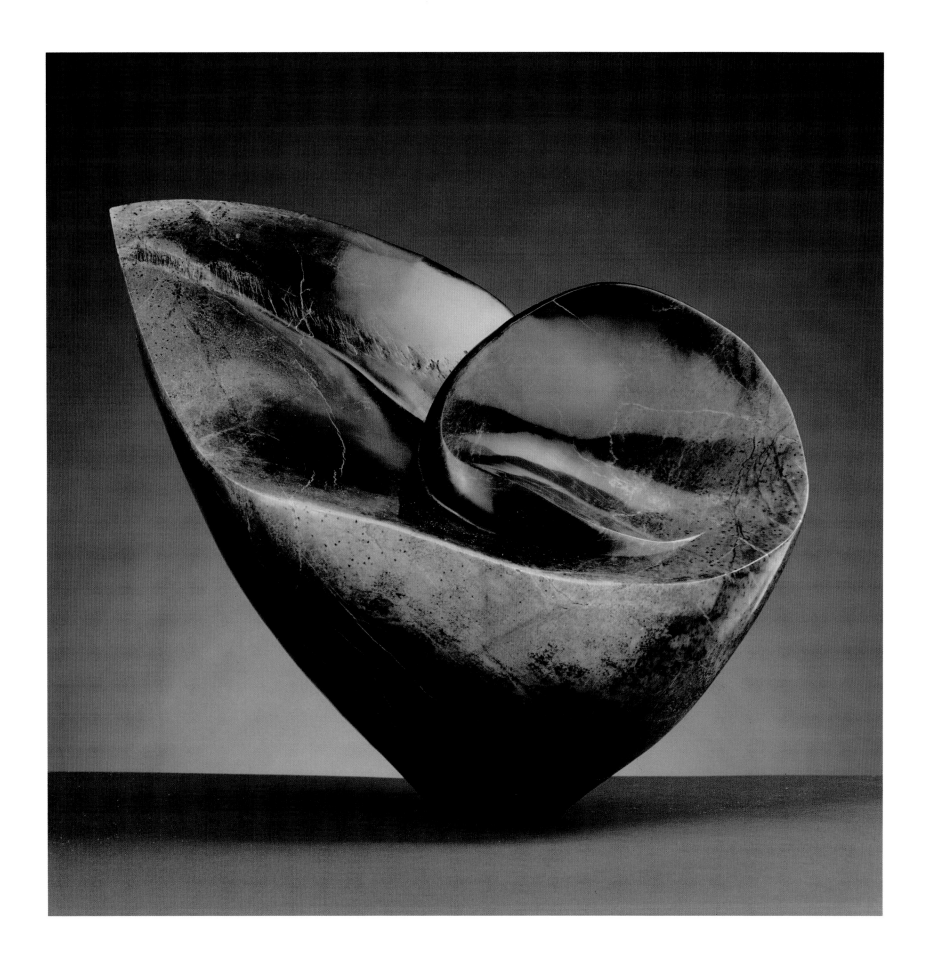

about the sculpture or his role in collecting it. His collection represented his love and respect for the art, the people and their culture, and I accepted it without question.

Energized by the art, Laura suddenly had thousands of questions. My father answered those he could and finally said, "Go on. Go find out for yourselves."

All of my carefully made plans were promptly forgotten as we hit

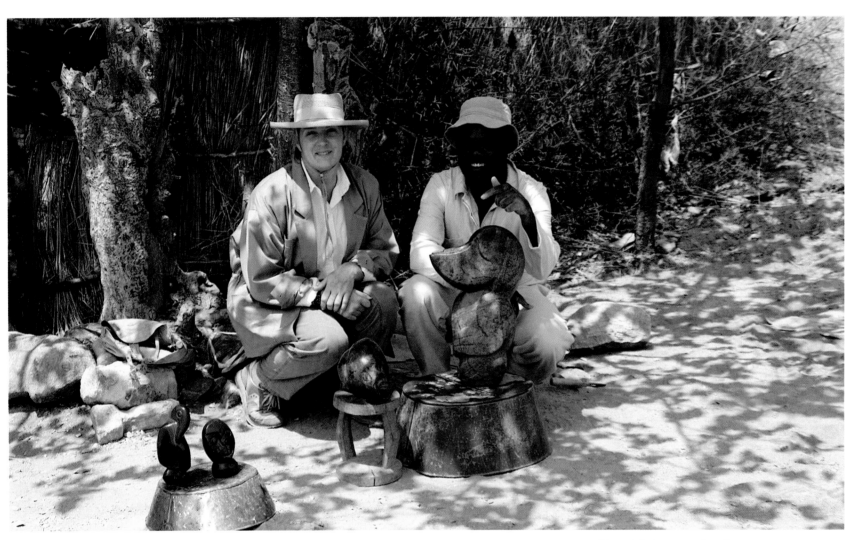

Edronce Rukodzi recites traditional folklore and Shona history to the author.

the road in search of Shona stone sculptors.

Our adventure was born on my father's terrace and it has returned there. My father was a collector in the best sense of the word. Much of our own philosophy of collecting developed from his wise counsel.

Born and raised in Zimbabwe, the grandson of English immigrants, my father was forced to leave school at an early age

when his father died. Still, he never lost his love of learning. A voracious reader with a brilliant analytic mind, he liked nothing more than a stimulating discussion of great ideas on a long Zimbabwe evening. From Greek philosophy to Churchill and World War II, from modern art to modern physics, he could knowledgeably debate just about any subject, and enjoyed doing so. The point was not to win, but to intellectually challenge one another and discover new ways of looking at the world.

By vocation he was a businessman and entrepreneur, but his avocation was encouraging young people to reach for their dreams. I will never know how many people he helped get started in business, or helped through a tough time, but I do know how much he helped Laura and me. When we decided we wanted to bring Shona sculpture to North America his advice was invaluable. If we were serious about building a collection and bringing it to the United States, he said, then we had better do it right.

From the beginning, our goal has been to support the artists in Zimbabwe by making their work accessible to a wide audience of people. Because of Zimbabwe's historical geo-political isolation, many collectors knew nothing of their work. We also believe very strongly in education. Although many people who know nothing about the Shona are immediately attracted to their work, we feel it is vital for people to have at least an introductory understanding of the culture which produces this exquisite art form. The Shona, with their cultural emphasis on the family and *ukama*, have much to teach us.

PERSONAL COLLECTING

Collecting for a project such as ours is quite different from building a private collection. From the beginning, we believed that the movement itself, with its inseparable connections to the spiritual and cultural life of the Shona, was of paramount importance. Also, we wanted to support Shona sculpture as a movement embracing hundreds of artists, young and old, not just a few select artists who had already achieved international recognition. After personally meeting many artists and experiencing their culture, we realized that this art movement was greater than any one sculptor or gallery with a proprietary stable of artists. Rather, the movement embraced an entire culture's inspirations, creativity and life force. So, why limit a collection or an art movement to just a few big names?

As an early supporter of this fledgling art movement, my father

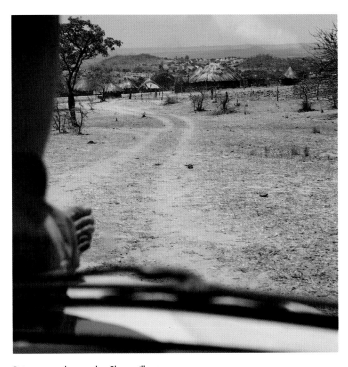

Being escorted to another Shona village
by a sculptor on the Land Rover's hood.

Family Embrace
Francis Mugavazi
16"

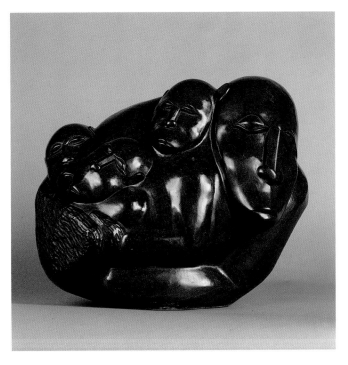

felt very strongly about not imposing his own artistic sensibilities on the artists. His collection of several hundred pieces was eclectic, to say the least. At a time when it was difficult for artists to find buyers for their work, he wanted them to continue carving their own visions, not what they thought others wanted to see.

Further, he never believed in an artist signing an 'exclusive contract' with respected internationally, there is always the danger that the marketplace will begin to dictate styles. Realizing that we, and others like us, have a discernible impact on the sculpture community when we purchase several hundred pieces at a time, Laura and I make a conscious effort to buy from a widely diverse selection of artists representing various styles. We feel strongly that the artists must continue carving to express

any man or business. These contractual chains would limit the artist's creativity and fetter their very souls. The inner life force existing in all human spirit, father wisely knew, could never be owned.

THE DYNAMIC MOVEMENT

Though Shona sculpture is becoming more widely recognized and their own visions and dreams, not carving to please our personal tastes or those of a mass market.

Building an overseas collection that sometimes numbers as many as 1,000 pieces at a time gives us a perspective of the dynamic nature of Shona sculpture that we might not have otherwise. Though a piece of sculpture from 20 years ago is as certainly Shona as a piece carved last year, we do see differences.

186

An artist who was carving abstract animal figures suddenly turns to human forms of a completely different style. Another artist becomes fascinated with a certain shape of *mudzimu* and begins a series of pieces. Though an artist might create as many as a dozen pieces on a theme, each is a slightly different variation. After a period of weeks, months or even years, an artist may move on to an entirely different style and never go back. Most frustrating, from our point of view, is the artist who sculpts one or two brilliant pieces and never carves again. We've returned to Africa many times eager to find an artist who showed great promise, only to discover that he disappeared into the countryside, perhaps returning to his primary role as a farmer or herder.

Now, the movement is so diverse in ideas, images and styles that no one 'style' can capture its essence. At a recent exhibit of 500 different works of Shona sculpture in North America, some members of the audience commented that in looking around the room they couldn't find a single style of which they could say definitively, "That is Shona."

Further, many who attend the Shona sculpture exhibits can't believe that all the art exhibited could possibly come from one small ethnic group within one small African country. In London, the *Kensington Times* was equally stunned and quoted Lord Chelwood as saying "It may be difficult for some people to wake up to the fact that quite suddenly, a small country in the heart of Africa is making a major contribution to contemporary art."

THE JURY IS IN

Because neither the artists nor the art follow the rules of "African art" as set by Western art critics, Shona sculpture is only very slowly gaining acceptance from Western art critics. When Laura and I first began bringing Shona sculpture to this country, we had trouble finding gallery owners who would even consider showing Shona sculpture. They hadn't heard of it, it didn't fit their preconceptions of African art, and therefore for them, it just didn't exist.

Most, as we discovered, were completely unaware of the history of Great Zimbabwe and its contribution to Southeastern Africa's development.

During November 1989 in New York, Sotheby's resident African art expert stated, "There is no significant culture or art in Southeastern Africa." This wholesale dismissal smacks of racism and arrogant ethnocentricity. It ignores the fact that Shona artists first began receiving international recognition during a 1962 exhibit at The Commonwealth Institute in London. In 1968, a Shona exhibit titled "New African Art" opened at the Museum of Modern Art in New York and toured several major American cities. The first exhibit of Shona sculpture at the prestigious Musée Rodin was in 1971.

The Smithsonian's National Museum of African Art still does not include any pieces of Shona sculpture or appreciable information on their culture. When asked in 1988 about the Shona and their sculpture, the curator first replied, "Shona is a religion, not a tribe." This indeed showed the need for further education and a reassessment of current understandings. Then, in March 1992, when asked again about Shona sculpture, the curator stated, "It's like any contemporary art. One waits a little for the dust to settle. The jury is still out."

By such limited logic, then the jury has been out for more than 25 years! In the meantime, collectors are rapidly making Shona sculpture a highly sought-after art form. And, though some artists disappear, it seems that with the increased international demand for Shona sculpture, more and more talented artists are appearing. It has become faddish recently to worry about protecting the purity of Shona sculpture, and some critics are wringing their hands and hearkening back to the good old days when the sculpture was powerful and the sculptors were unknown.

It seems, according to these critics, that the

Young third generation sculptors from Guruve

movement has become too popular and should be refined in some way, perhaps through the selective banishment of less recognized talents.

There is a certain narrow-mindedness, arrogance and grave danger to that viewpoint. Just who is to decide whose art should be encouraged and whose sculpture should be ignored?

When I was a teenager, Richard Mteki showed up at my father's house with crudely carved little owls and elephants to sell. The carving wasn't exceptional in any way, perhaps not even as intricately wrought as some of the sculpture which is dismissed today as 'airport art'. Still, my father saw a dream and a desire in the young man that he wanted to encourage.

Today Richard is one of the best known and best loved of the sculptors. He has developed a distinctive style that is instantly recognizable to his collectors around the world, and strikingly different from the work of his acclaimed older brother, Boira. As with many beginning artists, if Richard's early efforts had been dismissed, the world would be a poorer place.

COLLECTOR AS ARTIST

Fortunately, the beginning private collector need not worry about who should be encouraged and who should be exiled. The criteria for collecting is fairly straightforward: Does this art speak to me?

In essence we believe that it really is that simple, but it might be helpful to discuss collecting as the development of three basic attributes: commitment, aesthetic judgment and knowledge. These are not suggested in order of priority; one follows quite naturally from the other. None of these attributes is, or needs to be, fully developed in order to begin a collection. In fact, the novice usually begins with interest only and without highly developed aesthetic judgment or knowledge.

Good art can be collected even with modest means. Start with a specific budget in mind. Then, as your

Richard Mteki
at sunset with
Chaminuka
28"

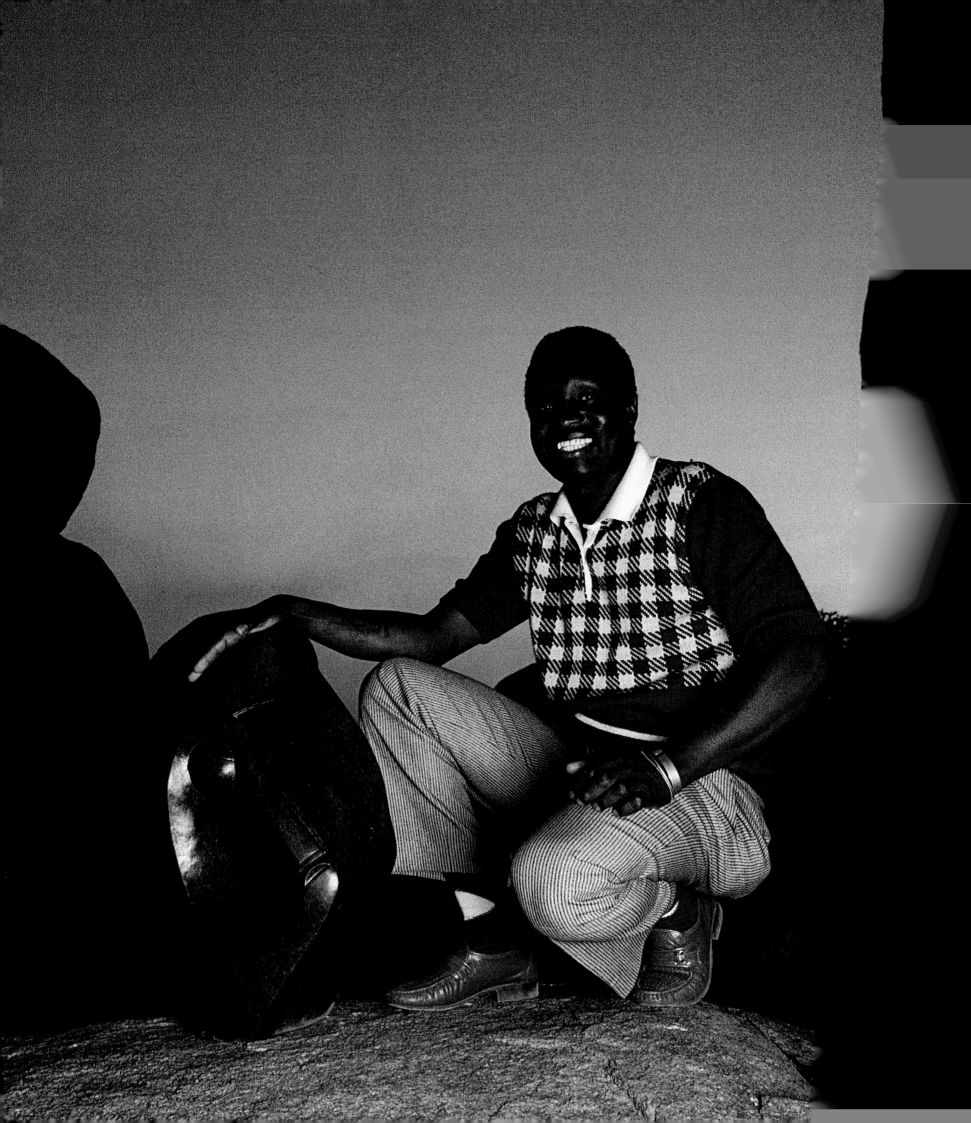

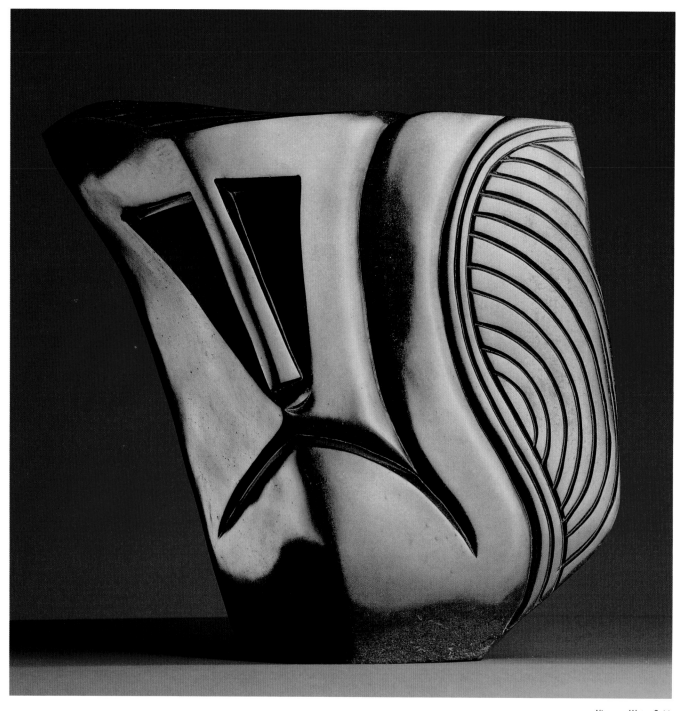

Njuzu or Water Spirit
Richard Mteki
26"

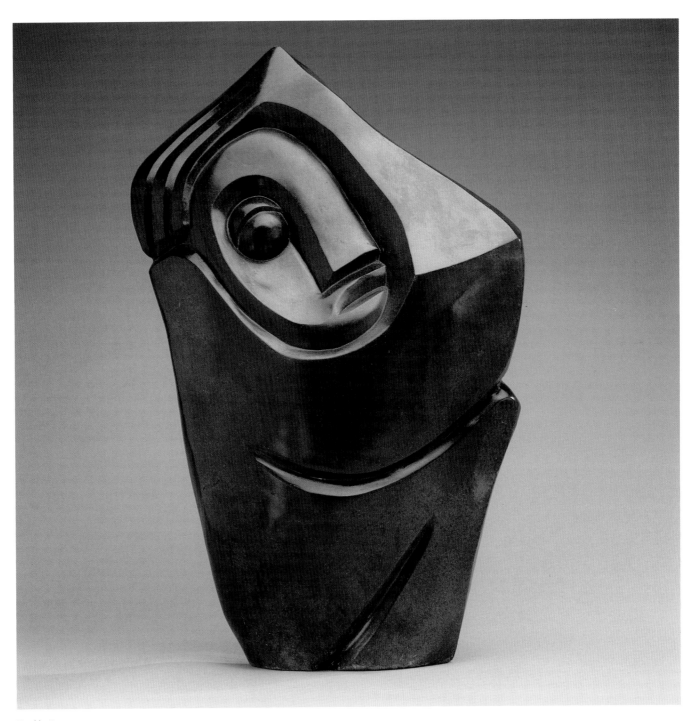

Humble Man
Richard Mteki
36"

judgment, taste and knowledge expands, you will become more confident of your ability to discern value.

Once the first choices are made, the collector has already begun to turn an interest into a commitment. From this small step begins a process of personal development that will parallel the development of the collection. The collector's visual perception and aesthetic responses are challenged by every choice of sculpture.

The development of aesthetic judgment can be hastened by studying art and cultural history, visiting museums and galleries, acquiring and reading books and art magazines and, most importantly, through travel. However, with the exception of a few books written and published in Zimbabwe, there has been very little written on Shona sculpture. And to date, this is the only book on Shona sculpture published outside of Zimbabwe.

With Shona sculpture, as with any other art form, it is clearly possible to derive enjoyment from a work of art without knowledge of the circumstances in which it was created. Ideally, however, one should have some background for a deeper appreciation. When collectors look at a carving, they naturally ask themselves, "What was the artist trying to do? Represent the spirit of an ancestor? Show the metamorphosis of the spirits into an animal or man? Depict a god?" and many other questions. In this respect, African art is the same as Western art—the greater the knowledge, the greater the enjoyment.

So, the third resource—knowledge—naturally follows from the first two. Collectors begin to study a specific area of interest more intently, to seek out the artists, the sculptural styles and the cultural meaning of the work that most interests them.

Ideally a collection should be open-ended; it should develop as the collector develops. To be unique, a collection should reflect the personality of its owner. Only then will a collection become more than the sum of its parts. Then it will add something new to the art

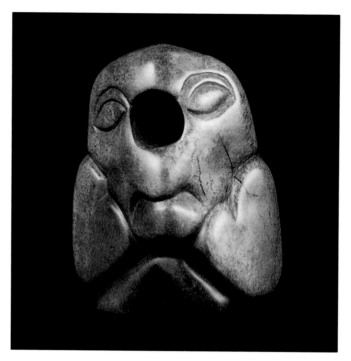

Upon first seeing this piece, I became excited and began to spout all sorts of Western metaphysical interpretations as to the sculpture's "meaning." The artist patiently stood by until my effusive oration had ended. Much to my embarrassment, he then quietly informed me that the piece was simply titled "Man With A Hole In His Head." In my rush to explain the piece, I myself had fallen prey to that very typical ethnocentric stereotyping of which I had so often warned others.
—Anthony Ponter

Man With A Hole In His Head
Charles Mudadirwa
12"

world—a new perception, a new approach, a new cultural or educational understanding.

The act of collecting inevitably involves risks. A collector reveals himself—his intuitions, sensitivity and aesthetic judgments—just as the artist does. Both collector and sculptor are vulnerable to outside evaluations and criticisms. But, without those risks, there never can be that very special sculpture or that very special personal collection.

Collecting sculpture is an intellectual and emotional exercise, of course, but it should be a tactile one as well. Artist Beniamino Bufano said, "[The sculpture] should be inviting to the touch as well as the eyes. Rubbing your hands over the artist's medium provides a most pleasant introduction to the work." To the learned eye and hand, the texture can tell a most wonderful story of the stone's components, age, geology and source. The stone itself contributes immensely to the subject of the work and enhances its symbolism. Semiprecious verdite, for example, has deep green and gold veining that resembles the verdant veldt of Africa. The finest verdite sculptures produced by the Shona invariably evoke the deep cultural links that the Shona feel to the land they inhabit.

Although there are many reasons for starting a collection, in the end, it must be a labor of love, as American painter Fred Uhlman points out.

"I bought my first African mask, not because I liked it, but because I felt that being now a painter, I had to be in the movement," he wrote in the early part of this century. "Most of the artists I admired—Picasso, Modigliani, Derain, to mention only a

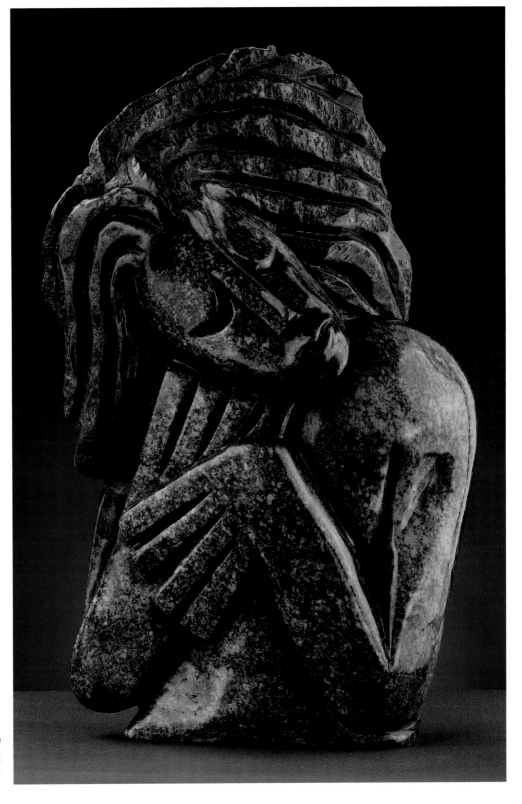

A Good Woman
Kennedy Musekiwa
22"

193

few—had collected African art and had been profoundly influenced by it.

"Shortly afterward, I bought the Baule fetish and the Baule bobbin, which are still two of the finest pieces in my collection. It is easy to see why I bought them and why, from that moment, I have never stopped collecting.

"The head of the bobbin, or heddle-pulley, which is, after all, only a functional object for the purpose of weaving, seemed to me then and today as beautiful as a Greek goddess. The fetish moved me as deeply as the bobbin by its silent tragic dignity and its air of profound meditation. They appealed to me as a European brought up in the classic tradition of Greece and Rome. Everything I have ever bought is submitted to the same test: does it speak to me or move me?

"Somebody may argue that this is too narrow an approach and that it means that I exclude works of great power. This may be so, but for me it is the only

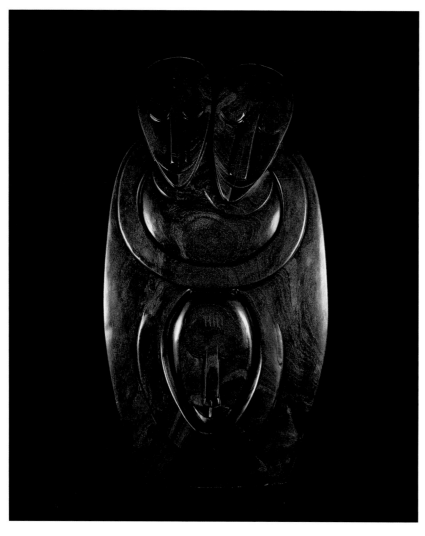

(Above)
Family Embrace
Phineas Kamangira
38"

(Right)
Good Man
Richard Katinhamure
34"

honest and reasonable approach if one collects for pleasure and not because something is strange or rare or a good investment. After all, I have to live with my collection."

Many collectors to whom we have spoken never dreamed that after acquiring their first sculpture they would acquire more. In fact, most acquired their first sculpture on the spur of the moment. However, as they live with their art, they find themselves seduced by its aesthetic and spiritual qualities. Some are so profoundly moved by their sculpture they later find themselves collecting more.

Anyone who collects art knows the feeling of walking into a roomful of art, only to be drawn to one particular piece. Some of our collectors tell us that their sculpture called to them. Collector Margaret Helke is one of many who have told us, "I would not have believed that a piece of stone could speak to me and so strongly move my soul."

The Shona say that each work of art finds its way home to its predestined owner. For whatever reason, that does seems to be true.

Once a sculpture does find its way home, the collectors often feel they have become, in some way, part of the extended Shona family. Perhaps that is because the sculpture evokes those feelings of harmony and peace—*ukama*—that earn the blessings of the ancestors and reminds them of our closer global family.

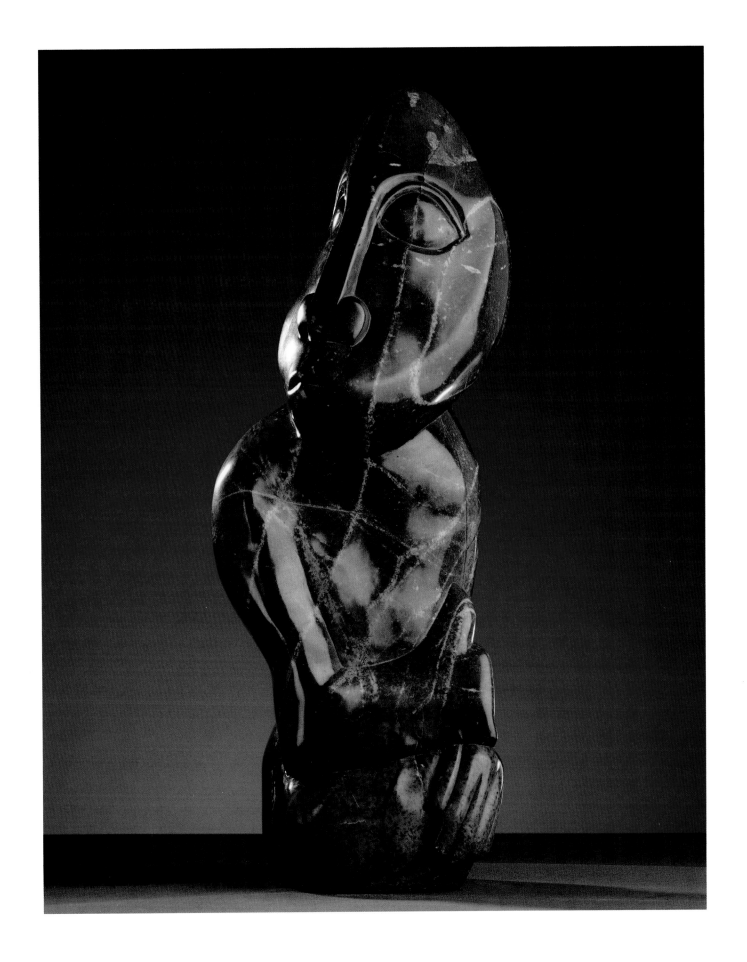

QUOTES

Over time, art critics have observed and reviewed the progress of Shona sculpture. The following examples document the universal appreciation of this art movement.

1962 "A new era begins in African Art."
Commonwealth Today, London

1962 "But in Africa a great movement is stirring. Something new is happening here, a fresh creative flood that will burst out to give a new dimension to international expression."
"The Arts in Review," London

1963 "One of the most important exhibitions to hit London since the war."
Studio London Commentary

1963 "The exhibition consisting of works from Rhodesia (Zimbabwe) is a striking demonstration that in Africa now vigorous expression can flourish."
The Times, London

1981 "A major Sculptural and artistic event. It expresses that rich, integrated connection between spirit, mind and sense that is the exhilarating gift that the Shona of Zimbabwe have to contribute to mankind."
"It is this urge to manifest the connection between the visible world and the world of cause and spirit which takes Shona sculpture into that major league of sculpture and art and humanity's profoundest expressions."
Sunday Telegraph, London

1981 "An exhibition of 170 sculptures… one of the most notable artistic events of recent years in London… The sculptures manifest just those qualities that Epstein stood for: a sensitive humanity and spiritual significance in the subjects chosen; a primitivism of approach in the sense of an original, deeply-felt approach to those subjects; a truth to materials that respect the nature of the stone and the contribution it makes, materially and spiritually, right through the whole process of shaping and expressing. Don't miss it."
What's On In London

1981 "The art form is no longer a new phenomenon to be enthused over in faddish art circles. To see the exhibition is to realise that Shona Sculpture has come of age and should be better appreciated internationally."
The Times, London

1983 "…you can forget the word 'ethnic' for this is sculpture of world quality and intensely human, spirited in every sense, and superbly skilled… it is extraordinary to think that of the leading 10 sculptor-carvers in the world, perhaps five come from one single African tribe (Shona)."
Sunday Telegraph, London

1983 "If the perfection of art is measured purely by emotional expressive power, then this art is beyond perfection."
West Indian World, London

1984 "It may be difficult for some people to wake up to the fact that quite suddenly, a small country in the heart of Africa (Zimbabwe) is making a major contribution to contemporary art… the evocative nature of these sculptures, which reflect the spirit of the Shona people and their ancestors, is bound to impress, stimulate and inspire. No one looking at them can feel indifferent."
—Lord Chelwood in the Kensington Times, London

1984 "Michelangelo's spiritual ideal, of the individual form waiting to be released from the individual stone, is even more apparent here than in most of Michelangelo's own marbles."
Sunday Telegraph, London

1984 "These marvelous Shona sculptors from Zimbabwe… speak for Africa, but they also speak for us all; they restore a dignity to art which it is in danger of losing."
Sunday Telegraph, London

1986 "...unlike art found in much of the rest of Africa, Shona sculpture... has become a wholly indigenous modern art form created exclusively as a form of artistic expression."
New York Times

1987 "The works are awesome in their beauty, and captivating in the mystery and spirituality that surround each creation... The primitive sculptures are graceful in design, their beauty is distinct, and the work and heritage that influences the pieces is uniquely Shona... This is a show of what's right with Africa. People who are purchasing these works are making a contribution toward the continuing self-sufficiency of Zimbabwe."
Beverly Hills 213

1987 "Shona sculpture from Zimbabwe is part of an art movement which emerged in Africa in the 1960s and has now been hailed on the international art scene. It is sculpture of world quality by African sculptor-carvers, extracting in the spirit of Michelangelo or Epstein the individual spirit of the stone."
The Courier Mail, London

1987 "They've never been to art school. They've never seen the works of Picasso or Bufano. And many do not know how to read. But working with tools made of tableware and crude chisels fashioned from discarded truck springs, members of Zimbabwe's Shona tribe are carving their future in stone... Working in exquisitely shaded verdite, serpentine, granite and soapstone, Shona sculptors are attracting world attention and are now earning incomes that rank them in the top third of their nation."
The Tribune, Oakland, California

1988 "Shona Sculpture is perhaps the most important art to emerge from Africa this century... Rockefellers and Rothschilds were early connoisseurs of Shona sculpture. Prince Charles has become a collector. Not long ago Richard Attenborough came to Zimbabwe... before leaving, the director shipped 29 crates of Shona pieces home to England."
Newsweek Magazine

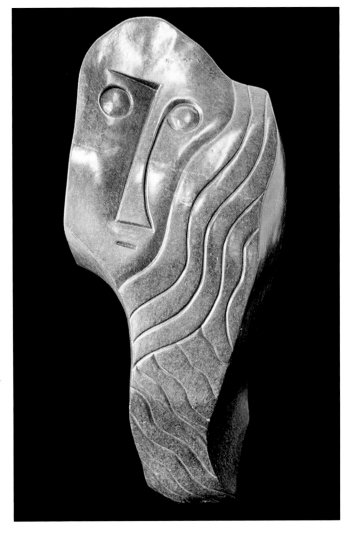

*Njuzu
(Water Spirit)
Richard Mteki
30"*

1988 "And they were selling like hotcakes at the exhibit's opening night last week, with people literally lining up to reserve their choices... Most of the artists in the show haven't heard of Moore or Brancusi or Miro, but you'd never know it to look at their work."
Chicago Tribune

1989 "They are producing fine stonework... the finest, some say, in the world... The naturalism and spiritual qualities of this work make it easily accessible to westerners...."
The Economist, London

1989 "The carving has gone from strength to strength and is a powerful art form in modern Zimbabwe."
The Spectator, London

"Zimbabwe ... a progressive country with the will and wherewithall to prosper."

—David Jones
The Nature of Zimbabwe

ZIMBABWE TODAY

Z IMBABWE, A LANDLOCKED NATION roughly the size of California, emerged from white-minority rule only 12 short years ago. The new majority government inherited, and has maintained, one of Africa's more stable and industrialized economies as well as a modern road network, a high literacy rate and high standard of living compared to other African nations. The number of schools has quintupled in the past ten years.

Since independence, Zimbabwe has achieved remarkable increases in rural small-scale agriculture. Before independence, the small rural farmer accounted for less than 2 percent of the nation's total agricultural output. Today, the independent farmer contributes about 30 percent to the country's farm wealth. No other African country has yet come close to such an improvement in the vital area of rural food production.

Zimbabwe's economy is fueled by more than 14,000 companies, both small and large, which operate

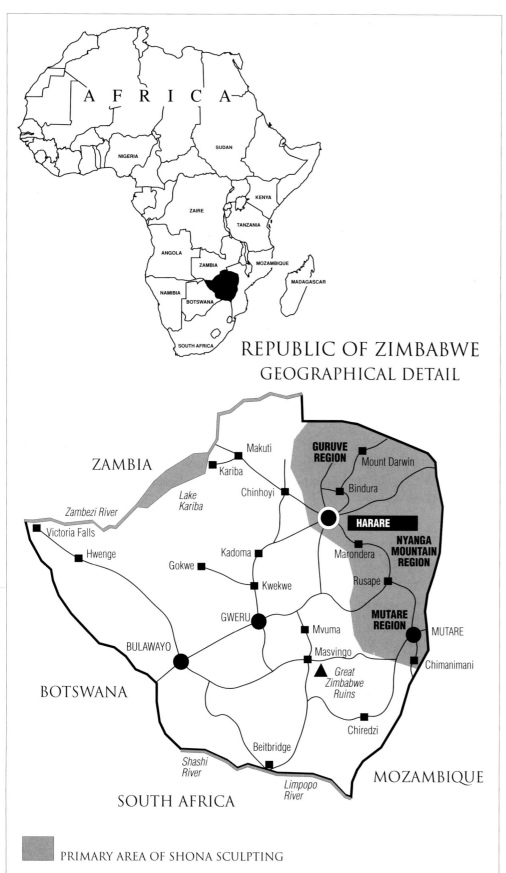

REPUBLIC OF ZIMBABWE
GEOGRAPHICAL DETAIL

AFRICA

NIGERIA
SUDAN
KENYA
ZAIRE
TANZANIA
ANGOLA
MOZAMBIQUE
ZAMBIA
MADAGASCAR
NAMIBIA
BOTSWANA
SOUTH AFRICA

ZAMBIA

Makuti
Kariba
Chinhoyi
Zambezi River
Lake Kariba
Victoria Falls
Hwenge
Gokwe
Kadoma
Kwekwe
GWERU
BULAWAYO
Mvuma
Masvingo
Great Zimbabwe Ruins
Chiredzi
Beitbridge
Shashi River
Limpopo River

GURUVE REGION
Mount Darwin
Bindura
HARARE
Marondera
NYANGA MOUNTAIN REGION
Rusape
MUTARE REGION
MUTARE
Chimanimani

BOTSWANA
SOUTH AFRICA
MOZAMBIQUE

PRIMARY AREA OF SHONA SCULPTING

with more than 1.2 million employees in agriculture, mining, manufacturing, construction and service industries.

ZIMBABWE—AT A GLANCE

Official Name
> Republic of Zimbabwe

Location
> Southeastern Africa, landlocked and bordered by the countries of Botswana, Mozambique, South Africa and Zambia.

Population
> 12,000,000 (estimate in 1997). Shona, Ndebele, Tonga, White, Indian, Chinese.

Capital City
> Harare (1.5 Million population).

Official Language
> English.

Major Local Languages
> Shona, Ndebele.

Area
> 150,873 Square Miles.

Highest Mountain
> Mount Inyangani: 8,541 feet.

Lowest Altitude
> 500 feet, at the confluence of the Sabi and Lundi Rivers.

Longest River
> Zambezi, 1,674 miles; (372 miles border northern Zimbabwe).

Largest Lake
> Lake Kariba: 2,000 square miles (manmade) created in 1959 by damming the Zambezi.

Highest Rainfall
> Nyanga Region: approximately 50 inches per year.

Type of Government
> Multi-Party State.

Head of State

President Robert Mugabe.

Parliament

House of Assembly with 150 members elected from constituencies to five-year terms.

Majority Political Party

ZANU-PF or Zimbabwe African National Union—Patriotic Front.

Principal Mining Minerals

Gold, asbestos, chromium, coal, cobalt, copper, iron, nickel, platinum, silver and tin.

Principal Crops

Tobacco, corn, sugarcane, wheat, barley, millet, sorghum, potatoes, cassava, soybeans, oranges, bananas, groundnuts, cotton, tea and coffee.

Principal Trading Partners

South Africa, Britain, Germany, United States, Japan, Italy, Botswana and Zambia.

Currency

100 cents = 1 Zimbabwe Dollar.

Harare Skyline

HISTORICAL CHRONOLOGY

All dates before 1700 A.D. are approximate.

30,000 B.C. Stone Age Khoisan (bushmen) hunters and gatherers arrive in Zimbabwe.

500 A.D. First Bantu people arrive.

1000 The Bantu Shona people settle the plateau.

800-1100 Great Zimbabwe was established along with hundreds of smaller stone settlements which supplied this trading center.

1100-1400 Great Zimbabwe rises to prominence as a commercial empire. Radiocarbon dating and archeological evidence suggest that this royal capitol reaches it greatest importance during this period.

1400 Mutapa state established in the north as Great Zimbabwe declines.

1450 Great Zimbabwe abandoned. The Khami stone settlement is established, along with numerous stone towns throughout central Zimbabwe.

1505 Portuguese establish a trading post in Mozambique.

1514 First European (Portuguese) steps foot in Zimbabwe.

1629 Mutapa state falls to Portuguese.

1693 Changamire State and Rozvi (Shona) expel Portuguese from plateau.

1700 Monomatapa (descendant from the Mutapa State) takes his kingdom into Portuguese territory.

1820 Zulu-born Mzilikazi flees Shaka and Zululand in South Africa. He takes refuge in the Transvaal and creates Ndebele nation.

1837 Boers drive Mzilikazi out of Transvaal into southwestern Zimbabwe.

1868 Mzilikazi dies and three years later his son, Lobengula, takes the throne.

1888 Lobengula unknowingly signs the treacherous Rudd Concession. This gives mineral rights to the British South Africa Company and also gives white British colonials the right to settle Mashonaland (Zimbabwe).

1890 First group of settlers hoisted the British Flag over Fort Salisbury.

1891 The Master and Servants Act is created, making it a criminal offense for any servant to not obey an order given by an employer.

1893 British settler force defeats Lobengula and the Ndebele.

1894 Lobengula dies.

1895 British territory proclaimed "Rhodesia" and British South African Company enforces mandatory registration for all Africans. Special passes are required for any African in "white" areas.

1896-97 The Shona and Ndebele rebel against British occupation. This is the first Chimurenga, or struggle against colonial oppression.

1923 British South Africa Company rule ends and the newly formed Southern Rhodesia becomes a British Crown Colony.

1930 Land Apportionment Act passed which separates the country into "white" and "black" areas of occupation, giving whites the exclusive use and control of 50.8 % of the land, including nearly all of the most productive agricultural land.

1934 Industrial Conciliation Act passed to prevent Africans from joining trade unions or training to become qualified for skilled work.

1950 Subversive Activities Act banned meetings and literature considered a threat to the colonial government.

1953 Federation of Northern Rhodesia (now Zambia), Southern Rhodesia (now Zimbabwe) and Nyasaland (now Malawi) formed.

1958 Public Order Act is passed. Anyone could be arrested or detained without charge or trial.

1959 Law and Order (Maintenance) Act, Native Affairs Amendment Act, and Preventive Detention Act and Unlawful Organizations Act are enacted. All gave the colonial government wide powers to limit individual civil rights.

1960 Eleven Africans killed by colonial police. These are the first deaths in the independence struggle since the 1896 rebellion.

1961 New constitution ratified which promised majority rule for Africans. However, it allowed the white government to postpone majority-rule government indefinitely.

1963 Federation disbands when Northern Rhodesia (Zambia) secedes.

1964 Ian Smith becomes Prime Minister of Southern Rhodesia.

1965 November 11th Prime Minister Ian Smith declares U.D.I. or Unilateral Declaration of Independence from Britain. Southern Rhodesia stands alone.

1966	United Nations places sanctions on Rhodesia.
1969	Prime Minister Smith introduces new constitution that demands segregation of all peoples in country and passes Land Tenure Act that imposes permanent segregation.
1970	United Nations does not recognize the new republic of Rhodesia.
1971	Prime Minister Smith offers settlement with British government for long term transition to Majority Rule. Bishop Abel Muzorewa forms the African National Council (ANC).
1972	Africans rebel against long term transition. Guerrilla activity increases.
1974	African nationalist leaders are released from prison and go into exile in order to organize the resistance.
1976	Formation of the Patriotic Front. Temporary alliance of Zimbabwe African National Union and Zimbabwe African Patriotic Union to stand as a united front.
1979	Leaders of the Patriotic Front, Robert Mugabe and Joshua Nkomo, signed the Lancaster House Agreement with representatives of the British government and a sanctioned transitional government. This agreement called for a cease-fire, the drafting of a new constitution and free elections within six months. By now, 27,000 on both sides have died in the struggle.
1980	Robert Mugabe's ZANU-PF party wins the first free election. April 18th, Zimbabwe is created as an independent state. Robert Mugabe becomes the new country's first Prime Minister. British flag taken down for the last time ending almost 90 years of colonial domination. New government unveils a $400 million program for reconstruction with emphasis on rural areas.
1981	Riddell Report sets groundwork for improved new relations between commercial employers and employees. Fair wages are established.
1982-84	Severe drought impacts Zimbabwe.
1982-85	Transitional National Development Plan initiated. Promotes economic growth, education, resources parity and health care.
1989	Liberalization of Investment Code. New business growth and foreign investment is encouraged.
1992	Worst drought in recorded history forces importation of food resources for entire population. President Mugabe declares first national emergency.

Downtown Harare

BASIC GLOSSARY
OF SHONA TERMS

adze	Handmade traditional iron hatchet		*mutsvairo*	Traditional broom
ambuya	Grandmother		*muroyi*	Witch
badza	Handmade traditional iron hoe		*mutupo*	Totem, (pl. *mitupo*)
chaiye	Good		*muzukuru*	Grandchild, niece or nephew (pl. *vazukuru*)
Chaminuka	Provincial spirit of southeast Mashonaland		*mvuu*	Hippo
chimurenga	Struggle for liberation		*mwari*	Shona God of creation
chipembere	Rhino		*mweya*	Spirit, soul or air
chihonye	Worm		*Ndebele*	Second largest ethnic group in Zimbabwe
dangwe	Eldest son		*Nehanda*	Provincial spirit of central Mashonaland
dare	Small family court meeting		*nganga*	Traditional healer or shaman
hakata	Divining bones used by the *nganga* to foretell the future		*ngozi*	Angry or evil spirit
Harare	Capital of Zimbabwe		*njuzu*	Waterspirit
hari	Pot of water		*nyama*	Flesh
hwahwa	Ceremonial brewed beer		*Nyami Nyami*	Provincial spirit in northern Mashonaland
imba	Traditional mud brick round house with thatched roof		*nzou*	Elephant
Kariba	Dam and manmade lake in Zimbabwe		*pfuma*	Wealth or worldly riches
kopje	Small hill (Afrikaans term, Dutch origin)		*roora*	Bridewealth
kubereka	Give birth		*rufaro*	Sublime happiness and contentment
kunzwanana	Harmony of the greater clan or community		*rugare*	Abundant physical comforts
kuzvinyorovesa	Soften oneself and not offend others		*rupasa*	Reed mat
kuzvipeta	Humbleness		*sahwira*	Ritual friend
mbereko	Blanket sling that carries the baby on the mother's back		*sekuru*	Paternal grandfather, head of the family
mhondoro	Clan spirits		*shumba*	Lion, lion totem, symbol of kings
mhuri	Family bonding and kinship		*svikiro*	Spirit medium or oracle (pl. *masvikiro*)
mombe	Cattle		*ukama*	Close family relationship
mudzimu	Ancestral spirit, (pl. *midzimu*)		*vanotichengeta*	Ancestral spirits who protect our family
munhu	Human being		*Vukutu*	Rural sculpture workshop established in 1969
muroora	Daughter-in-law		*wafa*	The dead
musasa	Tree indigenous to Africa. Acacia family.		*Zimbabwe*	Means house of stone and gravesite of the great chiefs

THE SCULPTORS

This list is in no way complete. Many artists carved in earlier times and are no longer active. We have no way of tracing their names. However, those that have been documented are listed. Also, there are many newer and younger artists now carving whom we have yet to discover. We estimate there are now over 2000 sculptors.

FIRST GENERATION ARTISTS

Makiwa Chimoyo
Tubayi Dube
Makina Kameya
Wazi Maicolo
Josia Manzi
Joram Mariga
Moses Masaya
Bernard Matemera
Bernard Manyandure
Lemon Moses
Phinias Moyo
Sylvester Mubayi
Thomas Mukarobgwa
Nicolas Mukomberanwa
Henry Munyaradzi
Boira Mteki
Joseph Ndandarika
Claude Nyanhongo

SECOND GENERATION ARTISTS

Fanizani Akuda
Baudeni
James Bechani
Biri
Brown Bulandi
C. Camady
Crispen Chakanyaka
Douglas Chamunarwa
Ephraim Chaurika
Shadu Chatsama
C. Chidarara
M. Chihota
Never Chihumba
Eric Chigwanda
Lazarus Chikore
Vaisi Chimange
Cephas Chimbetele
Louis Chipfupi
Campion Chipfuya
Christopher Chipfuya
Richard Chiro
Joseph Chitala
Edward Chiwawa
S. Dawanyi
Dofe
R. Dzinamararira
Edina
Edisoni
Arthur Fata
Charles Fernando
Filas
Fly
Fombe
Smart Garaza
Giresi
Gondo
David Gopito
Enos Gunja
Conesius Guri
Marko Guri
Pitias Gwinisa
Paul Gwichiri
G. Hatugari
John Hlatywayo
Jailos
B. Jobum
Josia
Peter June
Phineas Kamangira
M. Kamena
Makina Kameya
N. Kananoma
Biggie Kapeta
Bernard Karikayi
Pita Karuma
Richard Katinhamure
A. Kazingizi
Lazarus Khumalo
Kilela
Lemos
Rogers Letala
Simon Machile
Clever Machisa

C. Magone
E. Magoronga
Amali Mailolo
R. Maimano
Akence Makore
Albert Mamvura
Manazi
Peter Mandala
Camady Mandizvidza
Munawa Manhenga
Phanuel Manjera
Patrick Manjoro
Damien Manuhwa
Barnabas Manyadza
Isaac Manyadza
J. Manyandure
Manyowa
Kumberai Mapanda
Mapiri
Ephraim Mariga
Nemiah Mariga
Richard Mariga
Z. Mariga
Lovemore Marimo
A. Marowa
C. Marowa
Victor Matinga
Mike Mawumbe
Mazhambe
Jan Mbiriri
Milondi
Bottom Mpayi
Cornwall Mpofu
Ruben Mpofu
Richard Mteki
Sylvester Mubaiyi
Tichona Mudzinga
Raymond Mugari
A. Mukomberanwa
Joseph Muli
Agrippa Munyaradzi
C. Munzvandi
I. Mupfurira
Ephraim Mushambi
Crispin June Mutambika
Amon Mwareka
Wilo Ndale
Lucas Ndandarika
Edom Ndoro
Elephas Ndoro
David Neumatambgwe
F. Neumatambgwe
M. Ngwerume
Taylor Nkomo
Conrad Nyagwande
R. Ngoni
Paison
Isaac Pfumbi
Ramiya
Rashidi
Kizito Rwanza
Brighton Sango
Harry Taaka
Bernard Takawira
John Takawira
Lazarus Takawira
Edronce Rukodzi
Kizito Rwanza
Saidi
Sakambera
Kingsley Sambo
Nicholas Samhokore
Mneni Sibanda
J. Sibindi
M. Sikupa
Sam Songo
P. Takawira
Tsangu
Naboth Tsiga
Useni
Frank Vanji
Wazi
Wiladi
Witnis
David Zindoga
R.M. Zvinauashe

THIRD GENERATION ARTISTS

Isaac Abraham
Gilbert Aloise
C. Ali
D. Amon
Edwell Arufaneti
Joseph Backford
Timothy Backford
T. Balamu
Mathias Banda
Funga Bangira
David Bangura
Gift Bangura
Nevelle Bazirio
Dominic Benhura
L. Benjo

K. Bunaya
R. Butsu
M. Bwoni
Clifford Chaerera
O. Chazaidinga
E. Chakauya
M. Chakawa
W. Chakawa
Pitiyose Chakawa
Elvis Chamba
Mathew Chamba
Somono Chamba
Chinotomba Chaparadza
S. Charenga
Samson Charimari
Charoa
D. Chatsama
Shingirai Chatsama
Stephen Chatsama
Charles Chaya
Z. Chaya
O. Chazaidinga
Enos Chengo
S. Chengo
Virimbo Cheza
Ephraim Chibono
J. Chida
Tendai Chidhakwa
Cains Chidhakwa
F. Chidhakwa
Simbanashe Chidhakwa
Chidzo
Cosmas Chifamba
O. Chifamba
Wellington Chifamba
Michael Chigaredze
M. Chigwande
A. Chihota
Singi Chihota
Tinapi Chihota
C. Chijute
Charles Chikazunga
Newman Chikuni
Padzuwa Chikuse
David Chikuzeni
Gilbert Chikuzeni
N. Chilenga
Wengai Chilenga
G. Chilrota
J. Chimbekeya
Austin Chimanikire
J. Chimbekeya
Ernest Chimhapa
B. Chimtema
David Chimuka
Michael Chingagaidze
Jonathan Chingagaidze
Harry Chingono
Stebiah Chingwaro
Julius Chinhoi
C. Chinotomba
Oscarlet Chinyama
F. Chinyoka
J. Chipako
Chipaunde
C. Chipivere
Poline Chipunza
David Chirambadare
Raymond Chirambadare
Richard Chirambadare
Closer Chirengwa
Promise Chirengwa
Isaac Chirovapasi
David Chirambadare
Raymond Chirambadare
Richard Chirambadare
Chirovapasi
Samwell Chirume
C. Chisute
Isaiah Chitanda
Leonard Chitanda
George Chitaunhike
Lovemore Chitaunhike
Never Chitaunhike
Moffat Chitaunike
J. Chitauro
Frank Chitemerere
Shepard Chitsa
Stephen Chitsa
P. Chitura
Paul Chivese
Ronnie Chivese
Harry Chivoyo
Michael Chiwandire
Ernest Chiwaridzo
D. Chizoza
Clayton
E. Dangare
Ngoni Pondani Dhliwayo
Promise Dhliwayo
P. Dondai
Ronnie Dongo
John Dumba
Dunmore
Epiyos

Nyango Ewitt
Andrew Farai
B. Ferenando
E. Firmen
L. Firu
M. Fohari
Edmore Fradreck
Patrick Fredy
Louis Gaiyihayi Nyamukanga
Adam Gatsi
Tendai Gatsi
Turuziya Gatsi
Ernst Gaura
K. Gayayi
Cosmas Gayihayi
Cephas Gemu
Garikayi Gemu
Medicine Gengezha
Takemore Gengezha
Temba Gengezha
Mike Gewandire
Albert Gonzo
G. Gopito
Tapiwa Gorerino
Barankinya Gosta
Juliet Gotora
Tapfuma Gutsa
Clifford Guwu
Hama
Maxwell Hlabiswana
Tom Hlupeko
Luxmore Hwenda
Isaiac
John Iya
Saidi Iya
Joseph Jala
Chemedu Jemali
Chituwa Jemali
Salim Jemali
Edward Jimu
K. Jimu
Luke Jimu
C. Jonali
Eckiel Kabvura
A. Kadozora
Ceasar Kadungure
T. Kadzande
Simon Kadzima
Daniel Kadzunga
J. Kagiro
Enziwea Kagoda
Gladys Kagoda
Simon Kagoma
John Kagwize
N. Kahemba
Chakara Kamanika
Never Kamazo
F. Kamba
S. Kambeu
C. Kamhiriri
David Kangoma
Mudavanhu Kanokora
Norman Kanyedereza
Maikosi Kanyemba
Denny Kanyemba
Maehford Kanyemba
Shaibu Kanyemba
Steven Kanyemba
Maikosi Kanyeredza
Winciayi Kanyeredza
Ishmael Kapeta
Damian Kapfurutsa
Dana Kapfurutsa
Denny Kapfurutsa
Mackenzie Kapisa
T. Karidza
Luxon Karise
M. Stephen Kashiri
Christopher Kasina
Gibson Kasina
K. Kasina
Ruramai Katanda
Engrom Katinhimure
Sure Try Katinhimure
Ephraim Katsande
Jonathan Katsande
Tonderai Katsande
W. Katsatse
J. Kawerawera
H. Kingman
Myles Kudzunga
Patrick Kutinyu
Robin Kutinyu
Richard Kuvhengurwa
Samson Kuvhengurwa
Thomas Kuvhengurwa
Zephania Kuvhengurwa
Nelson Kwechete
Robert Kwechete
Ronnie Lazarus
Ausper Leon
John Leon
Wonder Luke
T. Mabheka
Moses Maburira

Onias Maburira
Godfrey Mabwe
D. Macheka
Shepard Madzikatire
Cleopas Madzongwe
Gwinyai Maguma
Pious Maguta
Z. Mahwekwe
Samuel Majone
Ernst Makande
F. Makande
Patrick Makoni
Albert Makore
Gift Makore
Junior Makore
Silas Makumba
E. Mamvura
Michael Mandala
Simon Mandala
Stanislaus Mandala
Richard Mandleve
Ian Manjeru
K. Manjoro
Kweta Manuoro
A. Manuwa
Richard Manxeye
I. Manyadza
Augustin Manyika
L. Manyika
Julius Mapako
Stephen Mapanda
George Mapfumo
S. Mapfumo
A. Maramawidzi
George Mareke
Tonderai Marezva
Edson Marime
Ernst Marime
Obert Marime
Robert Marime
A. Marora
Marumahoko
Levy Maruza
Shame Masango
Eddie Masaya
Edward Tendayi Masaya
Edi Shereni Masaya
Miguel Kennedy Masaya
Mike Masedza
Passmore Mashaya
Precious Mashaya
Tonderai Mashaya
Fernando Masimo
Mafio Masose
Ngoni Matafi
C. Matia
Patrick Matola
C. Matombo
P. Mavudzi
R. Mavudzi
Mazara
Paulos Mazuwa
R. Mazvidso
Simon Meza
Wellington Mdokwani
Wilson Mgambwa
Mhenenziya
Henry Mhere
J. Mhlanga
Jonathan Mhondorohuma
Peter Mhondorohuma
Alex Million
Peter Mitorozo
David Mlambo
Kucheza Mlambo
Nicodemus Mlambo
Phineas Mlambo
Richard Mlambo
Gerade Mlengeni
Nathan Molai
T. Moreza
Sebastian Moyowaonda
T. Mozoe
Ngoni Mrewa
Peter Mrewa
Thomas Mrewa
Cannissious Msengei
Phillip Mseteka
Mathias Msinkhupinza
Washington Msonza
Wellington Msonza
Peter Mstrozo
Thomas Mtasa
Bryan Mtchi
Stephen Mtenga
Brighton Mtongwizo
Victor Mtongwizo
Life Mubaiwa
E. Mubure
George Muchaparaparo
Joseph Muchaparaparo
Norman Muchena
Cosmas Muchenje
M.J. Muchenje
G. Muchimani

Charles Mudadirwa
Wellington Mudariki
Farai Mudhokwani
Stewart Mudzimurega
Francis Mugavazi
Luke Mugavazi
MacDonald Mugavazi
Skebios Mugugu
John Mukambachoto
Thomas Mukarobgwa
Percy Mukeda
John Mukombachoto
Mapurani Mukombachoto
Collins Mukomberanwa
Nesbert Mukomberanwa
Nezbitt Mukomberanwa
Naboth Mukomberanwa
Tendai Mukomberanwa
Sailas Mulinga
K. Mukwanda
Elijah Mumbure
K. Munga
Fanny Mupfawa
April Mupinga
July Mupinga
Lucky Mupinga
Isaac Mupotaringa
Timothy Mupotaringa
R. Mupumha
Paradzayi Mupumhira
E. Muriro
P. Muriro
R. Murisa
Paradzayi Murumhira
William Murunga
Musafari
Kennedy Musekiwa
K. Museriwa
D. Mushonga
Linos Mushambi
Niccodimus Mushore
R. Mushoshoma
O. Musiyiwa
W. Msonza
Tonderai Musvamhiri
S. Mutenga
Lincon S. Muteta
Peter Mutorozo
Kefas Muunga
Gift Muza
Patrick Muzanenhama
Takesure Muzengeza
Netsai Muzeya
Joseph Muzondo
Mvario
George Mwale
Leonard Mwanza
Noel Mwanza
Nova Mwanza
V. Mwanza
Lawrence Mzimba
Sebastian Mwoyowaonda
J. Namaisa
A. Ndongwe
Caspar Ndoro
Felix Ndoro
Everlast Nherera
Farrai Nheuka
Farai Ngamu
Kaitano Ngamu
Kennedy Ngamu
Matthew Ngawanyana
Phineas Ngiraza
Matthew Ngwanyana
Phillip Ngwenya
Everlast Nherera
Joel Nhete
Chengetai Nhunduru
Castane Njanji
Tamuka Njanji
Tangai Njanji
Zachariah Njobo
Moses Njumbo
T. Nkomo
M. Nkiwane
Nuamunga
Moses Nyagumbo
M. Nyakotyo
Makios Nyakuwaza
Obert Nyamapapira
Bursary Nyamasoka
Ratherford Nyamhingura
A. Nyamuchengwa
L. Gaviuayi Nyamukami
C. Nyamukanga
Moses Nyamunda
Bryan Nyamhongo
Ewitt Nyanhongo
Wellington Nyanhongo
C. Nyanyiwa
Christopher Nyanyiwa
F. Nyaranyanza
E. Nyatsika
M. Nyaungwa
Casten Nyowa

Migere Padago
Chikuse Padzuwa
Solomon Panda
Patricio
Murisa R.
V. Rangisse
B. Reed
Dickson Rice
M. Richard
Richard Rosani
Robin Rugare Kutinju
Tendai Rukodzi
Trust Rukodzi
Taurai Rukodzi-Jeremani
Nelson Rumano
Kingstone Runyanga
T. Rutsito
Saidi Sabiti
Edgar Sahondo
Lewis Samkanga
G. Sango
L. Sayihayi
Daniel Semwayo
Renai Sendedza
Stanley Chidoti Shadreck
Hermus Shaigo
Neriya Shamba
Shami
Benjamin Shamuyarira
Norbert Shamuyarira
Maxwell Agony Shangwa
Eddi Shereni
B. Sikireta
Tendai Simbi
Francis Simoni
W. Sinoia
Collin Sixpence
Nevison Solomon
Sosinay
E. Swatidazo
Gerald Takundwa
E. Tarwirei
W. Tauripo
Simon Tauzime
Passmore Tawasika
Safe Tawasika
R. Temera
N. Tichaona
Felix Tirivanhu
John Wellington Tyauripo
John Type
G. Ukama
Kucheza Virimho
Wadini
Tendai Watson
M. Whazan
K. Zano
P. Zenda
Bernard Zindonda
John Zindonda
Gladman Zinyeka
Thomas Zinyeka
Zirio
P. Zogolo
Mollis Zuze

WOMEN SCULPTORS

Annasia Chapardza
Lizwe Chidhakwa
Stebiah Chingwaro
Judith Chitauro
Evelyne Dzingisai
Turuziya Gatsi
Juliet Gotora
Tendai Gwadu
Shaileen Hozo
Gladys Kagoda
Clara Kamuchanyo
Ruramai Katanda
Leah Katinhamure
Ausper Leon
Mavis Mabwe
Margaret Magunha
Lydia Makwaza
Rosemary Malinga
Mercy Masose
Junior Mhembere
Nyarai Musvamhiri
Netsai Muzeya
Letwin Mugavazi
Farai Ndandarika
Rachel Ndandarika
Locadia Ndandarika
Beverly Ndlalambi
Stella Nyandoro
Agnes Nyanhongo
Marian Nyanhongo
Angeline Rukodzi
Queenie Sango
Alice Sani
Renal Sendedza
Neriya Shamba

PHOTO CREDITS

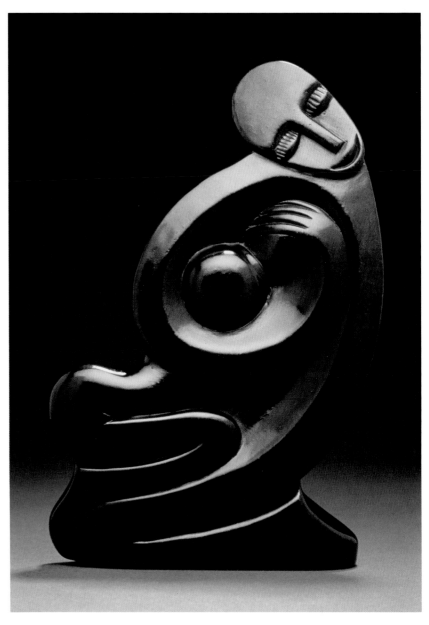

Mother and Child
David Gopito
12"

BIBLIOGRAPHY

Arnold, Marion, *Zimbabwean Stone Sculpture*, Louis Bolze Publishing, Bulawayo, Zimbabwe, 1981

Aschwanden, Herbert, *Symbols of Life*, Mambo Press, Harare, Zimbabwe, 1982

Beach, D.N., *The Shona and Zimbabwe 900-1850—An Outline of Shona History*, Mambo Press, Harare, Zimbabwe, 1980

Beier, Ulli, *Contemporary Art in Africa*, Frederick A. Praeger, Publishers, London, England, 1968

Bourdillon, Michael, *The Shona Peoples*, Mambo Press, Harare, Zimbabwe, 1976

Brentjes, Burchard, *African Rock Art*, Clarkson N. Potter Publisher, New York, New York, 1970

Biebuyck, Daniel, *Tradition and Creativity in Tribal Art*, University of California Press, Berkeley, California, 1969

Camerapix, *Spectrum Guide to Zimbabwe*, Books for Africa Publishing House, Harare, Zimbabwe, 1991

Chavunduka, G., *A Shona Urban Court*, Mambo Press, Gwelo, Zimbabwe, 1979

Cheney, Patricia, *The Land and People of Zimbabwe*, J.B. Lippincott, New York, New York, 1990

Chigwedere, A., *From Mutapa To Rhodes*, Longman Publishers, Harare, Zimbabwe, 1980

Clark, J. Desmond, *The Prehistory of Southern Africa*, Penguin Books, New York, New York, 1959

Daix, Pierre, *Cubists and Cubism*, Editions D'art Albert Skira, Rizzoli, New York, New York, 1982

Davidson, Basil, *The Lost Cities of Africa*, Little, Brown & Company, Boston, Massachusetts, 1959

Davidson, Basil, *African Kingdoms*, Time Inc., New York, New York, 1966

de Rachewiltz, Boris, *Introduction to African Art*, The New American Library, New York, New York, 1966

Elisofon, Eliot, and William Fagg, *The Sculpture of Africa*, Frederick A. Praeger, London, England, 1958

Elsen, Albert E., *Origins of Modern Sculpture: Pioneers and Premises*, George Braziller, Inc., New York, New York, 1974

Encyclopedia Zimbabwe, Quest Publishing, Harare, Zimbabwe, 1987

Fagg, William, *Tribes and Forms in African Art*, Tudor, 1965

Fagg, William, and Margaret Plass, *African Sculpture*, Dutton, 1964

Gelfand, Michael, *Witch Doctor—Traditional Medicine Man of Rhodesia*, Havill Press, London, 1964

Gelfand, Michael, *Ukama—Reflections on Shona and Western Cultures in Zimbabwe*, Mambo Press, Harare, Zimbabwe, 1981

Gelfand, Michael, *Growing Up in Shona Society—From Birth to Marriage*, Mambo Press, Harare, Zimbabwe, 1979

Gelfand, Michael, *The Genuine Shona—Survival Values of an African Culture*, Mambo Press, Harare, Zimbabwe, 1973

Giedion-Welcker, Carola, *Contemporary Sculpture: An Evolution in Volume and Space*, George Wittenborn, Inc., New York, New York, 1960

Hall, Richard N., *Ancient Ruins of Rhodesia*, 1902

Hall, Richard N., *Prehistoric Rhodesia*, 1909

Jones, David, *The Nature of Zimbabwe—A Guide to Conservation and Development*, International Union for Conservation of Nature and Natural Resources (IUCN), IUCN, Switzerland, 1988

Kilef, Clive and Peggy, eds., *Essays by African Writers, Shona Customs*, Mambo Press, Gwelo, Zimbabwe, 1985

Lan, David, *Guns & Rain—Guerrillas & Spirit Mediums in Zimbabwe*, Zimbabwe Publishing House, Harare, Zimbabwe, 1985

Marikana, P.C. and Johnstone, I.J., *Zimbabwe Epic*, National Archives, Harare, Zimbabwe, 1982

National Gallery of Zimbabwe Annual Exhibitions, *Zimbabwe Heritage—Contemporary Visual Arts*, National Gallery of Zimbabwe, Harare, 1986

Paulme, Denise, *African Sculpture*, Viking Press, New York, New York, 1962

Plangger, Albert B., *Serima*, Mambo Press, Harare, Zimbabwe, 1974

Radin, Paul, and James Johnson Sweeney, eds., *African Folktales and Sculpture*, Pantheon Books, New York, New York, 1964

Segy, Ladislas, *African Sculpture Speaks*, Da Capo Press, Inc., New York, New York, 1969

Trowell, Margaret, *Classical African Sculpture*, Frederick A Praeger, London, England, 1964

Walker, David A.C., *Paterson of Cyrene*, Mambo Press, Harare, Zimbabwe, 1985

Whyte, Beverly, *Yesterday, Today and Tomorrow—A 100 year History of Zimbabwe 1890-1990*, David Burkle Promotions, Harare, Zimbabwe, 1990

Winter-Irving, Cecelia, *Stone Sculpture in Zimbabwe*, Roblaw Publishers, Harare, Zimbabwe, 1991

INDEX

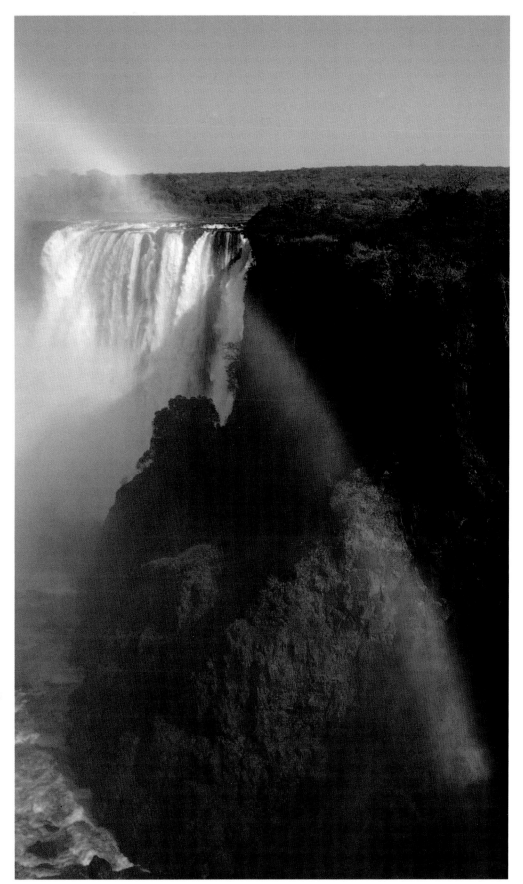

Victoria Falls

"The world's best unrecognised sculptors… are producing fine stonework… the finest, some say, in the world." —*The Economist*

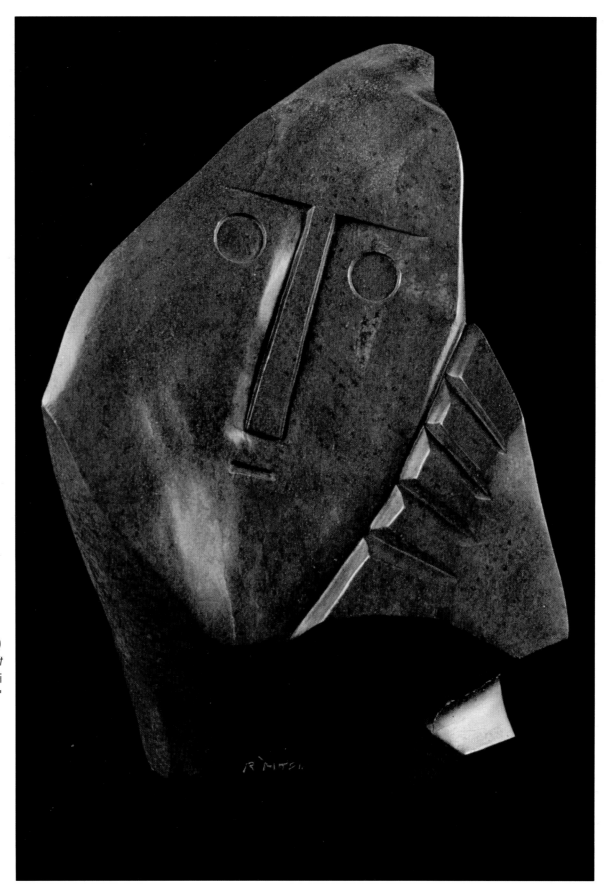

(Opposite)
Leaf Spirit
Richard Mteki
18"

213

"The Shona, my dear, have had hundreds of years to develop, and their art reflects those ancient roots."
—*Hubert Ponter*

Musasa Tree at sunset

214